D1262374

CREATIVE EFFECTS IN SOCK KNITTING

Op-Art SOCKS

STEPHANIE VAN DER LINDEN

INTERWEAVE
interweave.com

Editor	Ann Budd
Technical Editor	Lori Gayle
Photographer	Joe Hancock
Photo Stylist	Emily Smoot
Art Director	Julia Boyles
Cover Design	Pamela Norman
Interior Design	Julia Boyles
Layout	Brenda Gallagher
Illustration	Gayle Ford
Production	Katherine Jackson

© 2013 Stephanie van der Linden
Photography © 2013 Joe Hancock
Illustrations © 2013 Interweave
All rights reserved.

Interweave
A division of F+W Media, Inc.
201 East Fourth Street
Loveland, CO 80537
interweave.com

Manufactured in China by
RR Donnelley Shenzhen.

Library of Congress
Cataloging-in-Publication Data
Linden, Stephanie van der.
Op-art socks : creative effects in sock
knitting / Stephanie van der Linden.
pages cm
Includes index.
ISBN 978-1-59668-903-9 (pbk.)
ISBN 978-1-59668-942-8 (PDF)
1. Socks. 2. Knitting—Patterns.
3. Optical art. I. Title.
TT825.L56 2013
746.43'2--dc23
2013010974

10 9 8 7 6 5 4 3 2 1

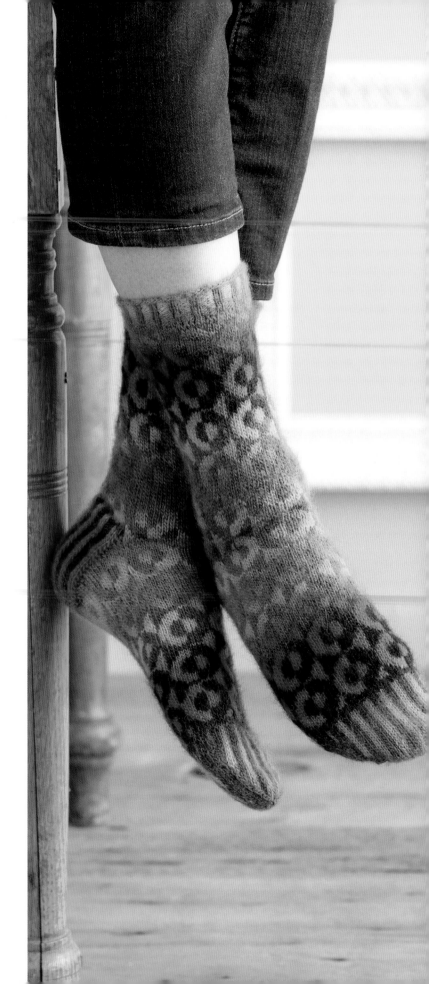

Acknowledgments

When I started designing knitting patterns, I had been a subscriber and reader of *Interweave Knits* for years. To have just one of my patterns featured in this magazine became my goal. In 2010, Interweave published an English translation of one of my German sock knitting books—*Around the World in Knitted Socks*. Wow! That was more than I ever dreamed of! I dared to submit the idea to use visual op-art effects for knitting patterns and came to work with these highly talented people. I'd like to thank you all for this opportunity, for the confidence in my work, and, most of all, for our shared excitement for this book!

"Ein herzliches Dankeschön"

To Anne Merrow for keeping in warm contact with me all these years now. You smoothed the way that I dared to make toward such a giant U.S. publisher.

To Allison Korleski for your energy and power, even if it meant endless discussions about the contract.

To Ann Budd, my editor with a tremendous amount of experience. You are one of those famous superstars for knitters but never let me feel that. Many thanks for backing me and backing this book with your know-how and your fresh and friendly nature! It was so good to have you at my side.

To Julia Boyles for the lovely design and careful art direction.

To Joe Hancock for all these wonderful photos and to Emily Smoot for the perfect styling.

To Lori Gayle for your thorough technical editing, Veronica Patterson for your keen copyediting, Nancy Arndt for your careful proofreading, and Hollie Hill for coordinating this project reliably. Thank you all very much!

To Klemens Zitron (Atelier Zitron) and Chantal Knüsel (Lang & Co. AG), who made available all the yarns that are featured in this book. *Vielen Dank für die tolle Unterstützung!*

To all my knitters and test knitters who checked the patterns first: Susanne Bach, Andrea Becker, Simone Dräger, Monika Eckert, Annie Hauber, Michaela Karzig, Stefanie Nelz, Gudrun Neumann-Mack, Michaela Petrovsky, Manuela Pohl, Petra Preyer, and Ingrid Seul—*Herzlichen Dank für Euren Einsatz, Ihr seid prima!*

To Renate Grunert-Paul, who helped me secure one last ball when we ran out of yarn six rounds before the tip of the toe and two days before deadline. *Renate, lieben Dank Dir!*

And finally, many special thanks to Joannes, my husband, and to Lioba, Dorothea, and Silja, my three ladies!

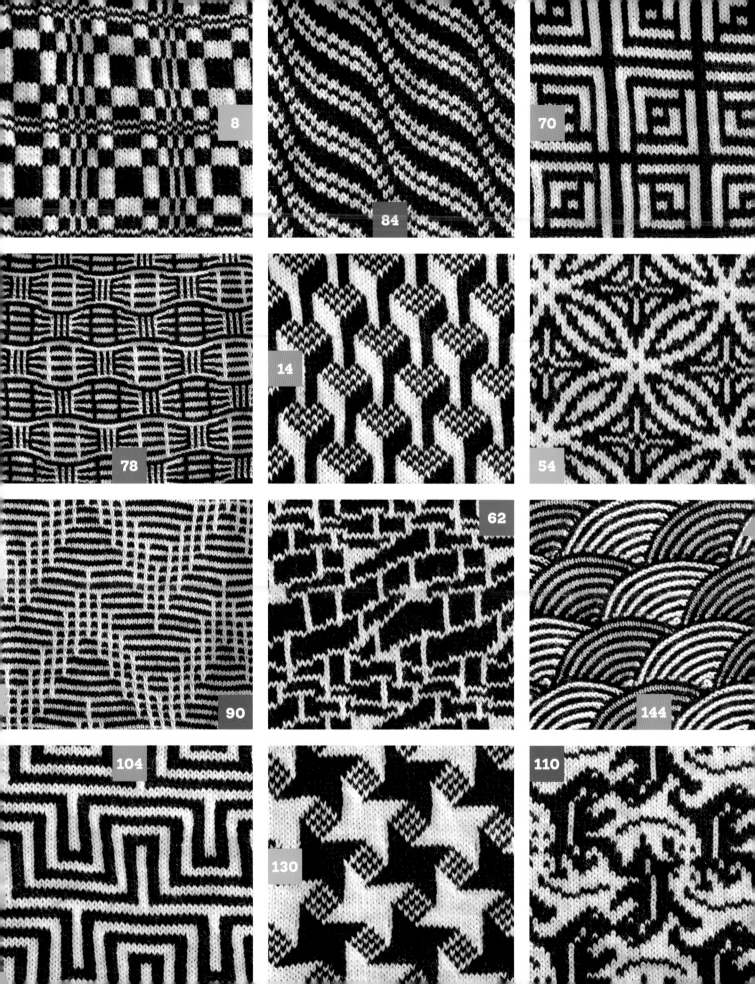

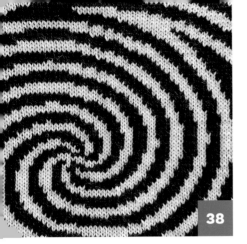

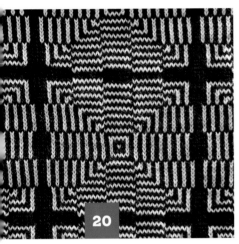

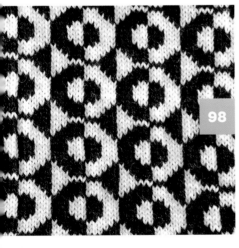

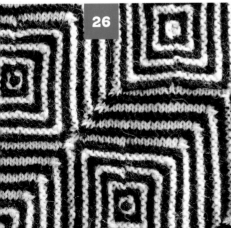

Contents

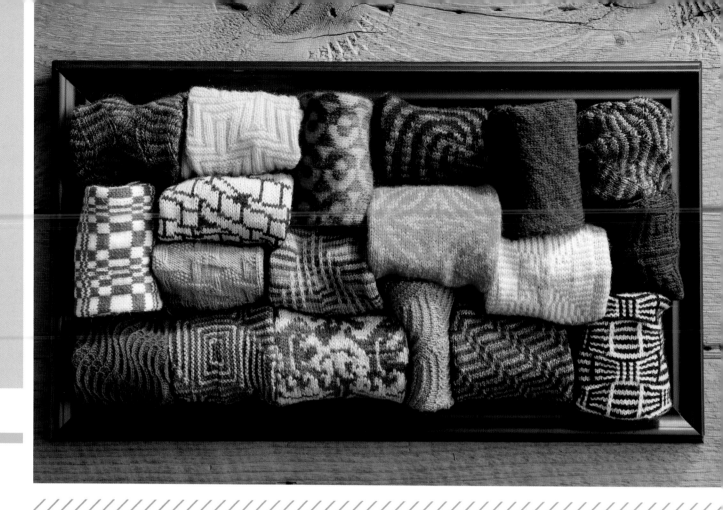

Introduction

Knitted socks are small projects that warm one's feet and make welcome gifts.
What is particular about designing knitted socks is that the stitch and color patterns must fit in rounds and must accommodate the particular construction. I like designing socks of all types, but I particularly like the challenge of designing socks that fit within themes. The optical art or op-art movement of the 1960s inspired the patterns in this book.

Derived from the German Bauhaus School founded by Walter Gropius in 1919, op art was identified in 1964 as a movement in the visual arts that emphasizes the psychological and physiological conditions of visual experience. Op art explores visual perception through the illusion of movement, much of which is unsettling to the viewer and difficult for the eye to resolve. It's closely related to research on how we see things and how we interpret what we see. Op-art paintings and drawings intentionally break symmetries and regularities to create impressions of depth (a third dimension) or dynamics (movement, flashing, vibration) by optical illusion.

Many of the best-known examples of op art are presented in black and

white and involve tiles or lines used in such a way that the difference between the figure and the background is obscured. The result is a seemingly volatile surface without a fixed reference point. In addition to depth and dynamics, these black-and-white works create lingering after-images or, at times, the illusion of color. Other works use contrasting colors—ranging from tone-on-tone to complementary colors—to stir visual impressions.

My approach to sock design is influenced by my background in mathematics, engineering, and chemistry. I'm also attracted to the Bauhaus tenet combining form and function. For the designs in this book, I interpreted classic op-art patterns in different knitting techniques to create socks that are both appealing and practical. Through the use of simple knit and purl stitches and stranded colorwork to represent blocks, lines, and angles, these socks are eye-catching explorations of depth, vibration, and reversals.

Before You Begin

To ensure the greatest enjoyment and success when you knit the socks in this collection, I have adopted a few techniques that are worth mentioning here.

NEEDLE SIZE

Because socks fit best if they have negative ease (the stitches are stretched when worn), those knitted with textured patterns are best worked at denser gauges than normally recommended for a particular yarn. This is why many of the socks in this collection are worked on the smallest recommended needle size.

STRANDED COLORWORK

A common challenge with stranded colorwork is maintaining proper tension on the yarn that floats across the back of the work, especially at the transitions between needles when working socks in rounds. If you turn the sock inside out, you can force the floats to follow a slightly longer path around the outside of the sock, which can help ensure that they are loose enough to allow the stitches to maintain the necessary stretch. To begin, cast on and work the first two rounds of the cuff as usual. Then turn the cuff inside out so that the right side of the knitting faces the inside of the circle. Everything will remain the same, but you'll knit on the back (or far) side of the circle instead of the front. When it comes time to work a heel flap in rows, turn the knitting around and work on just the heel-flap stitches; once you rejoin for working in rounds, turn the work inside out again to work on the far side.

Right side

Wrong side

For most of the socks in this book that involve stranded colorwork, the gusset stitches are picked up with just one color while the instep stitches are worked with two. To avoid having to cut the working yarns (and potentially interrupt the established color sequence), before you cast on stitches for the sock, cut

a length of yarn to be used for picking up the gusset stitches. Use this length when it comes time to pick up and knit stitches along the right side of the heel flap (the side that usually would be worked last), then use the attached yarn to work across the heel stitches and to pick up and knit stitches along the left side of heel flap. You'll then have both working yarns in position to work in rounds; the rounds will begin between the sole and instep stitches, instead at the center of the sole.

FOLLOWING CHARTS

Charts are a necessity for following op-art patterns in knitting. However, because by their nature the patterns cause visual movement, it can be difficult to follow the individual rows. To help keep track of your place, especially on large charts, make an enlarged photocopy of the chart (making a separate copy for each sock), then cross out each row as you complete it.

I find that it's easiest to work charted patterns if all of the stitches for a long section or complete repeat of the chart are on a single needle instead of split between two needles. This is why a number of my patterns call for working with two circular needles instead of four or five double-pointed ones. Working with two circular needles has the added advantage of minimizing the number of breaks between needles where ladders of loose stitches are likely to occur.

I hope that these hints will help you have as much fun knitting these socks as I had designing them!

Stephanie van der Linden

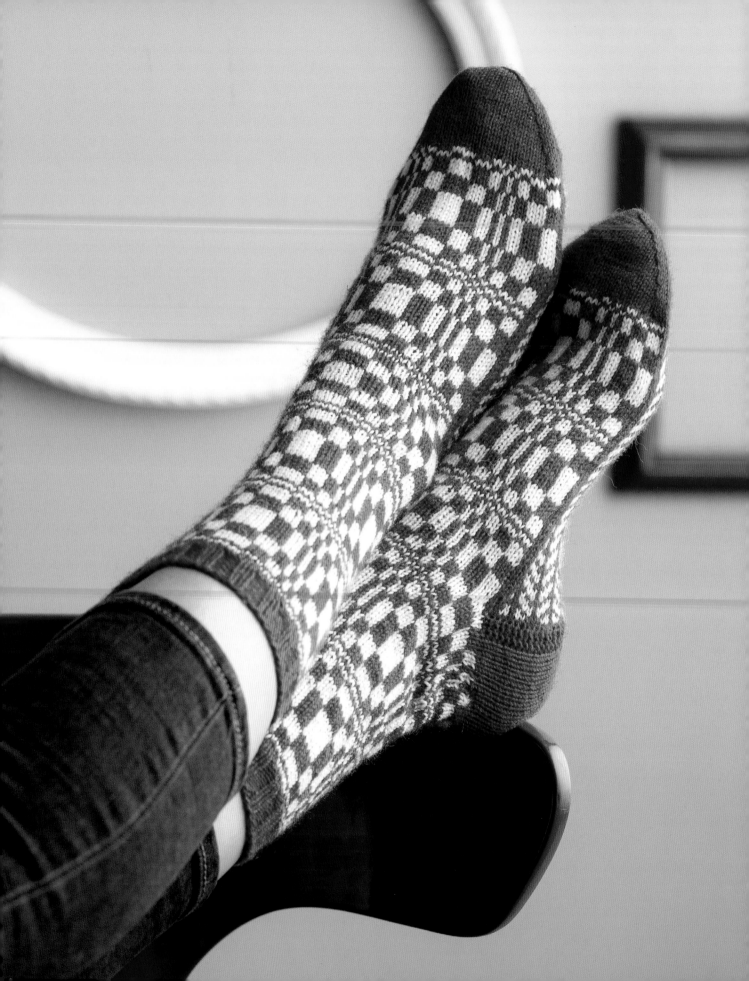

Fibonacci

FINISHED SIZE
About 8¼" (21 cm) foot circumference and 9¾ (10½)" (25 [26.5] cm) foot length from back of heel to tip of toe.

To fit U.S. women's shoe sizes 8–9 (10–11); European shoe sizes 39–41 (42–44).

Socks shown measure 10½" (26.5 cm) in foot length.

YARN
Fingering weight (Super Fine #1).

Shown here: Trekking Sport 4-Ply (75% new wool, 25% nylon; 459 yd [420 m]/100 g): #1493 red (MC) and #1400 white (CC), 1 ball each for both sizes.

NEEDLES
Size U.S. 1 (2.25 mm): two 24" (60 cm) circular (cir).

Adjust needle size if necessary to obtain the correct gauge.

NOTIONS
Tapestry needle.

GAUGE
32 sts and 44 rows/rnds = 4" (10 cm) in solid-color St st after blocking; 32 sts and 44 rows/rnds = 4" (10 cm) in solid-color St st and relaxed after blocking.

35 sts and 40 rnds = 4" (10 cm) in charted patts worked in rnds, after blocking and after relaxing.

Note: *Many gauges will be given in two forms; one after blocking and one relaxed after blocking.*

With a chessboard as its basis, a spatial impression of the two-dimensional original can be generated by symmetric compression and stretching in the order of the Fibonacci sequence. Leonardo da Pisa (a.k.a., Fibonacci) introduced the sequence in 1202, although it has earlier roots in Indian mathematics. The Fibonacci sequence begins 1, 1, 2, 3, 5, 8, with the last two numbers always added together to produce the next number. The sequence is intimately connected with the golden ratio (in which the sum of the smaller and larger quantity is equal to the ratio of the larger quantity to the smaller one). Many artists and architects have proportioned their works to approximate the golden ratio, especially in the form of the golden rectangle, which can be found several times in the chart pattern for the socks shown here.

Named for the Fibonacci principle, these socks feature this mathematic principle in two colors—red and white. They're knitted in the round with two circular needles to minimize the number of breaks between needles.

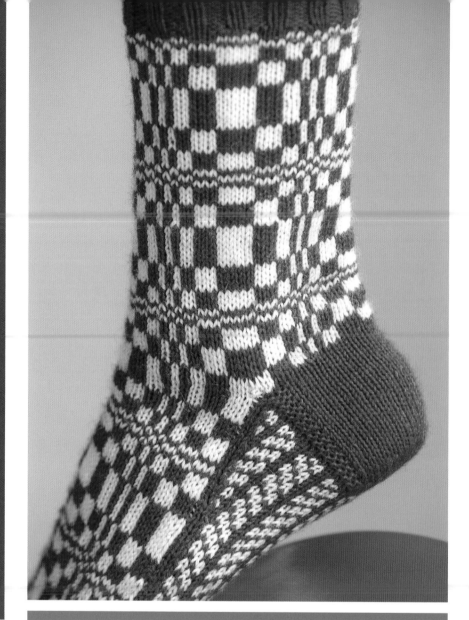

STITCH GUIDE

K2, P2 Cuff Pattern (multiple of 4 sts)

All rnds: *K2, p2; rep from *.

NOTE

× The gusset stitches are picked up with just one color while the instep stitches are worked with two. To avoid having to cut the working yarns, before you cast on for the cuff, cut a length of yarn to be used for picking up gusset stitches. Use this length to pick up and knit stitches along the right side of the heel flap (the side that usually would be worked last), then use the attached yarn to work across the heel stitches and to pick up and knit stitches along the left side of the heel flap. You'll then have both working yarns in position to work in rounds and will begin between the sole and instep stitches, instead of at the center of the sole.

Cuff

Cut a 24" (60 cm) length of MC and set aside to use later for picking up sts along the right side of the heel flap.

With MC, CO 64 sts for both sizes. Arrange sts evenly onto two cir needles—32 sts on each needle. Join for working in rnds, being careful not to twist sts.

Work in k2, p2 cuff patt (see Stitch Guide) for 12 rnds—piece measures about 1" (2.5 cm).

Leg

Set-up rnd: With MC, [k8, M1 (see Glossary)] 8 times—72 sts; 36 sts each needle.

Join CC and change to St st (knit all rnds).

Work Rnds 1–24 of Leg chart 2 times, then work Rnd 1 to Rnd 21 (12) once more—69 (60) chart rnds total; piece measures 8 (7)" (20.5 [18] cm) from CO.

• •

Note: *The pattern is planned to have the same number of total chart rounds between the cuff and the toe for both sizes; the larger size has fewer leg rounds in order to allow for more foot rounds.*

• •

Heel

The heel is worked back and forth on the last 36 sts of the leg rnds (Needle 2). Do not cut CC; leave the working strand of CC attached to use later when rejoining in the rnd for the gussets.

Turn work so the WS is facing.

LEG

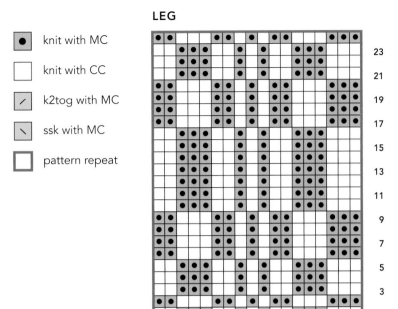

knit with MC

knit with CC

k2tog with MC

ssk with MC

pattern repeat

23
21
19
17
15
13
11
9
7
5
3
1

18-st repeat

GUSSET

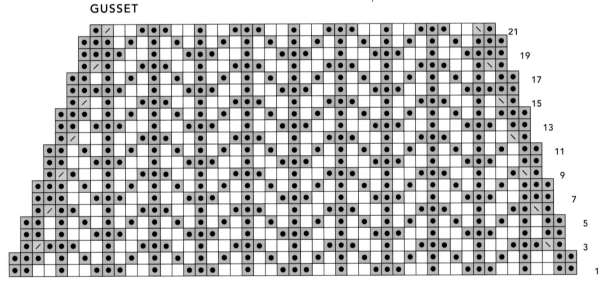

21
19
17
15
13
11
9
7
5
3
1

49 sts dec'd to 35 sts

Set-up row: (WS) With MC, p35, then sl the last st from the end of Needle 2 onto Needle 1—35 heel sts on Needle 2; 37 instep sts on Needle 1.

Cont on 35 heel sts as foll:

Row 1: (RS) [K7, k2tog] 3 times, k8—32 heel sts rem.

Row 2: (WS) K3, p26, k3.

Row 3: Knit.

Row 4: K3, p26, k3.

Rep the last 2 rows 14 more times—32 rows total (not counting the set-up row); 16 garter ridges along each selvedge.

TURN HEEL

Work short-rows as foll:

Short-row 1: (RS) K17, ssk, k1, turn work.

Short-row 2: (WS) Sl 1, p3, p2tog, p1, turn work.

Short-row 3: Sl 1, knit to 1 st before gap formed by previous RS row, ssk (1 st each side of gap), k1, turn work.

Short-row 4: Sl 1, purl to 1 st before gap formed by previous WS row, p2tog (1 st each side of gap), p1, turn work.

Rep the last 2 rows 5 more times—18 heel sts rem.

SHAPE GUSSET

Turn work so RS is facing and drop the strand of MC attached to beg of heel sts. Use the length of MC yarn cut and set aside before casting on to pick up sts along the first side of the heel flap as foll:

Set-up row: (RS) Using the cut length of MC, the other tip of the cir needle holding the heel sts, and beg in the corner between the heel flap and instep sts on the right side of the flap, pick up and knit 16 sts (1 st for each garter ridge) along the right side of the heel flap, then drop the extra strand of yarn.

Using the MC attached to beg of heel sts, work 18 heel sts as k8, k2tog, k8; then with same needle and MC pick up and knit 16 sts (1 st for each garter ridge) along left side of heel flap—49 heel and gusset sts on one needle (Needle 2).

Both MC and CC yarns are now at the start of the instep sts on Needle 1.

Next rnd: With Needle 1, work Rnd 22 (13) of Instep chart over 37 sts; with Needle 2, work Rnd 1 of Gusset chart over 49 sts—86 sts total.

Cont in established patts until Rnd 21 of Gusset chart has been completed, ending with Rnd 18 (9) of Instep chart—72 sts rem: 37 instep sts on Needle 1, 35 gusset and sole sts on Needle 2.

- ● knit with MC
- ☐ knit with CC
- ☐ pattern repeat

SOLE

8-st repeat

INSTEP

18-st repeat, plus 1

Foot

Next rnd: With Needle 1, work Rnd 19 (10) of Instep chart; with Needle 2, work Rnd 1 of Sole chart over 35 sts.

Cont in established patts, work 29 (38) more rnds, ending with Rnd 24 of Instep chart and Rnd 3 of Sole chart for both sizes.

Next rnd: With Needle 1, work Rnd 1 of Instep chart; with Needle 2, k35 with MC—121 total rnds completed from Leg and Instep charts; foot measures about 7¼ (8)" (18.5 [20.5] cm) from center back heel.

Toe

Cut off CC. Cont with MC only, knit 1 rnd. Cont as foll:

Rnd 1: With Needle 1, k3, [k2tog, k5] 4 times, k2tog, k4; with Needle 2, k5, [k2tog, k9] 2 times, k2tog, k6—64 sts rem: 32 instep sts on Needle 1, 32 sole sts on Needle 2.

Rnds 2 and 3: Knit.

Dec rnd: With Needle 1, *k1, ssk, knit to last 3 sts, k2tog, k1; with Needle 2, rep from *—4 sts dec'd; 2 sts dec'd each needle.

Knit 3 rnds even, then rep dec rnd—56 sts rem; 28 sts each needle.

[Knit 2 rnds even, then rep dec rnd] 2 times—48 sts rem; 24 sts each needle.

[Knit 1 rnd even, then rep dec rnd] 3 times—36 sts rem; 18 sts each needle.

Rep dec rnd every rnd 7 times—8 sts rem; 4 sts each needle; toe measures about 2½" (6.5 cm).

Finishing

Cut yarn, leaving an 8" (20.5 cm) tail. Thread tail onto tapestry needle, draw through rem sts, pull tight to close hole, and fasten off on WS.

Weave in loose ends. Block lightly.

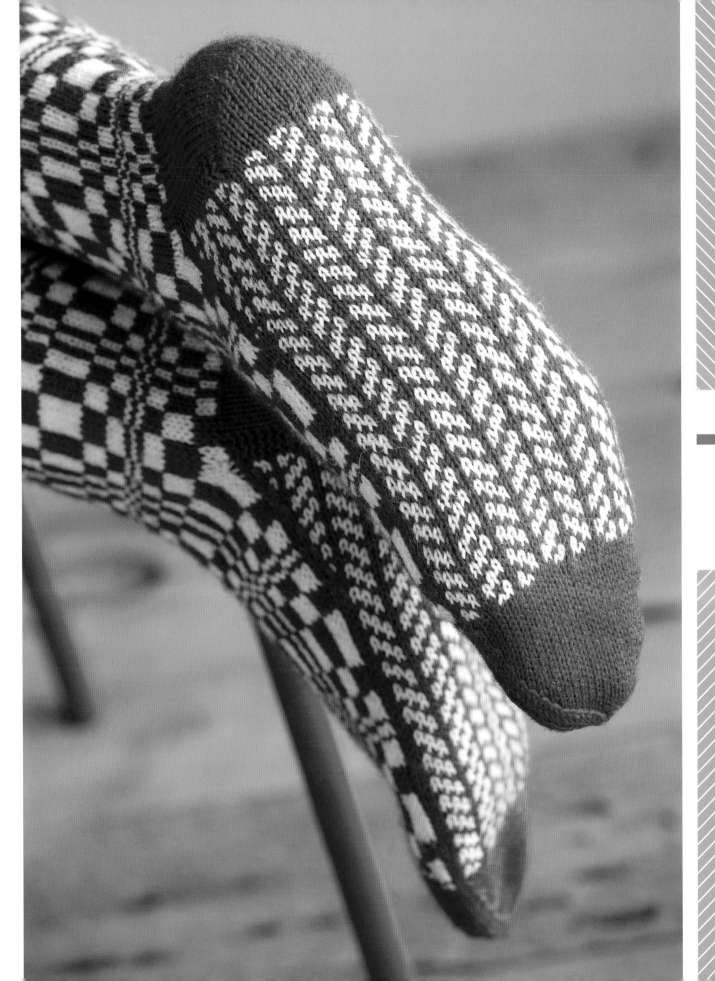

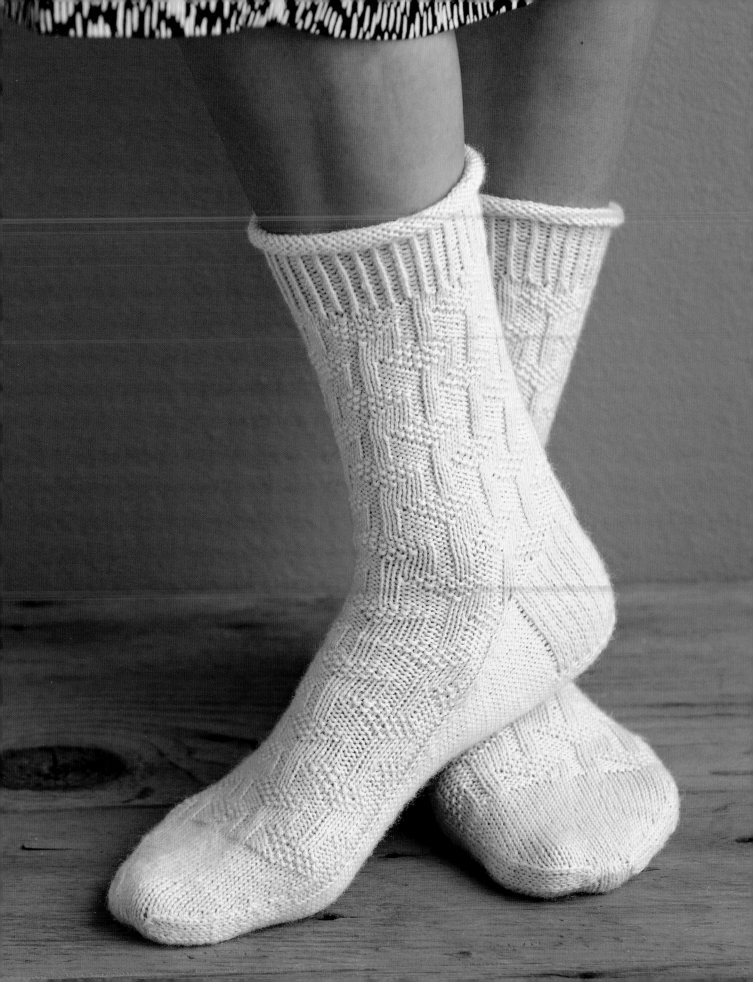

Necker

FINISHED SIZE
About 7½ (8)" (19 [20.5] cm) foot circumference, unstretched, and 9¼ (10¾)" (23.5 [27.5] cm) foot length from back of heel to tip of toe (length is adjustable).

To fit U.S. women's shoe sizes 7–8 (men's 9½–10½); European shoe sizes 38–40 (43–45).

Yellow socks shown in women's size; blue socks shown in men's size.

YARN
Fingering weight (#1 Super Fine).

Shown here: Trekking Sport 4-Ply (75% new wool, 25% nylon; 459 yd [420 m]/100 g): 1 ball for both sizes. Shown in #1488 yellow and #1440 blue.

NEEDLES
Size U.S. 1 (2.25 mm): two 24" (60 cm) circular (cir).

Adjust needle size if necessary to obtain the correct gauge.

NOTIONS
Tapestry needle.

GAUGE
32 sts and 40 rnd = 4" (10 cm) in St st, worked in rnds, after blocking; 34 sts and 48 rnds = 4" (10 cm) in St st worked in rnds and relaxed after blocking.

33 sts and 44 rnds = 4" (10 cm) in charted texture patt, worked in rnds, after blocking; 37 sts and 49 rnds = 4" (10 cm) in charted textured patt worked in rnds and relaxed after blocking.

The Necker cube, first published as a rhomboid in 1832 by Swiss crystallographer Louis Albert Necker 1786–1861), is an ambiguous line drawing—an illusion in which a two-dimensional drawing suggests cubes that simultaneously protrude out from and intrude into the page. The front and back "planes" of the cubes appear to change places, creating two possible perspectives. Because we view objects from above far more often than we view objects from below, our brains may prefer the interpretation that the cube is viewed from above. Much of the time, then, most of us interpret the lower-left face to be in front.

Named for Louis Necker, these textured socks are knitted in the round. The different faces of the cubes are delineated by areas of stockinette stitch and seed stitch.

Cuff

CO 66 (70) sts. Arrange sts on two cir needles so that there are 33 (35) sts on each needle. Join for working in rnds, being careful not to twist sts.

Women's size only
Knit 10 rnds for rolled edge.

All sizes
Rib rnd: *K1 through back loop (tbl), p1; rep from *.

Rep the last rnd 13 (15) more times—14 (16) rib rnds total; piece measures 1¼ (1½)" (3.2 [3.8] cm) from beg with edge of women's cuff allowed to roll.

Leg

Women's size only
Set-up rnd: With Needle 1, [M1 (see Glossary), k1, p5, k5, p2] 2 times, k2, p5; with Needle 2, [M1, k4, p2, k2, p5] 2 times, k5, p2—70 sts; 35 sts on each needle.

All sizes
Note: *The textured pattern is a multiple of 14 stitches, which could be worked 5 times around the sock leg, but that would cause one repeat to be split between the two circular needles. For the charts to correspond to the needle breaks, the continuous pattern has been divided into two charts, each of which is a multiple of 14 stitches plus 7 to accommodate the 35 stitches on each circular needle.*

Establish charted patts as foll:

Next rnd: With Needle 1, work Rnd 1 of Textured Boxes Chart A over 35 sts; with Needle 2, work Rnd 1 of Textured Boxes Chart B over 35 sts.

Cont in established chart patts, work Rnds 2–16 once, work Rnds 1–16

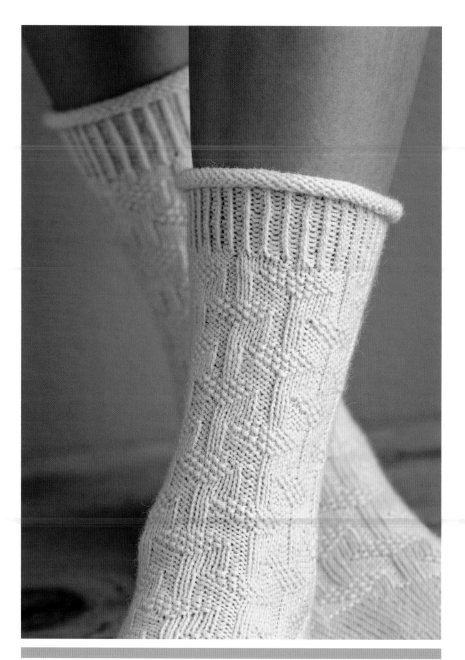

three times, then work Rnds 1–8 zero (one) more time—64 (72) chart rnds completed; 65 (72) total rnds including set-up rnd for women's size; piece measures 6½ (7¼)" (16.5 [18.5] cm) from beg with women's cuff allowed to roll.

Heel

The heel is worked back and forth in rows on the 35 sts of Needle 1; the 35 sts on Needle 2 will be worked later for the instep.

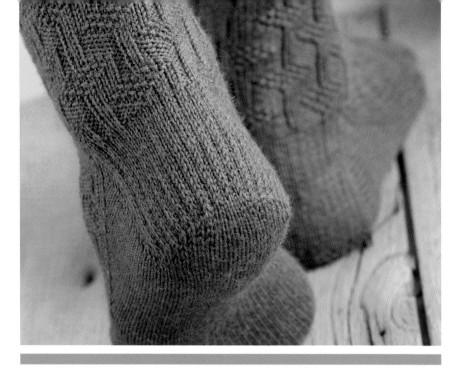

HEEL FLAP

Work back and forth in rows on Needle 1 as foll:

Row 1: (RS) K1, [k1, sl 1 with yarn in back (wyb)] 16 times, k2.

Row 2: (WS) K1, purl to last st, k1.

Rep these 2 rows 16 (17) more times—34 (36) rows total; 17 (18) garter ridges at each side.

TURN HEEL

Work short-rows as foll:

Short-row 1: (RS) K1, [k1, sl 1 wyb] 7 times, k5, ssk, k1, turn work.

Short-row 2: (WS) Sl 1 with yarn in front (wyf), p6, p2tog, p1, turn work.

Short-row 3: Sl 1 wyb, knit to 1 st before gap formed on previous RS row, ssk (1 st each side of gap), k1, turn work.

Short-row 4: Sl 1 wyf, purl to 1 st before gap formed on previous WS row, p2tog (1 st each side of gap), p1, turn work.

Rep the last 2 rows 5 more times—21 sts rem for all sizes.

SHAPE GUSSETS

Set-up Rnd 1: With Needle 1, k21 heel sts, then pick up and knit 17 (18) sts (1 st for each garter ridge) along left side of heel flap; with Needle 2, work Rnd 1 (9) of Textured Boxes Chart B over 35 instep sts as established.

Set-up Rnd 2: With Needle 1, pick up and knit 17 (18) sts (1 st for each garter ridge) along right side of heel flap, then knit 38 (39) sts to end of needle; with Needle 2, work next chart rnd over 35 instep sts as established—90 (92) sts total: 55 (57) sts heel and sole sts on Needle 1, 35 instep sts on Needle 2.

Legend

- ☐ knit
- ⊡ purl
- ☐ pattern repeat

TEXTURED BOXES CHART A

(rows numbered 1, 3, 5, 7, 9, 11, 13, 15)

14-st repeat

TEXTURED BOXES CHART B

(rows numbered 1, 3, 5, 7, 9, 11, 13, 15)

14-st repeat

Dec rnd: With Needle 1, k1, ssk, knit to last 3 sts, k2tog, k1; with Needle 2, cont as charted—2 sts dec'd on Needle 1.

Working all sts on Needle 1 in St st, [work 2 rnds even, then rep the dec rnd] 10 times, ending with Rnd 1 (9) of Textured Boxes Chart B—68 (70) sts rem; 33 (35) sole sts on Needle 1, 35 instep sts on Needle 2.

foot

Working the sts on Needle 1 in St st, on Needle 2 work Rnd 2 (10)–Rnd 16 once, then work Rnds 1–16 one (three) time(s), then work Rnds 1–8 one (zero) time—136 (160) total Chart B rnds completed for leg and instep; foot measures about 7¼ (8½)" (18.5 [21.5] cm) from center back heel.

Note: *For a longer foot, work all sts even in St st until foot measures 2 (2¼)" (5 [5.5] cm) less than desired length.*

Toe

Women's size only

Set-up rnd: With Needle 1, k33; with Needle 2, k15, k2tog, k16, k2tog—66 sts rem; 33 sts each needle.

All sizes

Knit 2 rnds even.

Dec rnd: With Needle 1, *k1, ssk, knit to last 3 sts, k2tog, k1; with Needle 2, rep from *—4 sts dec'd; 2 sts dec'd each needle.

Knit 3 rnds even, then rep dec rnd—58 (62) sts rem; 29 (31) sts each needle.

[Knit 2 rnds even, then rep dec rnd] 2 times—50 (54) sts rem; 25 (27) each needle.

[Knit 1 rnd even, then rep dec rnd] 3 (4) times—38 sts rem for both sizes; 19 sts each needle.

Rep dec rnd every rnd 4 times—22 sts rem; 11 sts each needle.

Next rnd: With Needle 1, *ssk, knit to last 2 sts, k2tog; with Needle 2, rep from *—18 sts rem; 9 sts each needle; toe measures about 2 (2¼)" (5 [5.5] cm).

finishing

Cut yarn, leaving a 24" (61 cm) tail. Thread tail onto a tapestry needle and use the Kitchener st (see Glossary) to graft rem sts tog.

Weave in loose ends.

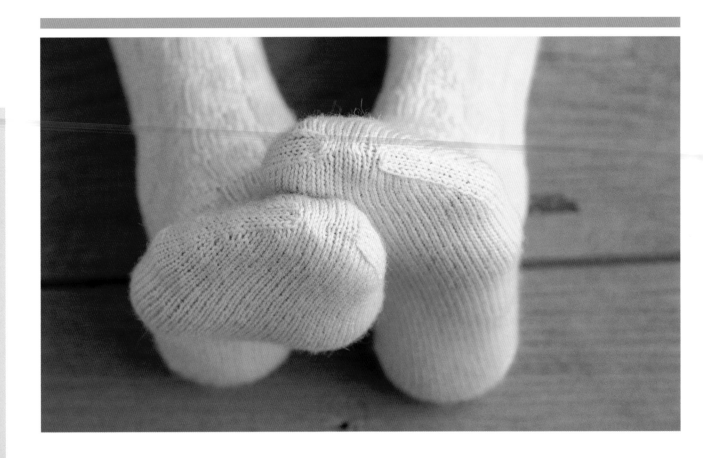

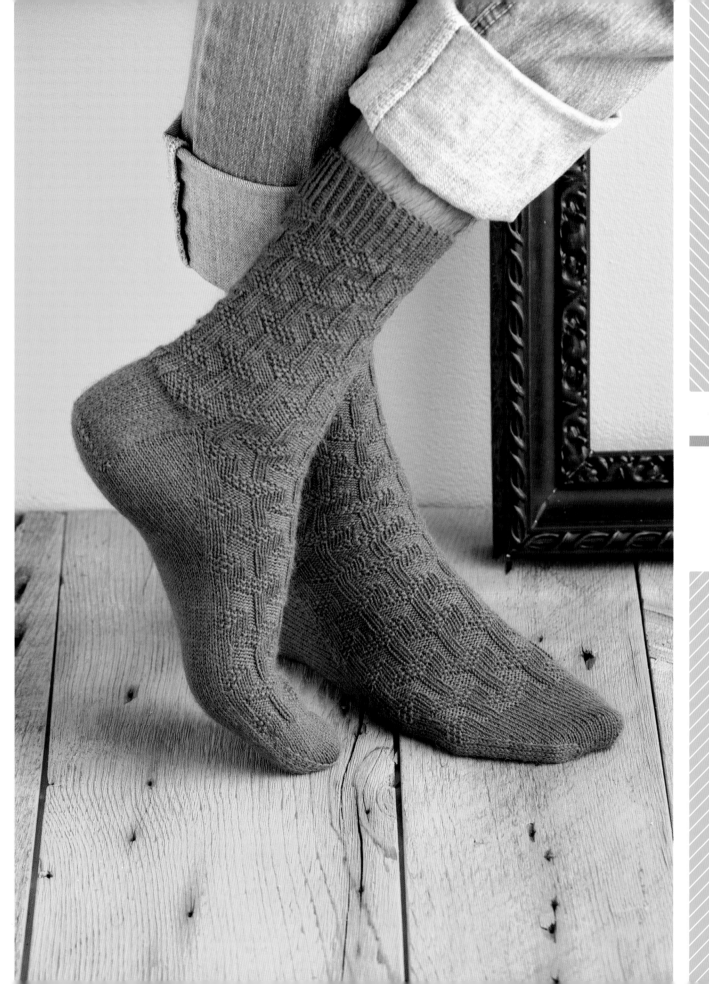

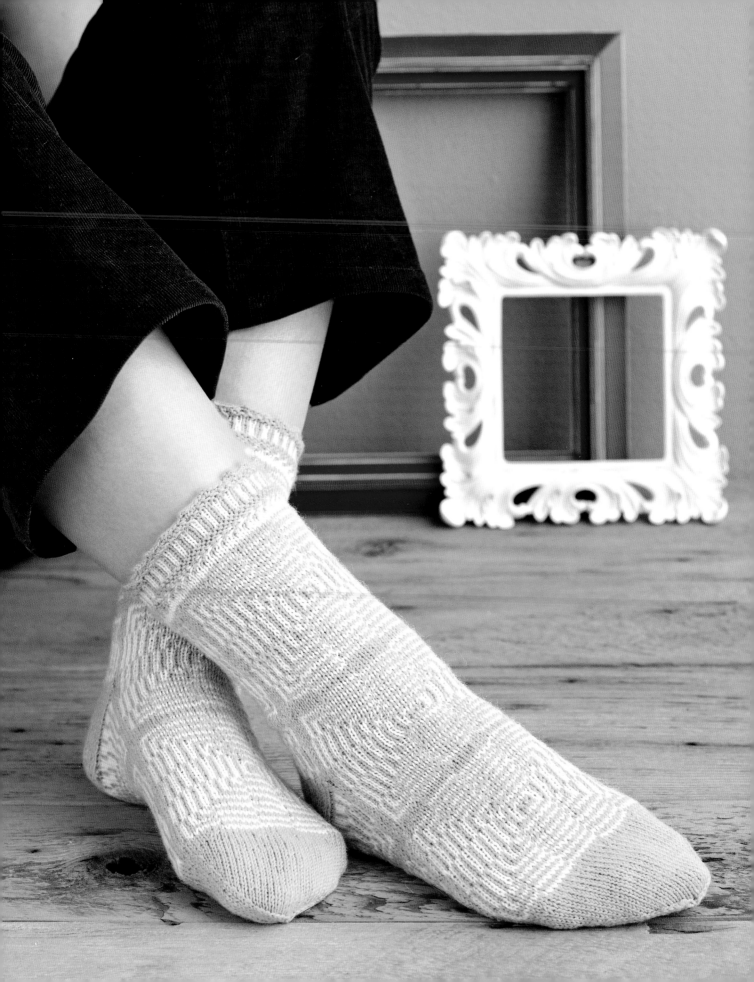

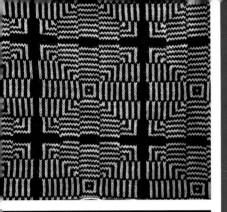

Herrmann

FINISHED SIZE
About 8¼" (21 cm) foot circumference, unstretched, and 9¾ (10)" (25 [25.5] cm) foot length from back of heel to tip of toe (length is adjustable).

To fit U.S. women's shoe sizes 7½–8½ (9–10); European shoe sizes 39–40 (41–42).

Socks shown measure 9¾" (25 cm) in foot length.

YARN
Fingering weight (#1 Super Fine).

Shown here: Lang Jawoll Superwash 4-ply (75% new wool, 18% nylon, 7% acrylic; 229 yd [210 m]/50 g): #83.0211 yellow (A), 2 balls for both sizes; #83.0094 ecru (B), 1 ball for both sizes.

NEEDLES
Size U.S. 1 (2.25 mm): two 24" (60 cm) circular (cir).

Adjust needle size if necessary to obtain the correct gauge.

NOTIONS
Size D/3 (3.25 mm) crochet hook; tapestry needle.

continued >>

In 1867, Herrmann von Helmholtz (1821–1894) published a book on optics in which he included some optical illusions. One of them, named the Helmholtz illusion, demonstrates that a square filled with horizontal lines will appear taller than a similar square filled with vertical lines (which is contrary to modern fashion advice). When squares contain both horizontal and vertical lines, the eye jumps from drawn line to imaginary line and the resulting figure seems to move.

For maximum effect, there needs to be sharp contrast between the two colors, which is why op-art artists typically pair black and white. These socks, named for Herrmann von Helmholtz, take a tamer approach, but feel free to choose whatever color combination suits your wardrobe. The sense of movement will remain.

GAUGE

32 sts and 40 rnds = 4" (10 cm) in solid-color St st worked in rnds, after blocking; 34 sts and 52 rnds = 4" (10 cm) in solid-color St st worked in rnds and relaxed after blocking.

35 sts and 42 rnds = 4" (10 cm) in charted patts worked in rnds, after blocking; 36 sts and 41 rnds = 4" (10 cm) in charted patts worked in rnds and relaxed after blocking.

STITCH GUIDE

Baltic Braid (worked over an even number of sts)

Note: Always bring each color to the back of the work to knit, then bring it to the front before exchanging the colors.

Rnd 1: Starting with both colors in front of work, *bring A over B and to the back, k1A, then bring A to front and drop it; bring B over A and to back, k1B, then bring B to front and drop it; rep from *.

Rnd 2: Starting with both colors in front of work, *bring A under B and to the back, k1A, then bring A to front and drop it; bring B under A and to back, k1B, then bring B to front and drop it; rep from *.

NOTE

× When rejoining in the round after completing the heel, the gusset stitches are picked up using just one color while the instep stitches are worked using two colors in the established pattern. Before you cast on for the cuff, cut a length of yarn to be used for picking up the gusset stitches and set it aside. Use this length to pick up and knit stitches along the right side of the heel flap (the side that usually would be worked last), then use the attached yarn to work across the heel stitches and to pick up and knit stitches along the left side of the heel flap. This will leave both working yarns in position to begin working in rounds, and the rounds will begin between the sole and instep stitches, instead of in the center of the sole.

Cuff

Cut a 24" (60 cm) length of A and set aside. This will be used to pick up sts along the right side of the heel flap so that the working yarn won't need to be cut.

With A and one cir needle, CO 64 (68) sts, turn work.

Rnd 1: (joining rnd) With Needle 1, *p32 (34); with Needle 2, rep from *—32 (34) sts on each needle.

Join for working in rnds, being careful not to twist sts.

Rnd 2: Knit.

Cont for your size as foll:

Size 9¾" (25 cm) only

Rnd 3: With Needle 1, *[k1A, k1B] 2 times, M1 (see Glossary) with A, [k1B, k1A] 4 times, M1 with B, [k1A, k1B] 4 times, M1 with A, [k1B, k1A] 4 times, M1 with B, [k1A, k1B] 2 times; with Needle 2, rep from *—72 sts; 36 sts each needle.

Size 10" (25.5 cm) only

Rnd 3: With Needle 1, *[k1A, k1B] 8 times, k1A, M1 (see Glossary) with B, [k1A, k1B] 8 times, k1A, M1 with B; with Needle 2, rep from *—72 sts; 36 sts each needle.

Both sizes

Rnd 4: *K1A, k1B; rep from *.

Rnds 5–8: Rep Rnd 4.

Rnds 9–11: With A, knit 1 rnd, then purl 2 rnds.

Rnds 12 and 13: Work Rnds 1 and 2 of Baltic Braid (see Stitch Guide).

Rnd 14: With B, knit—piece measures about 1" (2.5 cm).

Leg

Set-up rnd: With Needle 1, *k36B, M1 with B; with Needle 2, rep from *—74 sts; 37 sts each needle.

Work Rnds 1–37 of Leg and Foot chart once, then work Rnds 1–18 once more—55 chart rnds completed; 56 rnds total including set-up rnd; piece measures 6½" (16.5 cm) from CO.

Heel

The heel is worked back and forth in rows with A on the 37 sts of Needle 2; the 37 sts on Needle 1 will be worked later for the instep. Do not cut B.

Set-up row 1: (WS) Turn work so WS is facing and purl 37 sts of Needle 2.

Set-up row 2: (RS) K1, [k1, sl 1] 4 times, k2tog, sl 1, [k1, sl 1] 7 times, k2tog, sl 1, [k1, sl 1] 3 times, k2—35 heel sts rem.

Set-up row 3: Purl.

HEEL FLAP

Row 1: (RS) K1, [k1, sl 1] 16 times, k2.

Row 2: (WS) Purl.

Rep these 2 rows 14 more times—30 heel-flap rows; 33 rows total including set-up rows; heel measures about 2¼" (5.5 cm) from last rnd of Leg and Foot chart.

TURN HEEL

Work short-rows as foll:

Short-row 1: (RS) K20, ssk, k1, turn work.

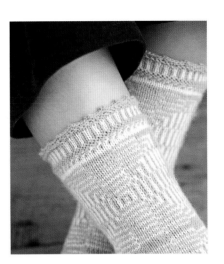

LEG AND FOOT

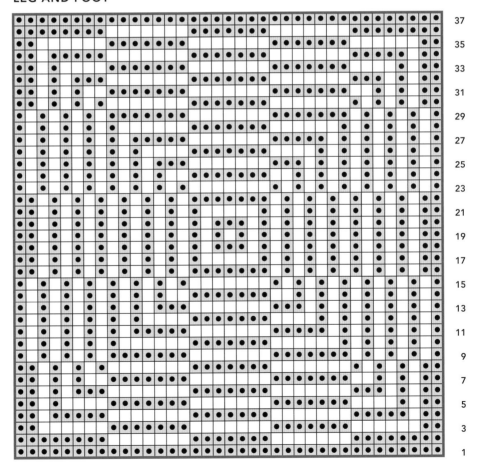

- ● knit with A
- ☐ knit with B
- ☐ pattern repeat

37 35 33 31 29 27 25 23 21 19 17 15 13 11 9 7 5 3 1

37-st repeat

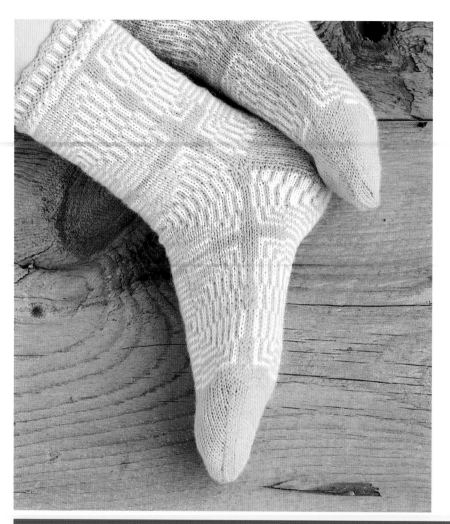

Short-row 2: (WS) Sl 1, p6, p2tog, p1, turn work.

Short-row 3: Sl 1, knit to 1 st before gap formed on previous row, ssk (1 st each side of gap), k1, turn work.

Short-row 4: Sl 1, purl to 1 st before gap formed on previous row, p2tog (1 st each side of gap), p1, turn work.

Rep the last 2 short-rows 5 more times—21 heel sts rem.

SHAPE GUSSETS

Turn work so RS is facing and drop strand of A attached to beg of heel sts. Use the length of A cut and set aside before casting on to pick up sts along the first side of the heel flap as foll:

Set-up row: (RS) With cut length of A, tip of heel needle, and beg in the corner between the heel flap and instep sts on the right side of the flap, pick up and knit 16 sts along right side of heel flap (about 1 st for every 2 heel-flap rows), then drop the extra strand of yarn. Using the same cir needle and A attached to beg of heel sts, k21 heel sts, then pick up

GUSSET

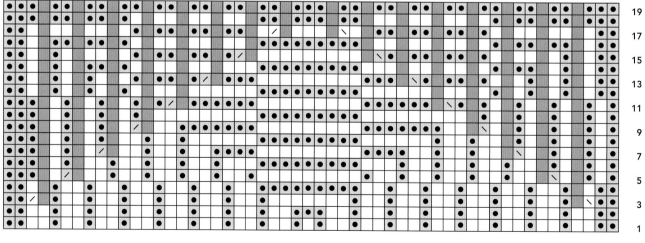

53 sts dec'd to 37 sts

and knit 16 sts (about 1 st for every 2 heel-flap rows) along left side of heel flap—53 heel gusset sts on one cir needle (Needle 2).

Both A and B yarns are now at the start of the instep sts on Needle 1.

Set-up rnd: With Needle 1, work Rnd 19 of Leg and Foot chart over 37 sts as established; with Needle 2, work Rnd 1 of Gusset chart over 53 sts—90 sts total; 37 instep sts on Needle 1, 53 gusset and sole sts on Needle 2.

Cont in established patts until Rnd 19 of Gusset chart has been completed, ending with Rnd 37 of Leg and Foot chart—74 sts rem; 37 instep sts on Needle 1; 37 sole sts on Needle 2.

FOOT

Next rnd: With Needle 1, *work Rnd 1 of Leg and Foot chart over 37 sts; with Needle 2, rep from *.

Cont in established patt for 37 more rnds, ending with Rnd 1 of chart—foot measures 7½" (19 cm) from center back heel.

- ● knit with A
- ☐ knit with B
- ╱ k2tog with A
- ╲ ssk with A
- ╱ k2tog with B
- ╲ ssk with B
- ▨ no stitch
- ☐ pattern repeat

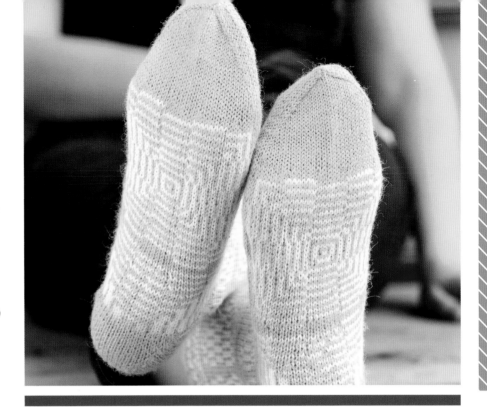

Toe

Cut B and cont with A only.

. .

Note: *To adjust the foot length, work even in St st with A until foot measures 2¼ (2½)" (5.5 [6.5] cm) less than desired length.*

. .

Knit 1 rnd even.

Next rnd: With Needle 1, *k5, k2tog, [k10, k2tog] 2 times, k6; with Needle 2, rep from *—68 sts rem; 34 sts each needle.

Knit 1 (5) rnds even.

Dec rnd: With Needle 1, *k1, ssk, knit to last 3 sts, k2tog, k1; with Needle 2, rep from *—4 sts dec'd; 2 sts dec'd each needle.

Knit 3 rnds even, then rep dec rnd—60 sts rem; 30 sts each needle.

[Knit 2 rnds even, then rep dec rnd] 2 times—52 sts rem; 26 sts each needle.

[Knit 1 rnd even, then rep dec rnd] 4 times—36 sts rem; 18 sts each needle.

Rep dec rnd every rnd 7 times—8 sts rem; 4 sts each needle; toe measures about 2¼ (2½)" (5.5 [6.5] cm).

Finishing

Cut yarn, leaving an 8" (20.5 cm) tail. Thread tail onto a tapestry needle, draw through rem sts, pull tight to close hole, and fasten off on WS.

CROCHET EDGING

Join A to CO edge. With crochet hook, *work 1 sc (see Glossary for crochet instructions) in each of the next 3 CO sts, ch 2, work 1 sc into same CO st at base of ch-2, skip the next CO st; rep from * around cuff edge.

Cut yarn and pull tail through last st to secure.

Weave in loose ends. Block if desired.

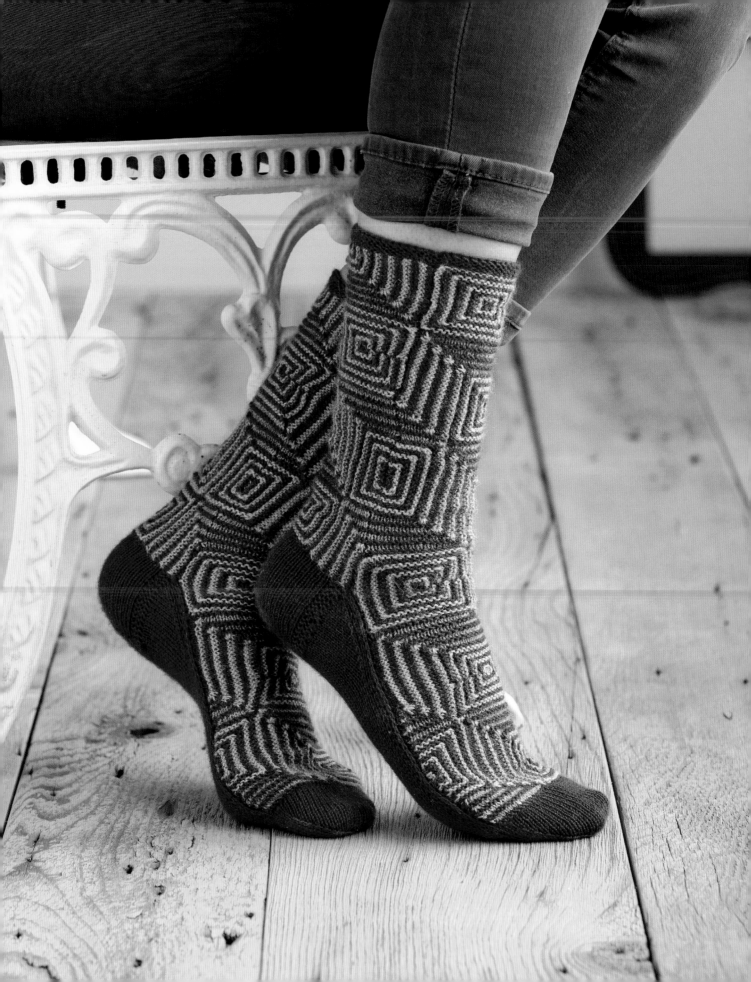

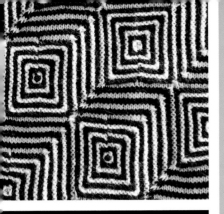

FINISHED SIZE

About 7¼ (7½)" (18.5 [19] cm) foot circumference, unstretched, and 9¼ (10¾)" (23.5 [27.5] cm) foot length from back of heel to tip of toe (minor length adjustments possible).

To fit U.S. women's shoe sizes 7–8 (men's 10½–11½); European shoe sizes 38–40 (44–46).

Socks shown measure 9¼" (23.5 cm) in foot length.

YARN

Fingering weight (#1 Super Fine).

Shown here: Lang Jawoll Superwash 4-ply (75% new wool, 18% nylon, 7% acrylic; 229 yd [210 m]/50 g): #83.0280 violet (MC) and #83.0045 grey/brown (CC), 2 balls each for both sizes.

NEEDLES

Size U.S. 1 (2.25 mm): three 24" (60 cm) circular (cir).

Adjust needle size if necessary to obtain the correct gauge.

NOTIONS

Markers (m); tapestry needle.

GAUGE

32 sts and 40 rows/rnds = 4" (10 cm) in solid-color St st, after blocking; 38 sts and 50 rows/rnds = 4" (10 cm) in solid-color St st, relaxed after blocking.

Squares A, D, and H measure about 1⅞" (4.8 cm) on each side.

A reversible figure is an ambiguous two-dimensional drawing that represents a three-dimensional object in a way that lets an observer see it from two different perspectives. The optical illusion is created by an unstable visual perception that leads the beholder to vacillate between two or more interpretations. The reversible cube in this design consists of two squares that represent the front and back side of the cube. The tiling arrangement lets the cubes be viewed from above or below. Because both interpretations are valid, the viewer's eye often causes the image to flip back and forth between the two possibilities. Josef Albers (1888–1976) used this effect for his 1942 work *Prefation*.

For these socks, named after Josef Albers, I worked the leg and instep in two-color shadow knitting following a modular technique in which sections are built one upon the other. The heel, sole, and toe are worked in a solid color.

NOTES

- ✕ The modular construction used here involves many yarn breaks and therefore lots of ends to be woven in. Weave in the ends as you go to minimize the number to be woven in during finishing.

- ✕ When you use the long-tail method to cast on stitches at the end of a row or after having picked up stitches, use the other end of the same ball of yarn as the second strand for working the cast-on, then cut this extra strand when the cast-on is complete. For example, if your working yarn is coming from the outside of the ball, use the strand from the center for the cast-on, or vice versa if the working yarn is coming from the center of the ball.

- ✕ The leg and instep are worked in one piece made up of modular units. Each square unit is worked in the round from the outer edge toward the center using two circular needles. The stairstep units are zigzag strips that begin with a combination of cast-on stitches and picked-up stitches and are worked back and forth in rows with mitered increases and decreases to form the zigzags. Smaller units are used to fill in the outline of the overall shape as required.

- ✕ To maintain a tidy edge when joining the sole and instep, be sure to keep the tension snug on the adjacent stitches.

Leg and Instep

SQUARE A

Note: *This unit is worked in the round from the outer edge inward. Hold both yarns behind the work, bringing each yarn to the front when it's needed to purl, then take the yarn to the back again.*

Rnd 1: (CO counts as first rnd) With CC, CO 68 sts. Arrange sts evenly onto two cir needles so that there are 34 sts on each needle. Join for working in rnds, being careful not to twist sts.

Rnd 2: With CC, on Needle 1, *p7, p3tog, p1, place m (pm), p13, p3tog, p1, pm, p6; on Needle 2, rep from *—60 sts rem; 30 sts each needle.

Rnd 3: With MC, knit, slipping markers (sl m) as you come to them.

Rnd 4: With MC, *purl to 3 sts before m, p3tog, remove m, p1, replace m; rep from * 3 more times, purl to end—8 sts dec'd.

Rnd 5: With CC, knit, sl m as you come to them.

Rnd 6: With CC, *purl to 3 sts before m, p3tog, remove m, p1, replace m; rep from * 3 more times, purl to end—8 sts dec'd.

Rnds 7–14: Rep Rnds 3–6 two more times, removing all m without replacing them in Rnd 14—12 sts rem; 6 sts each needle.

Rnd 15: With MC, knit.

Rnd 16: With MC, [p3tog] 4 times—4 sts rem; 2 sts each needle.

Cut both yarns, leaving 8" (20.5 cm) tails. Thread MC tail onto tapestry needle, draw through rem sts, pull tight to close center of square, and fasten off on WS.

Make 3 (2) more squares in the same manner—4 (3) Square A units total.

STAIRSTEP B

Note: *This unit is worked back and forth in rows on one circular needle and joins the Square A units. Refer to* **Figure 1** *or* **Figure 2** *according to your size. Stairstep B is shown in white; Square A units are shaded gray. Cast-on stitches are indicated by green lines; picked-up stitches are indicated by red lines.*

Women's size only

Row 1: (RS; CO counts as part of first row) With MC, CO 17 sts. With MC and RS of squares facing, *pick up and knit 16 sts along one side of first Square A, 1 st in corner, and 16 sts along the next side of the same square, then use the backward-loop method (see Glossary) to CO 1 st; rep from * 2 more times, then pick up and knit 16 sts along one side of the fourth Square A—135 sts total.

Men's size only

Row 1: (RS; CO counts as part of first row) With MC, CO 9 sts. With MC and RS of squares facing, *pick up and knit 16 sts along one side of first Square A, 1 st in corner, 16 sts along the next side of the same square, then use the backward-loop method (see Glossary) to CO 1 st; rep from * once more, then pick up and knit 16 sts along one side of the third Square A—93 sts total.

Both sizes

Row 2: (WS) With MC, *k15, p3tog, p1, pm, p14, M1 (see Glossary), p1, M1; rep from * 2 (1) more time(s), k15, p3tog, p1, pm, purl to end—133 (91) sts rem.

Row 3: With CC, knit, sl m as you come to them.

Row 4: With CC, *purl to 3 sts before m, p3tog, remove m, k1, replace m, k14, M1, p1, M1; rep from * 2 (1) more time(s), purl to 3 sts before m, p3tog, remove m, k1, replace m, knit to end—2 sts dec'd.

Row 5: With MC, knit, sl m as you come to them.

Row 6: With MC, *knit to 3 sts before m, p3tog, remove m, p1, replace m, p14, M1, p1, M1, rep from * 2 (1) more time(s), knit to 3 sts before m, p3tog, remove m, p1, replace m, purl to end—2 sts dec'd.

Rows 7–16: Rep Rows 3–6 two more times, then work Rows 3 and 4 once more, removing all m without replacing them in the last row—119 (77) sts rem.

With CC and RS facing, loosely BO all sts. Cut yarns and weave in loose ends.

HALF-SQUARE A (MEN'S SIZE ONLY)

Note: *This unit is worked back and forth in rows on one circular needle. Refer to* **Figure 3**.

Row 1: (RS; CO counts as part of first row) With CC, CO 25 sts. With CC and RS of assembled Square A and Stairstep B piece facing, pick up and knit 1 st in corner of Square A, then 8 sts along CO edge of Stairstep B—34 sts.

Row 2: (WS) With CC, k7, k3tog, k1, pm, k13, k3tog, k1, pm, k6—30 sts rem.

Row 3: With MC, knit, sl m as you come to them.

Row 4: With MC, *knit to 3 sts before m, k3tog, remove m, k1, replace m; rep from * once more, knit to end—4 sts dec'd.

Row 5: With CC, knit, sl m as you come to them.

Row 6: With CC, *knit to 3 sts before m, k3tog, remove m, k1, replace m;

rep from * once more, knit to end—4 sts dec'd.

Rows 7–14: Rep Rows 3–6 two more times, removing m without replacing them in the last row—6 sts rem.

Rnd 15: With MC, knit.

Rnd 16: With MC, [p3tog] 2 times—2 sts rem.

Cut both yarns, leaving 8" (20.5 cm) tails. Thread MC tail onto tapestry needle, draw through rem sts, pull tight to close center of square, and fasten off on WS.

Weave in loose ends.

STAIRSTEP C

Note: *This unit is worked back and forth in rows like Stairstep B, except that it's worked along the remaining Square A sides. Refer to* **Figure 4** *or* **Figure 5** *according to your size.*

Women's size only
Rotate assembled piece (shaded in gray) as shown in **Figure 4**.

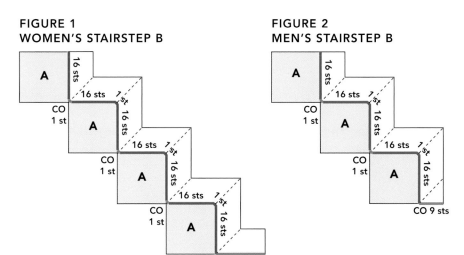

FIGURE 1
WOMEN'S STAIRSTEP B

FIGURE 2
MEN'S STAIRSTEP B

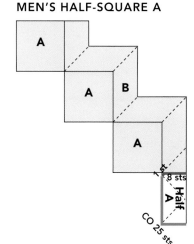

FIGURE 3
MEN'S HALF-SQUARE A

Row 1: (RS; CO counts as part of first row) With MC, CO 18 sts. With MC and RS of piece facing, *pick up and knit 16 sts along one side of first Square A, 1 st in corner, and 16 sts along the next side of the same square, then pick up 1 st in the corner of Stairstep B; rep from * 2 more times, then pick up and knit 16 sts along one side of the fourth Square A—136 sts.

Men's size only

Rotate assembled piece (shaded in gray) as shown in **Figure 5**.

Row 1: (RS; CO counts as part of first row) With MC, CO 18 sts. With MC and RS of piece facing, *pick up and knit 16 sts along one side of first Square A, 1 st in corner, and 16 sts along the next side of the same square, then pick up 1 st in the corner of Stairstep B; rep from * 2 more times, then pick up and knit 16 sts along one side of Half-Square A—136 sts.

Both sizes

Row 2: (WS) With MC, *k15, p3tog, p1, pm, p14, M1, p1, M1; rep from * 3 more times.

Row 3: With CC, knit, sl m as you come to them.

Row 4: With CC, *purl to 3 sts before m, p3tog, remove m, k1, replace m, k14, M1, p1, M1; rep from * 3 more times.

Row 5: With MC, knit, sl m as you come to them.

Row 6: With MC, *knit to 3 sts before m, p3tog, remove m, p1, replace m, p14, M1, p1, M1, rep from * 3 more times.

Rows 7–16: Rep Rows 3–6 two more times, then work Rows 3 and 4 once more, removing all m without replacing them in the last row—still 136 sts.

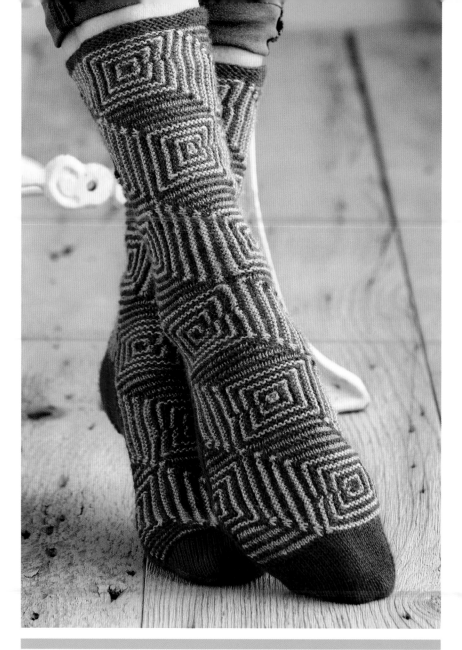

With CC and RS facing, loosely BO all sts. Cut yarns and weave in loose ends.

SQUARE D

Note: *This unit is worked in the round on two circular needles, beginning with a combination of cast-on stitches and stitches picked up from Stairstep C. The order of the colors is reversed from Square A. Refer to* **Figure 6** *or* **Figure 7** *according to your size for placement.*

Women's size only

Rnd 1: (CO counts as part of first rnd) With MC, RS facing, and Needle 1, pick up and knit 34 sts along two inner sides of Stairstep C as shown in **Figure 6** by picking up [16 sts along one entire side, then 1 st in next corner] 2 times, then use the long-tail method to CO 8 sts, drop the first 8 picked-up sts at the start of Needle 1 off the needle and ravel them—34 sts on Needle 1. With Needle 2 and the same strands of yarn, use the long-tail method to

FIGURE 4
WOMEN'S STAIRSTEP C

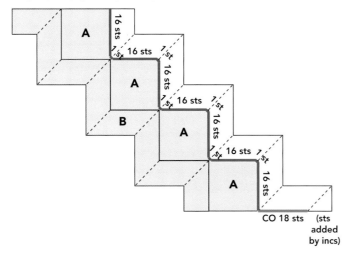

FIGURE 5
MEN'S STAIRSTEP C

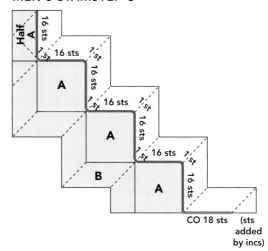

FIGURE 6
WOMEN'S SQUARE D

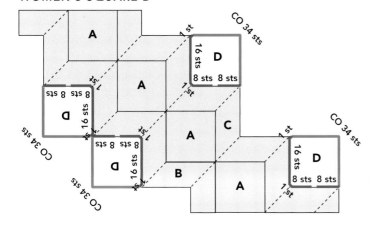

FIGURE 7
MEN'S SQUARE D

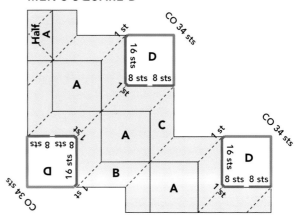

CO 26 sts, then pick up and knit 8 sts along the side of Stairstep C where you dropped the 8 sts from the start of Needle 1, ending in the center of the first Stairstep C edge as shown—68 sts total; 34 sts each needle. Cut the extra strand of yarn used for the CO.

Men's size only

Rnd 1: With MC, RS facing, and Needle 1, pick up and knit 34 sts along two inner sides of Stairstep C as shown in **Figure 7** by picking up [16 sts along one entire side, then 1 st in next corner] 2 times, use the long-tail method to CO 8 sts, then drop the first 8 picked-up sts at the start of Needle 1 off the needle and ravel them—34 sts on Needle 1. With Needle 2 and the same strands of yarn, use the long-tail method to CO 26 sts, then pick up and knit 8 sts along the side of Stairstep C where you dropped the 8 sts from the start of Needle 1, ending in the center of the first Stairstep C edge as shown—68 sts total; 34 sts each needle. Cut the extra strand of yarn used for the CO.

Both sizes

Rnd 2: With MC, on Needle 1, *p6, pm, p1, p3tog, p13, pm, p1, p3tog, p7; with Needle 2, rep from *—60 sts; 30 sts each needle.

Rnd 3: With CC, knit, sl m as you come to them.

Rnd 4: With CC, *purl to 3 sts before m, p3tog, remove m, p1, replace m; rep from * 3 more times, purl to end—8 sts dec'd.

Rnd 5: With MC, knit, sl m as you come to them.

Rnd 6: With MC, *purl to 3 sts before m, p3tog, remove m, p1, replace m; rep from * 3 more times, purl to end—8 sts dec'd.

Rnds 7–14: Rep Rnds 3–6 two more times, removing all m without replacing them in Rnd 14—12 sts rem; 6 sts each needle.

Rnd 15: With CC, knit.

Rnd 16: With CC, [p3tog] 4 times—4 sts rem; 2 sts each needle.

Cut both yarns, leaving 8" (20.5 cm) tails. Thread CC tail onto tapestry needle, draw through rem sts, pull tight to close center of square, and fasten off on WS.

Women's size only

Make a second Square D picked up from Stairstep C as shown in **Figure 6**. Rotate piece so Stairstep B is across the top, and make a third and fourth Square D at the remaining two locations shown in **Figure 6**— 4 Square D units total.

Men's size only

Make a second Square D picked up from Stairstep C as shown in **Figure 7**. Rotate piece so Stairstep B is across the top, and make a third Square D at the location shown in **Figure 7**—3 Square D units total.

STAIRSTEP E

Note: *This unit is worked back and forth in rows as for Stairsteps B and C, with stitches picked up along the edges of Square D. Refer to **Figure 8** or **Figure 9** according to your size.*

Women's size only

Rotate the piece and the page containing **Figure 8** so that the diagonally adjacent Squares D are across the top.

Row 1: (RS; CO counts as part of first row) With CC, CO 9 sts. With CC and RS of piece facing, *pick up and knit 16 sts along one side of first Square D, 1 st in corner, 16 sts along the next side of the same square, then pick up 1 st in the corner of Stairstep B; rep from * once more for second Square D as shown, then use the long-tail method to CO 9 sts—86 sts total.

Row 2: (WS) With CC, p7, *p3tog, k1, pm, k14, M1, p1, M1, p15; rep from * once more, p3tog, k1, pm, k7—84 sts rem.

Row 3: With MC, knit, sl m as you come to them.

Row 4: With MC, *knit to 3 sts before m, p3tog, remove m, p1, replace m, p14, M1, p1, M1; rep from * once more, knit to 3 sts before m, p3tog, remove m, p1, replace m, purl to end—2 sts dec'd.

Row 5: With CC, knit, sl m as you come to them.

Row 6: With CC, *purl to 3 sts before m, p3tog, remove m, k1, replace m, k14, M1, p1, M1; rep from * once more, purl to 3 sts before m, p3tog, remove m, k1, replace m, knit to end—2 sts dec'd.

Rows 7–16: Rep Rows 3–6 two more times, then work Rows 3 and 4 once more, removing all m without replacing them in the last row—70 sts rem.

With RS facing, loosely BO all sts. Cut yarns and weave in loose ends.

Men's size only

Rotate the piece and the page containing **Figure 9** so the side with the single Square D is across the top.

Row 1: (RS; CO counts as part of first row) With CC and RS of piece facing, pick up and knit 16 sts along one side of Square D as shown, 1 st in corner, then use the long-tail method to CO 8 sts—25 sts total.

Row 2: (WS) With CC, p7, p3tog, p1, pm, knit to end of needle—23 sts rem.

Row 3: With MC, knit, sl m as you come to it.

Row 4: With MC, knit to 3 sts before m, p3tog, remove m, p1, replace m, purl to end—2 sts dec'd.

Row 5: With CC, knit, sl m as you come to it.

Row 6: With CC, purl to 3 sts before m, p3tog, remove m, p1, replace m, knit to end—2 sts dec'd.

Rows 7–16: Rep Rows 3–6 two more times, then work Rows 3 and 4 once more, removing m in the last row—9 sts rem.

With RS facing, loosely BO all sts. Cut yarns and weave in loose ends.

STAIRSTEP F

Note: *This unit is worked back and forth in rows as for the previous stairsteps, with stitches picked up along two edges of another Square D. This stairstep is worked the same for both the women's and men's versions. Refer to **Figure 8** or **Figure 9** according to your size for placement, rotating the piece and the page containing the figure so the pick-up can be worked along the top edge.*

FIGURE 8
WOMEN'S STAIRSTEPS E, F, AND G

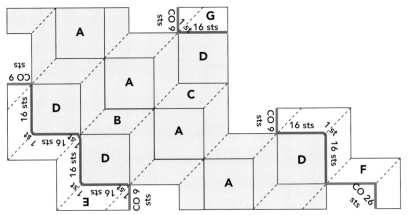

FIGURE 9
MEN'S STAIRSTEPS E, F, AND G

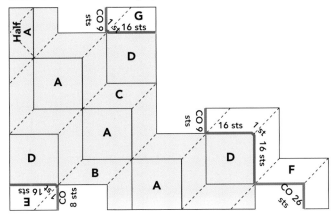

Row 1: (RS; CO counts as part of first row) With CC, CO 26 sts. With RS of piece facing, pick up and knit 16 sts along one side of Square D, 1 st in corner, and 16 sts along the next side of square, then use the long-tail method to CO 9 more sts—68 sts total.

Row 2: (WS) With CC, p7, p3tog, p1, pm, k14, M1, p1, M1, p15, p3tog, k1, pm, k14, M1, p1, M1, purl to end.

Row 3: With MC, knit, sl m as you come to them.

Row 4: With MC, *knit to 3 sts before m, p3tog, remove m, p1, replace m, p14, M1, p1, M1; rep from * once more, knit to end.

Row 5: With CC, knit, sl m as you come to them.

Row 6: With CC, *purl to 3 sts before m, p3tog, remove m, p1, replace m,

k14, M1, p1, M1; rep from * once, purl to end.

Rows 7–16: Rep Rows 3–6 two more times, then work Rows 3 and 4 once more, removing m in the last row.

With RS facing, loosely BO all sts. Cut yarns and weave in loose ends.

STAIRSTEP G

Note: *This unit is worked back and forth in rows as for the previous stairsteps, with stitches picked up along the edge of a single Square D. This stairstep is worked the same for both the women's and men's versions. Refer to* **Figure 8** *or* **Figure 9** *according to your size for placement.*

Row 1: (RS; CO counts as first row) With CC, pick up and knit 16 sts along one side of Square D, 1 st in corner of Stairstep C, then use the long-tail method to CO 8 more sts—25 sts.

Row 2: (WS) With CC, p7, p3tog, p1, pm, knit to end of needle—23 sts rem.

Row 3: With MC, knit, sl m as you come to it.

Row 4: With MC, knit to 3 sts before m, p3tog, remove m, p1, replace m, purl to end—2 sts dec'd.

Row 5: With CC, knit, sl m as you come to them.

Row 6: With CC, purl to 3 sts before m, p3tog, remove m, p1, replace m, knit to end—2 sts dec'd.

Rows 7–16: Rep Rows 3–6 two more times, then work Rows 3 and 4 once more, removing m in the last row—9 sts rem.

With RS facing, loosely BO all sts. Cut yarns and weave in loose ends.

SQUARE H

Note: *As for Square D, this unit is worked in the round using two circular needles, beginning with a combination of cast-on stitches and stitches picked up from the assembled piece. The color order is the same as in Square A. Refer to* **Figure 10** *or* **Figure 11** *according to your size for placement.*

Women's size only

Work first Square H as foll:

Rnd 1: (CO counts as part of first rnd) With CC, beg in center of one edge of Stairstep F as shown in **Figure 10**, and Needle 1, pick up and knit 8 sts to corner, 1 st in corner, 16 sts along entire next stairstep edge, 1 st in next corner, then use the long-tail method to CO 8 sts; with Needle 2, CO 26 more sts, then pick up and knit 8 sts along the first stairstep edge, ending in the center as shown—68 sts total; 34 sts each needle.

Rnds 2–16: Work as for Square A— 4 sts rem; 2 sts each needle.

Cut both yarns, leaving 8" (20.5 cm) tails. Thread MC tail onto tapestry needle, draw through rem sts, pull tight to close center of square, and fasten off on WS.

Rotate the piece and the page containing **Figure 10** so that the pick-up can be worked along the top edge. Work second Square H as foll:

Rnd 1: (CO counts as part of first rnd) With CC, beg in center of one edge of Stairstep E as shown in **Figure 10**, and Needle 1, pick up and knit 8 sts to corner, 1 st in corner, 16 sts along entire next stairstep edge, 1 st in next corner, then use the long-tail method to CO 8 sts; with Needle 2, CO 26 more sts, then pick up and knit 8 sts along the first

stairstep edge, ending in the center as shown—68 sts total; 34 sts each needle.

Complete as for first Square H.

Men's size only

Work one Square H as foll:

FIGURE 10
WOMEN'S SQUARE H AND HALF-SQUARE I

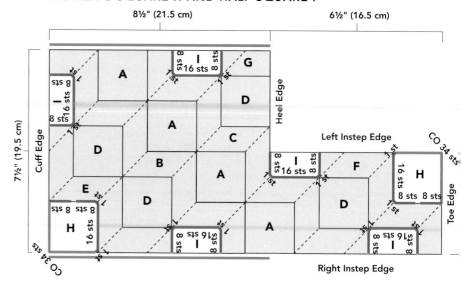

FIGURE 11
MEN'S SQUARE H AND HALF-SQUARE I

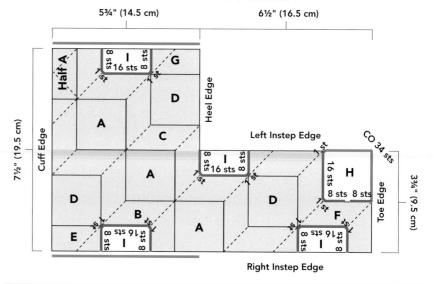

Rnd 1: (CO counts as part of first rnd) With CC, beg in center of one edge of Stairstep F as shown in **Figure 11**, and Needle 1, pick up and knit 8 sts to corner, 1 st in corner, 16 sts along entire next stairstep edge, 1 st in next corner, then use

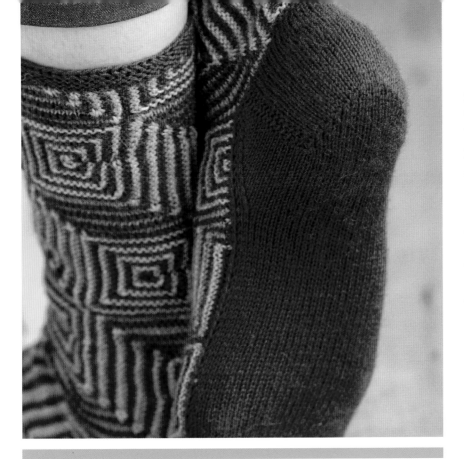

the long-tail method to CO 8 sts; with Needle 2, CO 26 more sts, then pick up and knit 8 sts along the first stairstep edge, ending in the center as shown—68 sts total; 34 sts each needle.

Rnds 2–16: Work as for Square A— 4 sts rem; 2 sts each needle.

Cut both yarns, leaving 8" (20.5 cm) tails. Thread MC tail onto tapestry needle, draw through rem sts, pull tight to close center of square, and fasten off on WS.

HALF-SQUARE I

Note: *This unit is worked back and forth in rows with one circular needle. Refer to* **Figure 10** *or* **Figure 11** *according to your size for placement. Work 5 (4) half-squares to fill in the remaining "notches" of the shape and complete the leg and instep piece as foll:*

Row 1: (RS) With MC and RS of piece facing, pick up and knit 8 sts along first short side of notch, 1 st in corner, 16 sts across long side, 1 st in corner, and 8 sts along second short side— 34 sts total.

Row 2: (WS) With MC, k7, k3tog, k1, pm, k13, k3tog, k1, pm k6—30 sts rem.

Row 3: With CC, knit, sl m as you come to them.

Row 4: With CC, *knit to 3 sts before m, k3tog, remove m, k1, replace m; rep from * once more, knit to end— 4 sts dec'd.

Row 5: With MC, knit, sl m as you come to them.

Row 6: With MC, *knit to 3 sts before m, k3tog, remove m, k1, replace m; rep from * once more, knit to end— 4 sts dec'd.

Rows 7–14: Rep Rows 3–6 two more times, removing m without replacing them in the last row—6 sts rem.

Rnd 15: With CC, knit.

Rnd 16: With CC, [p3tog] 2 times— 2 sts rem.

Cut both yarns, leaving 8" (20.5 cm) tails. Thread CC tail onto tapestry needle, draw through rem sts, pull tight to close center of square, and fasten off on WS.

Weave in loose ends.

LEG SEAM

Referring to **Figure 10** or **Figure 11** according to your size, use the mattress st (see Glossary) to sew the edges indicated by blue lines on together to form a tube for the leg. The rectangular section extending from the tube is the instep. Weave in any remaining loose ends.

Heel and Sole Set-up

Note: *The heel and sole are worked back and forth in rows in solid-color stockinette with the main color (MC). The heel stitches are picked up along the heel edge of the leg tube and worked with a conventional heel flap and heel turn. At the point where an in-the-round sock would resume working on all stitches, the sole stitches of this sock are worked back and forth in rows, as one sole stitch is joined to one stitch from the side of the instep extension at the end of every row until all the instep stitches have been used up.*

Set-up Row 1: (RS) Join MC to the left side of the instep flap at the toe edge. With Needle 1 and working from the toe toward the leg, pick up and knit 56 sts evenly spaced along

left side of instep; with Needle 2, pick up and knit 32 sts evenly spaced along heel edge of leg tube; with Needle 3, pick up and knit 56 sts evenly spaced along right side of instep from the leg to the toe edge—144 sts total.

. .

Note: *The length of the sole is determined by the number of rows needed to join all the instep stitches. Picking up more or fewer stitches along the sides of the instep may cause the sides of the extension to pucker or flare, so significant length adjustments are not recommended. There is an opportunity to increase the foot length in the toe section later.*

. .

Cont for your size as foll.

Women's size only

Set-up Row 2: (WS) With Needle 3, *p2tog, p1, [p2tog] 2 times; rep from * 7 more times; with Needle 2, k3, p26, k3; with Needle 1, **[p2tog] 2 times, p1, p2tog; rep from ** 7 more times—96 sts rem; 32 sts each needle.

Cut yarn.

Men's size only

Set-up Row 2: (WS) With Needle 3, p2, *p2tog, p1; rep from * 17 more times; with Needle 2, M1, k2, p28, k2, M1, with Needle 1, *p1, p2tog; rep from * 17 more times, p2—110 sts: 34 sts on Needle 2, and 38 sts each on Needle 1 and Needle 3.

Cut yarn.

Heel Flap

The heel flap is worked back and forth in rows on 32 (34) sts of Needle 2; the rem sts on Needle 1 and Needle 3 will be worked later when joining the sole. Rejoin yarn to beg of sts on heel needle with RS facing and work as foll:

Row 1: (RS) Knit.

Row 2: (WS) K3, purl to last 3 sts, k3.

Rep the last 2 rows 15 (16) more times—32 (34) heel-flap rows; 16 (17) garter ridges along each selvedge; heel flap measures about 2½ (2¾)" (6.5 [7] cm).

Turn Heel

Work short-rows as foll:

Short-row 1: (RS) K17 (19), ssk, k1, turn work.

Short-row 2: (WS) Sl 1, p3 (5), p2tog, p1, turn work.

Short-row 3: Sl 1, knit to last st before gap formed on previous row, ssk (1 st each side of gap), k1, turn work.

Short-row 4: Sl 1, purl to last st before gap formed on previous row, p2tog (1 st each side of gap), p1, turn work.

Rep the last 2 rows 5 more times—18 (20) heel sts rem. Do not cut yarn.

Shape Gussets

Cut a separate 24" (60 cm) strand of MC.

Set-up row: (RS) With RS facing and beg in the corner between the instep and heel flap, use the extra strand of yarn to pick up and knit 16 (17) sts (1 st for each garter ridge) along right side of heel flap, then drop the extra strand. Using same needle and yarn attached to beg of heel-flap sts, k18 (20) heel sts, then pick up and knit 16 (17) sts (1 st for each garter ridge) along left side of heel flap—114 (130) sts total; 50 (54) sole sts on Needle 2, 32 (38) instep sts each on Needle 1 and Needle 3.

Work back and forth in rows on sole sts of Needle 2, dec for gussets and joining to instep sts as foll:

Row 1: (WS) Purl to last st of Needle 2, p2tog (last st of Needle 2 tog with 1 st from Needle 1), turn—1 st joined from Needle 1.

Row 2: (RS) Sl 1, k1, ssk, knit to last 4 sts of Needle 2, k2tog, k1, ssk (last st of Needle 2 tog with 1 st from Needle 3), turn—2 sole sts dec'd on Needle 2; 1 st joined from Needle 3.

Row 3: Sl 1, purl to last st of Needle 2, p2tog (last st of Needle 2 tog with 1 st from Needle 1), turn—1 st joined from Needle 1.

Rep Rows 2 and 3 eight (nine) more times—77 (89) sts rem; 22 (27) sts on Needle 1, 32 (34) sole sts on Needle 2, 23 (28) sts on Needle 3.

. .

Note: *Needle 1 has one less stitch than Needle 3 because it had an extra stitch joined in Row 1.*

. .

Sole

Work even in rows on sole sts while cont to join instep sts as foll:

Row 1: (RS) Sl 1, knit to last st of Needle 2, ssk (last st of Needle 2 tog with 1 st from Needle 3), turn—1 st joined from Needle 3.

Row 2: (WS) Sl 1, purl to last st of Needle 2, p2tog (last st of last st of Needle 2 tog with 1 st from Needle 1), turn—1 st joined from Needle 1.

Rep these 2 rows 21 (26) more times, then work Row 1 once more—32 (34) sole sts rem; all instep sts have been joined; foot measures about 7 (8¼)" (18 [21] cm) from center back heel.

Toe

Set-up rnd: With RS facing and an empty cir needle (Needle 1), pick up and knit 32 sts along toe edge of instep extension; with Needle 2, knit—64 (66) sts total; 32 sts on

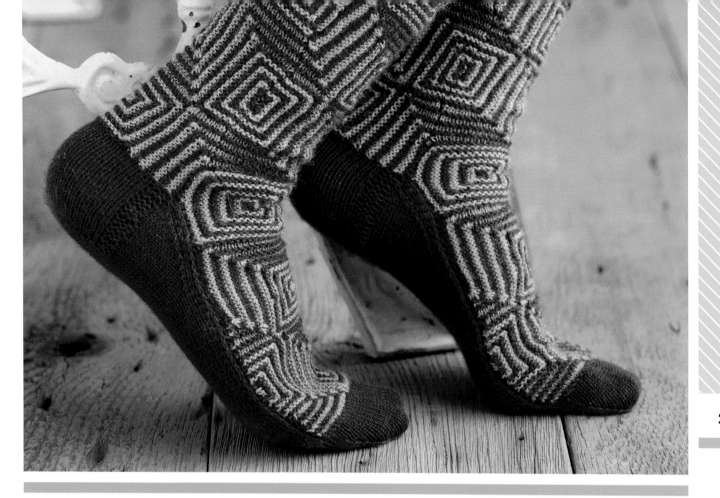

Needle 1 for both sizes, 32 (34) sts on Needle 2.

Women's size only
Knit 2 rnds.

Men's size only
Next rnd: With Needle 1, [k16, M1] 2 times; with Needle 2, knit—68 sts; 34 sts each needle.

Next rnd: Knit.

Both sizes
. .
Note: *For a longer foot, work more rounds even here before beginning the toe decreases; every 3 rounds added will lengthen the foot by about ¼" (6 mm).*
. .

Dec rnd: With Needle 1, *k1, ssk, knit to last 3 sts, k2tog, k1; with Needle 2, rep from *—4 sts dec'd; 2 sts dec'd each needle.

Knit 3 rnds even, then rep dec rnd—56 (60) sts rem; 28 (30) sts each needle.

[Knit 2 rnds even, then rep dec rnd] 2 times—48 (52) sts rem; 24 (26) sts each needle.

[Knit 1 rnd even, then rep dec rnd] 5 (6) times—28 sts rem for both sizes; 14 sts each needle.

Work dec rnd every rnd 5 more times—8 sts rem for both sizes; 4 sts each needle; toe measures about 2¼ (2½)" (5.5 [6.5] cm).

finishing
Cut yarn, leaving an 8" (20.5 cm) tail. Thread tail onto a tapestry needle, draw through rem sts, pull tight to close hole, and fasten off on WS.

CUFF
With MC and RS facing, pick up and knit 64 (68) sts evenly spaced along the cuff edge of the leg opening. Arrange sts evenly on two cir needles so that there are 32 (34) sts on each needle. Join for working in rnds.

[Knit 1 rnd, then purl 1 rnd] 3 times, then knit 1 rnd.

BO as foll: P1, *yo, p1, with left needle pull the first p1 and the yo up and over the second p1 and off the needle; rep from * until 1 st rem, then fasten off last st.

Weave in loose ends.

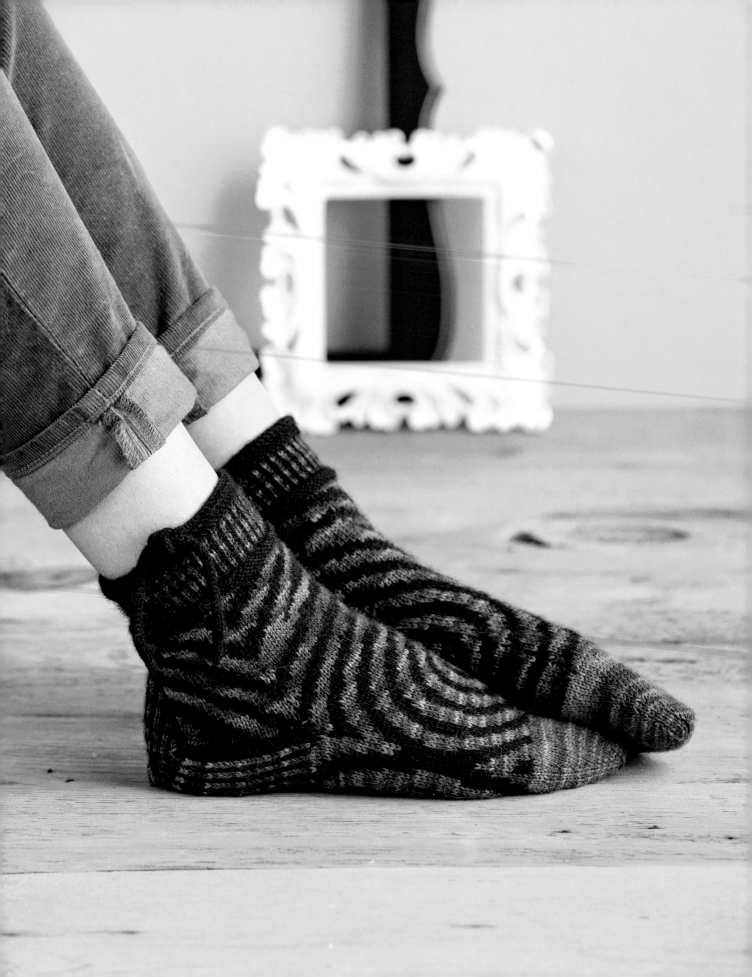

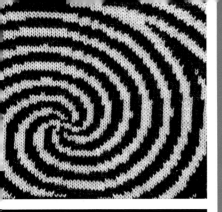

Victor

Many op-art patterns stimulate the beholder's eye with color contrast or graphic elements such as black-and-white lines, curves, or angles. Spirals formed by dark and light can evoke the impression of rotation, a sensation that can be forced when the lines and curves change their widths. Victor Vasarely (1906–1997) played with this effect for his 1937 work *Zebras*.

Named after Victor Vasarely, the socks shown here are worked from the toe up in an unnerving swirl pattern that has no repeat. The swirl continues across both insteps of right and left sock, as well as around both soles so that the full pattern appears when the feet are placed together.

FINISHED SIZE
About 7¾" (19.5 cm) foot circumference, unstretched, and 10 (10½)" (25.5 [26.5] cm) foot length from back of heel to tip of toe (length is adjustable).

To fit U.S. women's shoe sizes 8½–9½ (10–11); European shoe sizes 40–41 (42–44).

Socks shown measure 10" (25.5 cm) in foot length.

YARN
Fingering (#1 Super Fine).

Shown here: Trekking XXL (75% new wool, 25% nylon; 459 yd [420 m]/100 g): #455, grey variegated (A), 1 ball for both sizes.

Trekking Sport 4-ply (75% new wool, 25% nylon; 459 yd [420 m]/100 g): #1437, black (B), 1 ball for both sizes.

NEEDLES
Sock: size U.S. 1 (2.25 mm): two 24" (60 cm) circular (cir).

I-cord: size U.S 2 (2.75 mm): two double-pointed (dpn).

Adjust needle size if necessary to obtain the correct gauge.

NOTIONS
Tapestry needle.

continued >>

GAUGE

32 sts and 40 rnds = 4" (10 cm) in solid-color St st worked in rnds on smaller needles, after blocking; 34 sts and 46 rnds = 4" (10 cm) in solid-color St st worked in rnds on smaller needles and relaxed after blocking.

35 sts and 40 rnds = 4" (10 cm) in charted patts worked in rnds on smaller needles, after blocking; 37 sts and 40 rnds = 4" (10 cm) in charted patts worked in rnds on smaller needles and relaxed after blocking.

STITCH GUIDE

K-yo-R

(knit yarnover, twisted right) Slip yo of the previous rnd as if to knit, return it to the left needle in its new orientation, then knit the yo through its front loop to twist it.

K-yo-L

(knit yarnover, twisted left) Knit the yo of the previous rnd through its back loop to twist it.

NOTES

✕ After completing the toe, turn the sock inside out so the right side of the pattern is on the inside of the tube. Work the stranded colorwork pattern by knitting across the needle on the far side of the tube instead of the needle closest to you, and everything else stays the same. The sock can be turned back right side out at any time—when it comes to working a heel flap back and forth, for example. Afterward, turn the sock inside out again to work the stranded colorwork patterns on the leg.

✕ Because the foot is planned to contain an exact number of chart rounds, length adjustments must be made in the toe section before beginning the foot chart. For a longer foot, after you complete the toe shaping, work even in stockinette with A until the foot measures 7½" (19 cm) less than the desired length. For a shorter foot, omit some of the plain knit rounds from the toe shaping instructions. Every 3 rounds added or removed will lengthen or shorten the foot by about ¼" (6 mm).

✕ Different charts are used for the right and left gussets and leg.

✕ In this construction, the heel flap is worked along the bottom of the foot, under the heel. After completing the foot, the heel flap is worked back and forth in rows on the sole stitches, which are the first 36 stitches of the round (Needle 1) for the right sock and the last 36 stitches of the round (Needle 2) for the left sock.

✕ After finishing the heel flap, a separate length of yarn is used to pick up and knit stitches along the right side of the heel flap (the side that usually would be worked last), then one of the working yarns is reattached at the end of the heel stitches and used to pick up and knit stitches along the left side of the heel flap. The second color is reattached at this point, and both working yarns will be in position to resume working in rounds, with the rounds beginning at the side of the leg with the front-of-leg stitches, instead of at the center back leg.

Toe

Cut a 24" (60 cm) length of B and set aside. This length will be used to pick up sts along the first side of the heel flap.

With A and cir needle (Needle 1), use the long-tail method (see Glossary) to CO 11 sts, but hold the tail end of the yarn over your index finger and the ball end over your thumb.

Turn Needle 1 upside down, then, with a second cir needle (Needle 2), pick up and knit 10 sts along CO edge—21 sts total; 11 sts on Needle 1, 10 sts on Needle 2.

Set-up rnd: With Needle 1, k10, drop last st, then tighten the working and ball ends of the yarn to remove the slack caused by the dropped st; with Needle 2, k10—20 sts rem; 10 sts each needle.

Cont according to your size as foll:

Size 10" (25.5 cm) only

Rnd 1: With Needle 1, *k1, yo, k8, yo, k1; with Needle 2, rep from *—24 sts; 12 sts each needle.

Rnd 2: With Needle 1, *k1, yo, k-yo-R (see Stitch Guide), knit to last 2 sts, k-yo-L (see Stitch Guide), yo, k1; with Needle 2, rep from *—4 sts inc'd; 2 sts each needle.

Rnds 3–5: Rep Rnd 2 three more times—40 sts; 20 sts each needle.

Rnd 6: With Needle 1, *k1, k-yo-R, knit to last 2 sts, k-yo-L, k1; with Needle 2, rep from *—no change to st count.

Rnd 7: With Needle 1, *k1, yo, knit to last st, yo, k1; with Needle 2, rep from *—4 sts inc'd; 2 sts each needle.

Rnd 8: With Needle 1, *k1, k-yo-R, knit to last 2 sts, k-yo-L, k1; with Needle 2, rep from *—no change to st count.

Rnds 9–14: Rep Rnds 7 and 8 three more times—56 sts; 28 sts each needle.

Rnd 15: Knit.

Rnd 16: With Needle 1, *k1, yo, knit to last st, yo, k1; with Needle 2, rep from *—4 sts inc'd; 2 sts each needle.

Rnd 17: With Needle 1, *k1, k-yo-R, knit to last 2 sts, k-yo-L, k1; with Needle 2, rep from *—no change to st count.

Rnds 18–23: Rep Rnds 15–17 two times—68 sts; 34 sts each needle.

Rnds 24 and 25: Knit.

Rnds 26 and 27: Rep Rnds 16 and 17 once—72 sts; 36 sts each needle.

Rnd 28: Knit—29 toe rnds completed including set-up rnd; toe measures 2½" (6.5 cm) from CO.

Size 10½" (26.5 cm) only

Rnd 1: With Needle 1, *k1, yo, k8, yo, k1; with Needle 2, rep from *—24 sts; 12 sts each needle.

Rnd 2: With Needle 1, *k1, yo, k-yo-R (see Stitch Guide), knit to last 2 sts, k-yo-L (see Stitch Guide), yo, k1; with Needle 2, rep from *—4 sts inc'd; 2 sts each needle.

Rnds 3 and 4: Rep Rnd 2 two more times—36 sts; 18 sts each needle.

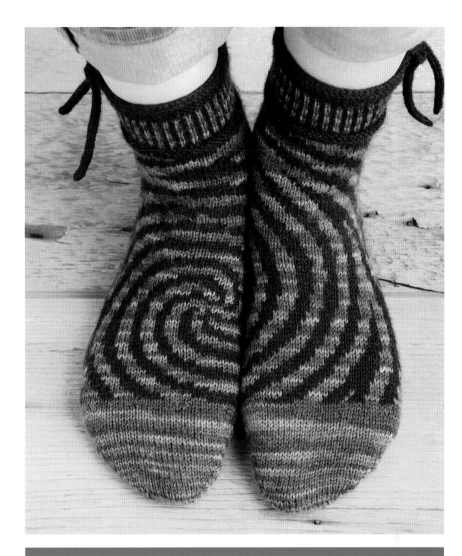

Rnd 5: With Needle 1, *k1, k-yo-R, knit to last 2 sts, k-yo-L, k1; with Needle 2, rep from *—no change to st count.

Rnd 6: With Needle 1, *k1, yo, knit to last st, yo, k1; with Needle 2, rep from *—4 sts inc'd; 2 sts each needle.

Rnd 7: With Needle 1, *k1, k-yo-R, knit to last 2 sts, k-yo-L, k1; with Needle 2, rep from *—no change to st count.

Rnds 8–11: Rep Rnds 6 and 7 two more times—48 sts; 24 sts each needle.

Rnd 12: Knit.

Rnd 13: With Needle 1, *k1, yo, knit to last st, yo, k1; with Needle 2, rep from *—4 sts inc'd; 2 sts each needle.

Rnd 14: With Needle 1, *k1, k-yo-R, knit to last 2 sts, k-yo-L, k1; with Needle 2, rep from *—no change to st count.

Rnds 15–20: Rep Rnds 12–14 two times—60 sts; 30 sts each needle.

Rnds 21 and 22: Knit.

Rnds 23 and 24: Rep Rnds 13 and 14 once—4 sts inc'd; 2 sts each needle.

Rnds 25–32: Rep Rnds 21–24 two times—72 sts; 36 sts each needle.

Rnd 33: Knit—34 toe rnds completed including set-up rnd; toe measures 3" (7.5 cm) from CO.

Foot

Note: *For both the right and left socks, each Foot chart round begins at the outside of the foot. For the right sock, the stitches on Needle 1 form the sole and the stitches on*

Needle 2 form the instep. For the left sock, the stitches on Needle 1 form the instep and the stitches on Needle 2 form the sole. Each foot has a different half of the chart pattern positioned on the top of the foot as indicated on the charts.

Set-up rnd: With Needle 1, work the first 36 sts from Rnd 1 of the Foot chart, ending at the blue line in the center of the chart; with Needle 2, work the last 36 rnds from Rnd 1 of the Foot chart.

Cont in established patt, work Rnds 2–38 of chart—foot measures 6¼ (6¾)" (16 [17] cm) from tip of toe.

- ☐ knit with A
- ⊙ knit with B
- ▍ needle boundaries

Heel

Note: *The heel flap is worked along the bottom of the foot.*

HEEL FLAP
Work right and left sock as foll:

Right sock
Work heel sts back and forth in rows on the 36 sts at the beg of the rnd (Needle 1); the 36 sts on Needle 2 will be worked later for instep.

Set-up Row 1: (RS) K2tog with B, k1B, [k1A, k1B] 16 times, k1B—35 heel sts rem.

Set-up Row 2: (WS) K1B, [p1B, p1A] 16 times, p1B, k1B.

FOOT

Row numbers (right side): 37, 35, 33, 31, 29, 27, 25, 23, 21, 19, 17, 15, 13, 11, 9, 7, 5, 3, 1

36 sts Needle 2
instep of right sock
sole of left sock

36 sts Needle 1
sole of right sock
instep of left sock

Left sock

Work heel sts back and forth in rows on the 36 sts at the end of the rnd (Needle 2); the 36 sts on Needle 1 will be worked later for instep. Turn work so WS is facing.

Set-up Row: (WS) K1B, p2tog with B, [p1A, p1B] 16 times, k1B—35 heel sts rem.

Right and left socks

Row 1: (RS) K2B, [k1A, k1B] 16 times, k1B.

Row 2: (WS) K1B, [p1B, p1A] 16 times, p1B, k1B.

Rep these 2 rows 16 more times— 34 rows total, not including set-up row(s).

TURN HEEL

Work short-rows as foll:

Short-row 1: (RS) K2B, [k1A, k1B] 9 times, ssk with A, k1A, turn work.

Short-row 2: (WS) Sl 1, [p1A, p1B] 3 times, p2tog with A (1 st each side of gap), p1A, turn work.

Short-row 3: Sl 1, k1A, *k1B, k1A; rep from * to 1 st before gap formed by previous row, ssk with A (1 st each side of gap), k1A, turn work.

Short-row 4: Sl 1, *p1B, p1A; rep from * to 1 st before gap formed by previous row, p2tog with A (1 st each side of gap), p1A, turn work.

Short-row 5: Sl 1, k1B, *k1A, k1B; rep from * to 1 st before gap formed by previous row, ssk with A (1 st each side of gap), k1A, turn work.

Short-row 6: Sl 1, *p1A, p1B; rep from * to 1 st before gap formed by previous row, p2tog with A (1 st each side of gap), p1A, turn work.

Rep the Short-rows 3–6 two more times—21 heel sts rem.

Cut both yarns.

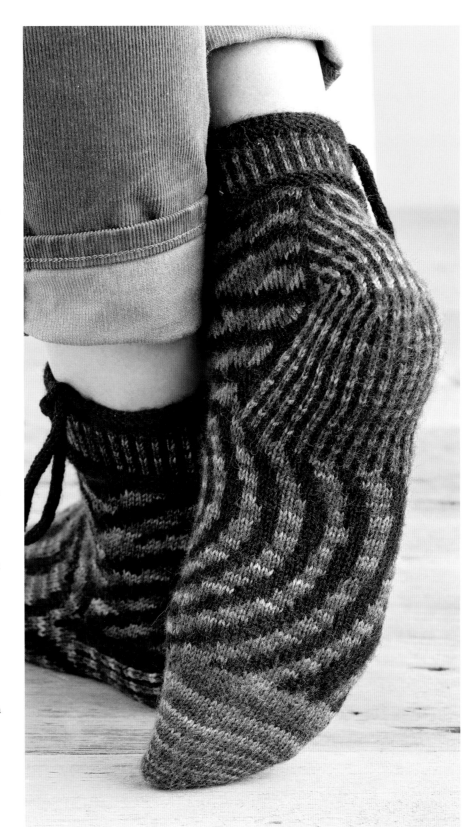

Op-Art Socks

LEFT GUSSET AND LEG

33 31 29 27 25 23 21 19 17 15 13 11 9 7 5 3 1

36 sts Needle 1
front-of-leg

57 sts dec'd to 37 sts Needle 2
gusset and back-of-leg

RIGHT GUSSET AND LEG

33 31 29 27 25 23 21 19 17 15 13 11 9 7 5 3 1

36 sts Needle 1

57 sts dec'd to 37 sts Needle 2

- ☐ knit with A
- ⊙ knit with B
- ⟋ k2tog with B
- ⟍ ssk with B
- ⋀ sl 2 sts as if to k2tog, k1, p2sso with B
- ▨ no stitch
- | needle boundaries

Gusset and leg

Turn work so RS is facing. Pick up gusset sts as foll:

Set-up row: (RS) With cut length of B, heel needle, and beg in the corner between the heel flap and instep, pick up and knit 18 sts (1 st in corner and about 1 st for every 2 heel-flap rows) along right edge of heel flap; slip the 21 heel sts pwise to the right needle without working them; rejoin B and pick up and knit 18 sts (about 1 st for every 2 heel-flap rows and 1 st in corner) along right edge of heel flap, then rejoin A at end of picked-up sts—57 heel and gusset sts on back-of-leg needle.

Both A and B yarns are now at the start of the front-of-leg sts.

Set-up rnd: Work right and left sock as foll:

Right sock

With Needle 1, work first 36 sts from Rnd 1 of the Right Gusset and Leg chart over 36 instep sts; with Needle 2, work last 57 sts of chart over gusset and back-of-leg sts.

Left sock

With Needle 1, work first 36 sts from Rnd 1 of the Left Gusset and Leg chart over 36 instep sts; with Needle 2, work last 57 sts of chart over gusset and back-of-leg sts.

Both Socks

Cont in established patts until Rnd 34 of chart has been completed—73 sts rem; 36 front-of-leg sts on Needle 1, 37 back-of-leg sts on Needle 2.

Cuff

Rnd 1: With B, knit.

Rnd 2: With B and Needle 1, p36; with Needle 2, p18, p2tog, p17—72 sts rem; 36 sts each needle.

Rnds 3–5: With B, purl 2 rnds, then knit 1 rnd.

Rnd 6: With Needle 1, *[k1B, k1A] 18 times; with Needle 2, rep from *.

Rnds 7–15: Rep Rnd 6 nine more times.

Cut A, and cont with B only.

Knit 1 rnd, then cont for your size as foll:

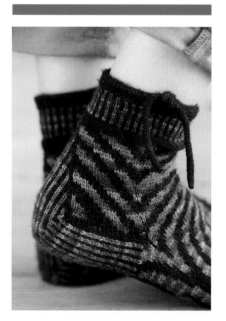

Size 10" (25.5 cm) only

Next rnd: With Needle 1, *[p10, p2tog] 3 times; with Needle 2, rep from *—66 sts rem; 33 sts each needle.

Size 10½" (26.5 cm) only

Next rnd: Knit.

Both sizes

[Knit 1 rnd, purl 1 rnd] 2 times.

Cut B; leave sts on needle.

I-CORD TIES AND BIND-OFF

With B and dpn, CO 4 sts.

Work unattached 4-st I-cord as foll: *With yarn in back, sl these 4 sts pwise from right needle tip onto left needle tip, k4; rep from * until piece measures about 4½" (11.5 cm). Leave sts on dpn.

Beg at start of back-of-leg needle for right sock and start of front-of-leg needle for left sock, work I-cord BO as foll:

*With yarn in back, sl 4 sts pwise from dpn onto cir needle holding cuff sts, k3, k2tog (last I-cord st tog with 1 cuff st); rep from * until 4 sts rem on dpn and no cuff sts rem.

With dpn, work unattached 4-st I-cord as for start of tie until piece measures about 4½" (11.5 cm) from last BO cuff st.

Finishing

Cut yarn, leaving a 6" (15 cm) tail. Thread tail onto tapestry needle, draw through rem sts, pull tight to close end of cord, and fasten off on inside of tube.

Weave in loose ends. Block if desired.

Tie I-cords in knots on the outside of each leg as shown.

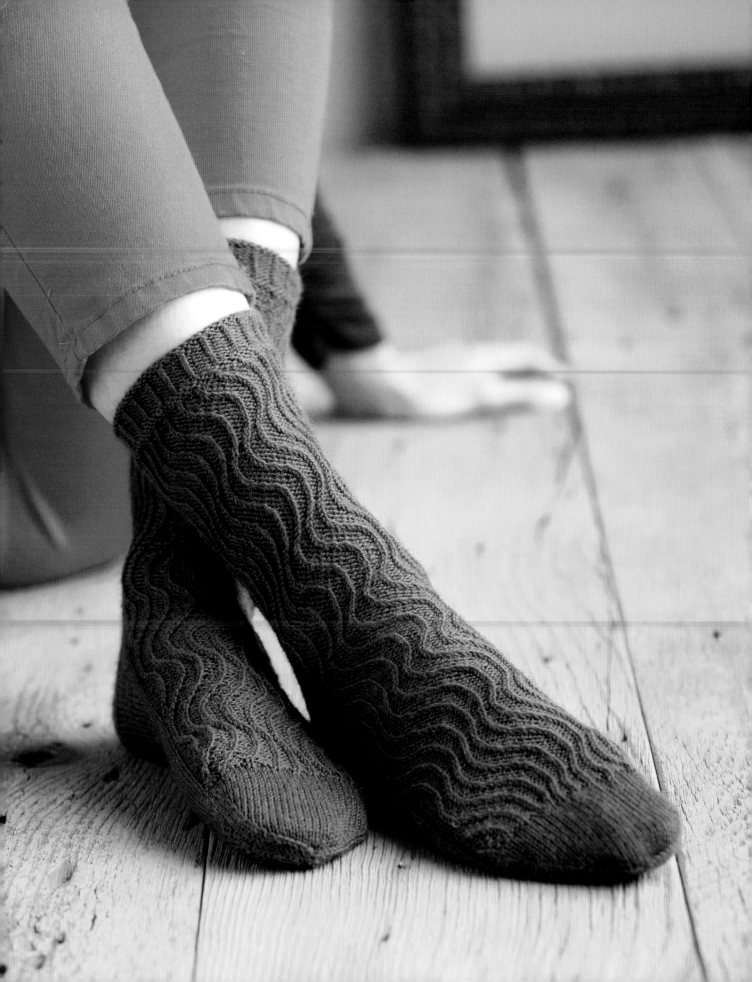

FINISHED SIZE
About 7" (18 cm) foot circumference for both sizes, unstretched, and 9¼ (9¾)" (23.5 [25] cm) foot length from back of heel to tip of toe (length is adjustable).

To fit U.S. women's shoe sizes 7–8 (9–10); European shoe sizes 38–40 (41–52).

Socks shown measure 9¾" (25 cm) in foot length.

YARN
Fingering (#1 Super Fine).

Shown here: Lang Jawoll (75% superwash wool, 18% nylon, 7% acrylic; 229 yd [210 m]/50 g): #83.0288 petrol, 2 balls for both sizes.

NEEDLES
Size U.S. 1 (2.25 mm): two 24" (60 cm) circular (cir).

Adjust needle size if necessary to obtain the correct gauge.

NOTIONS
Cable needle (cn); tapestry needle.

GAUGE
32 sts and 40 rows/rnds = 4" (10 cm) in St st after blocking; 36 sts and 48 rows/rnds = 4" (10 cm) in St st and relaxed after blocking.

36 sts and 40 rnds = 4" (10 cm) in charted patts worked in rnds, after blocking; 45 sts and 46 rnds = 4" (10 cm) in charted patts worked in rnds and relaxed after blocking.

Thin black-and-white wavy lines placed close to one another, then shifted a little away from each other on a flat surface create such a volatile figure-ground relationship that it can cause the viewer's eyes to hurt. Bridget Riley (born 1931) used this effect for her 1964 work *Crest*.

For this sock pattern, named after Bridget Riley's work, the lines are formed by a ribbing pattern of twisted stitches and purled stitches comprised of an intriguing arrangement of tiny cables. A vertical mirrored pattern for right and left socks accentuates the flicker effect. Moreover, the socks look different, depending on the direction from which you view them.

STITCH GUIDE

Make-two (M2)

Insert the left needle tip from front to back under the strand between the two needles and lift the strand onto the left needle. Knit into the front of the lifted strand without removing it from the needle, then purl into the back of the same lifted strand and slip it from the needle—2 sts inc'd.

Gold highlighted cables

Some rnds in the leg charts have cables worked across the breaks between the needles; these cables are highlighted in gold.

In a rnd containing a gold cable symbol, work in patt to the gold cable at the end of Needle 1, use the right tip of Needle 1 to transfer the next 1 or 2 sts required for the cable from the beg of Needle 2 onto Needle 1, then slip the transferred sts to the left tip of Needle 1 and work the cable. Work in patt to the gold cable at the end of Needle 2, use the right tip of Needle 2 to transfer the next 1 or 2 sts required for the cable from the beg of Needle 1 onto Needle 2, then slip the transferred stitches to the left tip of Needle 2 and work the cable. The boundaries between the needles (as well as the end-of-rnd at the end of Needle 2) have temporarily shifted 1 or 2 sts to the left to accommodate the gold cables.

On the following rnd, restore the needle boundaries and end-of-rnd to their original positions. On Needle 1, work to the chart line indicating the end of Needle 1, then transfer the extra 1 or 2 cable sts back to the beg of Needle 2. On Needle 2, work in patt to the end of the chart, then transfer the extra 1 or 2 sts at the end of Needle 2 back to the beg of Needle 1 and stop there. The boundaries between the needles (as well as the end-of-rnd at the end of Needle 2) have returned to their original positions.

NOTES

✕ Different charts are used for the right and left socks.

✕ To adjust foot length, work more or fewer rounds at the end of the foot, before starting the toe, until the foot measure 2¼" (5.5 cm) less than desired length; every 3 rounds added or removed will lengthen or shorten the foot by about ¼" (6 mm). The instep charts go up to Rnd 74 to accommodate a longer foot; if you need more rounds than that, work any additional rounds after the chart entirely in stockinette.

✕ The cuff for this project would look nice on a simple stockinette sock. You can also use the other side of the fabric by turning cuff inside out before working the last cuff round. To prevent a hole from forming where the direction of the knitting is reversed, after completing Round 14, wrap the first stitch on Needle 1, then turn the piece inside out. The working yarn will be coming from the wrapped stitch on the right-hand needle (now Needle 2), and you'll be ready to purl Round 15 in the opposite direction.

Leg

With one cir needle, use the long-tail method (see Glossary) to CO 66 sts. Do not join.

CUFF

Row 1: (RS) Purl to end, turn work.

Row 2: (WS) Knit to end, turn work.

Join for working in rnds using two cir needles as foll:

Rnd 3: With current cir needle (Needle 1), k33; with a second cir needle (Needle 2), k33, then join for working in rnds, being careful not to twist sts.

Rnds 4–11: *K1 through back loop (tbl), p2; rep from *.

Rnd 12: *K1tbl, k2; rep from *.

Rnds 13 and 14: Purl.

Rnd 15: Knit—piece measures 1" (2.5 cm) with CO edge allowed to roll.

Leg

Work set-up rnd for right or left sock as foll:

Next rnd, right sock: Work set-up rnd of Right Leg chart—74 sts; 37 sts each needle.

Next rnd, left sock: Work set-up rnd of Left Leg chart—74 sts; 37 sts each needle.

For both right and left socks, work in established chart patt until Rnd 74 of leg chart has been completed (see Stitch Guide)—piece measures 7½" (19 cm) with CO edge allowed to roll.

Heel

For both right and left socks, the heel is worked back and forth in rows on the 37 sts of Needle 1; the 37 sts on Needle 2 will be worked later for the instep.

Legend

ℛ	k1tbl	
·	purl	
↗	p2tog	
M	M1P	

gold highlighted cables (see Stitch Guide)

| needle boundaries

⌣ M2 (see Stitch Guide)

sl 1 st to cn and hold in back, k1, p1 from cn

sl 1 st to cn and hold in front, p1, k1 from cn

sl 2 sts to cn and hold in back, k1, p2 from cn

sl 1 st to cn and hold in front, p2, k1 from cn

RIGHT LEG

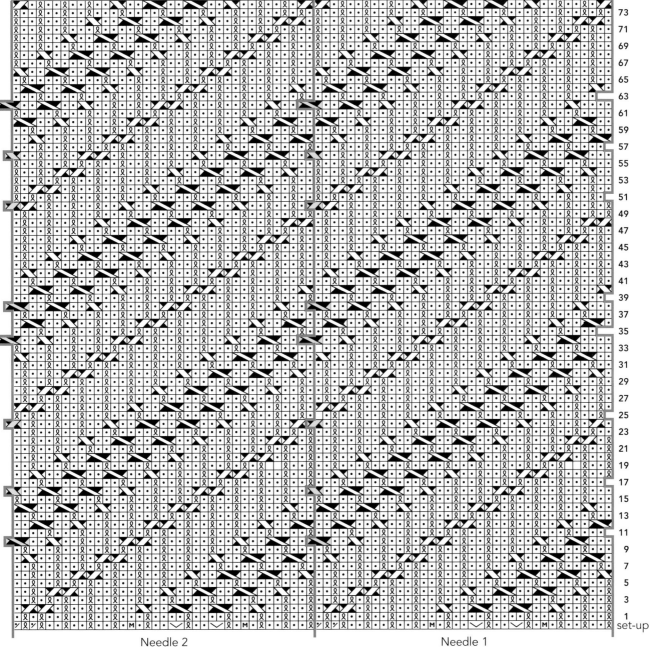

73
71
69
67
65
63
61
59
57
55
53
51
49
47
45
43
41
39
37
35
33
31
29
27
25
23
21
19
17
15
13
11
9
7
5
3
1
set-up

Needle 2
37 sts

Needle 1
37 sts

∫	k1tbl
•	purl
⟍	p2tog
M	M1P

gold highlighted cables
(see Stitch Guide)

| needle boundaries |

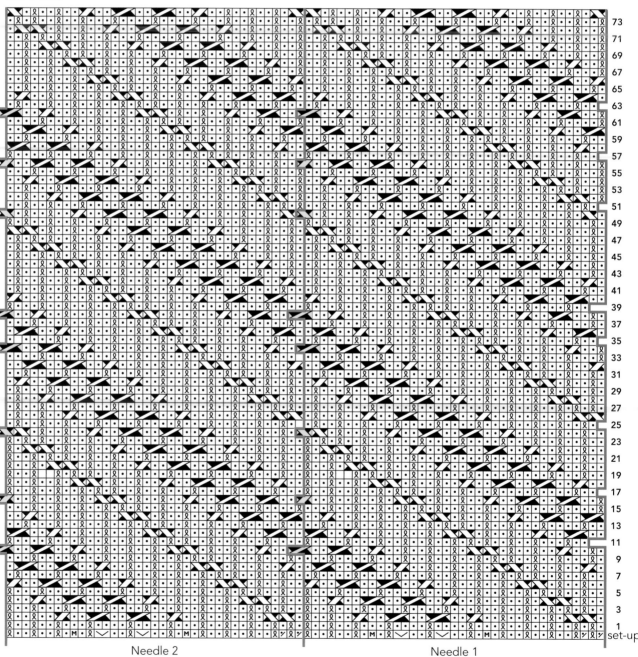 M2 (see Stitch Guide)

sl 1 st to cn and hold in back, k1, p1 from cn

sl 1 st to cn and hold in front, p1, k1 from cn

sl 2 sts to cn and hold in back, k1, p2 from cn

sl 1 st to cn and hold in front, p2, k1 from cn

LEFT LEG

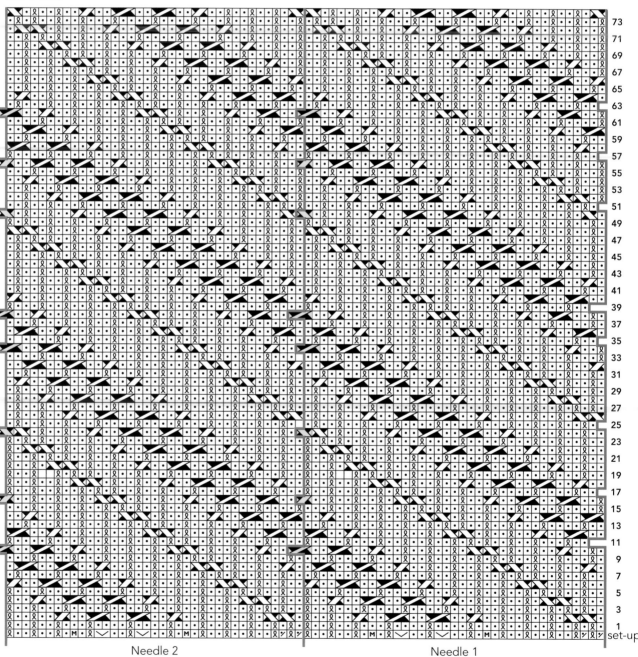

73
71
69
67
65
63
61
59
57
55
53
51
49
47
45
43
41
39
37
35
33
31
29
27
25
23
21
19
17
15
13
11
9
7
5
3
1
set-up

Needle 2
37 sts

Needle 1
37 sts

HEEL FLAP

Row 1: (RS) K37.

Row 2: (WS): P4, [p2tog, p7] 3 times, p2tog, p4—33 sts rem.

Row 3: K2, *sl 1, k1; rep from * to last st, k1, turn.

Row 4: P33.

Rep the last 2 rows 13 (14) more times—30 (32) heel rows total.

TURN HEEL

Work short-rows as foll:

Short-row 1: (RS) K2, [sl 1, k1] 6 times, k4, ssk, k1, turn work.

Short-row 2: (WS) Sl 1, p4, p2tog, p1, turn work.

Short-row 3: Sl 1, knit to 1 st before gap formed on previous row, ssk (1 st each side of gap), k1, turn work.

Short-row 4: Sl 1, purl to 1 st before gap formed on previous row, p2tog (1 st each side of gap), p1, turn work.

Rep the last 2 rows 5 more times—19 heel sts rem.

SHAPE GUSSETS

Set-up Rnd 1: With Needle 1, work 19 heel sts as sl 1, k18, then pick up and knit 15 (16) sts evenly spaced along left side of heel flap; with Needle 2, work Rnd 1 of either Right Instep or Left Instep chart over 37 sts.

Set-up Rnd 2: With Needle 1, pick up and knit 15 (16) sts evenly spaced along right side of heel flap, then k34 (35) to end of needle; with Needle 2, work Rnd 2 of instep chart as established over 37 sts—86 (88) sts total; 49 (51) heel and sole sts on Needle 1; 37 instep sts on Needle 2.

Working all sts on Needle 1 in St st and cont in established patt on Needle 2, work 2 rnds even.

RIGHT INSTEP

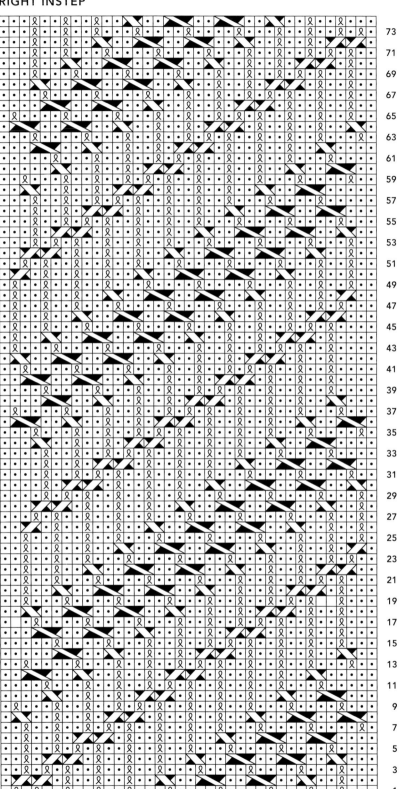

37 sts

LEFT INSTEP

Symbol	Description
ℓ (boxed)	k1tbl
•	purl

sl 1 st to cn and hold in back, k1, p1 from cn

sl 1 st to cn and hold in front, p1, k1 from cn

sl 2 sts to cn and hold in back, k1, p2 from cn

sl 1 st to cn and hold in front, p2, k1 from cn

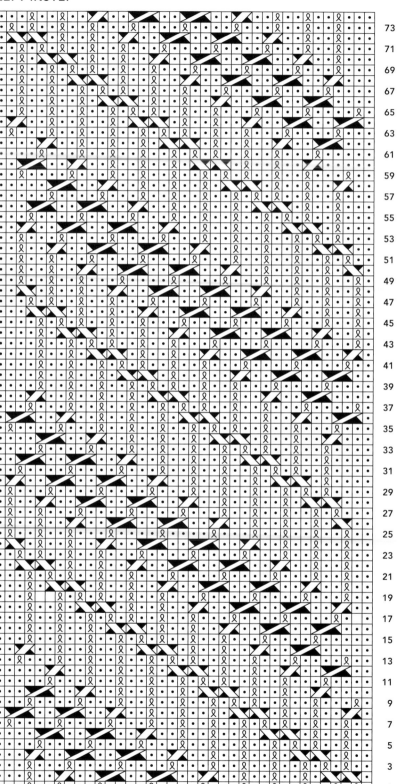

73
71
69
67
65
63
61
59
57
55
53
51
49
47
45
43
41
39
37
35
33
31
29
27
25
23
21
19
17
15
13
11
9
7
5
3
1

37 sts

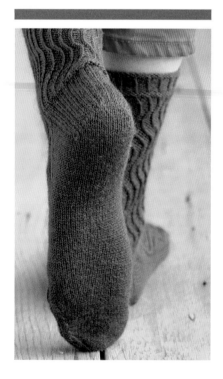

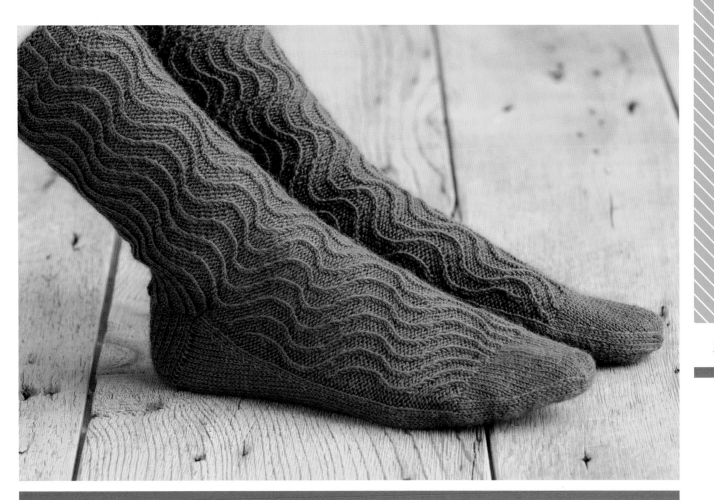

Dec rnd: With Needle 1, k1, ssk, knit to last 3 sts, k2tog, k1; with Needle 2, cont in established patt—2 sts dec'd on Needle 1.

Cont as established, [work 2 rnds even, rep the dec rnd] 7 (8) more times—70 sts rem for both sizes; 33 sole sts on Needle 1; 37 instep sts on Needle 2.

foot

Cont as established until Rnd 61 (67) of instep chart has been completed or to desired length (see Notes)—foot measures about 7 (7½)" (18 [19] cm) from center back of heel.

Toe

Knit 1 rnd.

Next rnd: With Needle 1, k30, k2tog, k1; with Needle 2, k4, [k2tog, k5, k2tog, k4] 2 times, k2tog, k5—64 sts rem; 32 sts each needle.

Dec rnd: With Needle 1, *k1, ssk, knit to last 3 sts, k2tog, k1; with Needle 2, rep from * once more—4 sts dec'd; 2 sts dec'd each needle.

Knit 3 rnds even, then rep dec rnd—56 sts rem; 28 sts each needle.

[Knit 2 rnds even, then rep dec rnd] 2 times—48 sts rem; 24 sts each needle.

[Knit 1 rnd even, then rep dec rnd] 4 times—32 sts rem; 16 sts each needle.

Work dec rnd every rnd 6 more times—8 sts rem; 4 sts each needle; toe measures about 2¼" (5.5 cm).

finishing

Cut yarn, leaving an 8" (20.5 cm) tail. Thread tail onto a tapestry needle, draw through rem sts, pull tight to close hole, and fasten off on WS.

Weave in loose ends.

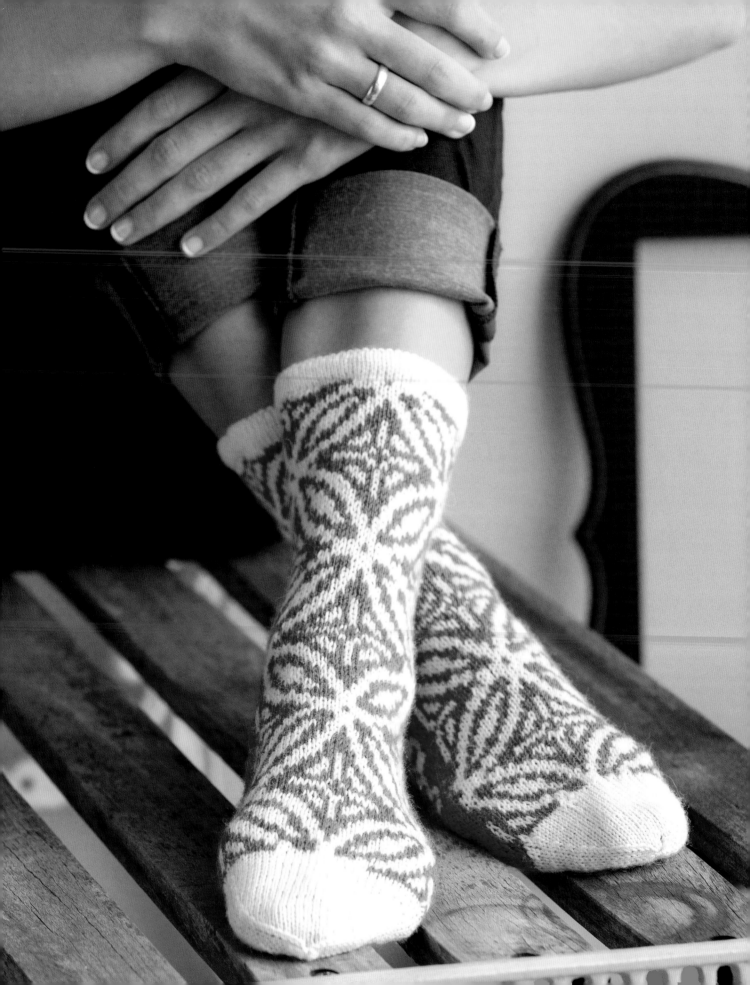

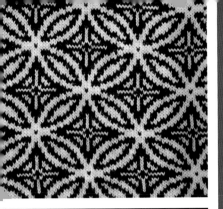

Alhambra

FINISHED SIZE

About 7¾ (8½)" (19.5 [21.5] cm) foot circumference, unstretched, and 8¾ (11)" (22 [28]) foot length from back of heel to tip of toe (length is adjustable).

To fit U.S. women's shoe sizes 5½–6½ (11–12); European shoe sizes 36–38 (44–46).

Pink-and-white socks shown in size 5½–6½; red-and-orange socks (see photograph on page 59) shown in size 11–12.

YARN

Fingering weight (Super Fine #1).

Shown here: Trekking Sport 4-ply (75% new wool, 25% nylon; 459 yd [420 m]/100 g).

Trekking XXL (75% new wool, 25% nylon; 459 yd [420 m]/100) g).

Shown in smaller size with Sport 4-ply #1400 white (MC) and #1421 pink (CC), 1 ball each.

Shown in larger size with Sport 4-ply #1492 red and Trekking XXL #145 variegated orange, 1 ball each (colors exchange places in the two socks).

NEEDLES

Size U.S. 1 (2.25 mm): two 24" (60 cm) circular (cir).

Adjust needle size if necessary to obtain the correct gauge.

NOTIONS

Size C/2 (3 mm) crochet hook; tapestry needle.

continued >>

A tiling of interlocking figures such as circles, squares, or hexagons may lead the viewer's eye from one to another figure. But after a while, the viewer's focus tends to flip back and forth between them. This type of reverse tiling of interlocking figures is often found in Arabic ornamentation, such as in designs at the Alhambra, a fourteenth-century castle in Granada, Spain.

The stranded pattern in these socks will appear more prominent if you choose two colors with sharp contrast. For even more visual appeal, reverse the main and contrast colors for the second sock, as shown in the red-and-orange version on page 59.

GAUGE

32 sts and 40 rows/rnds = 4" (10 cm) in solid-color St st, after blocking; 32 sts and 48 rows/rnds = 4" (10 cm) in solid-color St st and relaxed after blocking.

35 sts and 40 rnds = 4" (10 cm) in charted patts worked in rnds, after blocking; 34 sts and 39 rnds = 4" (10 cm) in charted patt worked in rnds and relaxed after blocking.

NOTES

✕ For the smaller socks shown, the lighter color is used for the MC and the darker color for the CC. For the larger socks, the light MC/dark CC color arrangement is used for the right sock, and the colors are reversed in the left sock. Reversing the colors is optional, but if you choose to do so, select one color for the MC and the other for the CC for the first sock and then remember to exchange the MC and CC color assignments for the second sock.

✕ In the larger socks shown in the photographs, the pattern on the front of the leg does not flow continuously from cuff to toe. After rejoining in the round for the gussets, the sample socks began the pattern with Rnd 16 of the instep chart (instead of Rnd 1) and ended the pattern at the toe with Rnd 15. The directions below will produce a sock that has the pattern flowing continuously all the way down the front of the leg (as shown in the smaller pink-and-white socks); the pattern will begin with Rnd 1 of the instep chart at the start of the gussets and end with Rnd 30 at the start of the toe.

✕ The gusset stitches are picked up with just one color while the instep stitches are worked with two. To avoid having to cut the working yarns, before you cast on for the cuff, cut a length of yarn to be used for picking up gusset stitches. Use this length to pick up and knit stitches along the right side of the heel flap (the side that usually would be worked last), then use the attached yarn to work across the heel stitches and to pick up and knit stitches along the left side of the heel flap. You'll then have both working yarns in position to work in rounds and the rounds will begin between the sole and instep stitches, instead of at the center of the sole.

✕ To make a large adjustment in foot length, add or remove rounds in 15-round increments so the foot ends with Rnd 15 or Rnd 30 of the instep chart; every 15 rounds added or removed will lengthen or shorten the foot by about 1½" (3.8 cm). If you need to make a length adjustment of less than 1½" (3.8 cm), you'll have an opportunity to do so before starting the toe decreases.

Op-Art Socks

Cuff

Cut a 24" (60 cm) length of MC (see Notes) and set aside. This length will be used to pick up sts along the right side of the heel flap so that the working yarn won't need to be cut.

With CC and crochet hook, make a very loose crochet chain (see Glossary) of about 80 sts. With MC, cir needle, and beg about 8 chain sts from one end, pick up and knit 1 st from the "bump" in the back of the next 64 chain sts for both sizes, taking care not to split CC yarn as you go.

Arrange sts evenly onto two cir needles so that there are 32 sts on each needle. Join for working in rnds, being careful not to twist sts.

Knit 5 rnds, purl 1 rnd for fold line, then knit 6 rnds—12 rnds total.

Joining rnd: Fold piece along the fold line with WS of fabric facing tog and provisional CO edge behind the live sts on the needle. Removing CC yarn from provisional CO as you go, *pick up first exposed CO st and place it on the left needle, then k2tog (1 live st tog with picked-up st); rep from * until all CO sts have been joined—64 sts; hem measures about ½" (1.3 cm) from fold line.

Leg

Work for your size as foll:

Size 5½–6½ only

Work Rnds 1–30 of Small Leg chart once, then work Rnds 1–15 of chart once more—45 chart rnds completed; piece measures about 5½" (14 cm) from hem fold line.

Size 11–12 only

Inc rnd: With Needle 1, k4, *[M1 (see Glossary), k8] 3 times, M1, k4; with Needle 2, rep from *—72 sts; 36 sts each needle.

knit with MC

knit with CC

pattern repeat

Work Rnds 1–30 of Large Leg chart
2 times, then work Rnds 1–15 of chart
once more—75 chart rnds completed;
piece measures about 8¼" (21 cm)
from hem fold line.

Heel

The heel is worked back and forth in
rows on the sts at the end of the rnd
(Needle 2); sts on Needle 1 will be
worked later for the instep. Do not cut
CC; leave the working strand of CC
attached to use later when rejoining
in the rnd for the gussets.

HEEL FLAP

With MC, work heel sts back and
forth in rows as foll:

Set-up row: (WS) Turn work so WS is
facing, p31 (35), sl last st of Needle 2
onto Needle 1—31 (35) heel sts
on Needle 2; 33 (37) instep sts on
Needle 1.

Cont on 31 (35) heel sts as foll:

Row 1: (RS) Knit.

Row 2: (WS) K3, purl to last 3 sts, k3.

Rep these 2 rows 15 (16) more
times—33 (35) rows total, includ-
ing set-up row; 16 (17) garter ridges
at each side; heel measures about
2¾ (3)" (7 [7.5] cm) from last rnd of
chart patt.

SMALL LEG

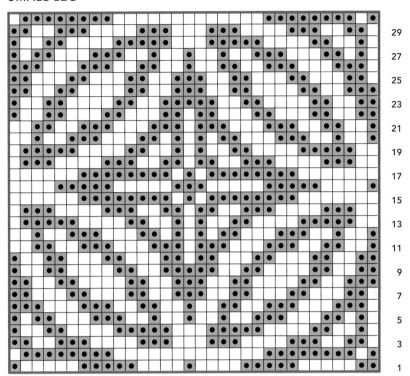

29
27
25
23
21
19
17
15
13
11
9
7
5
3
1

32-st repeat

LARGE LEG

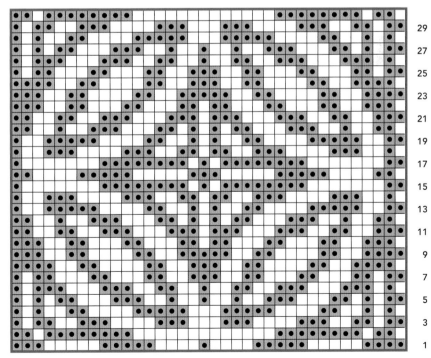

29
27
25
23
21
19
17
15
13
11
9
7
5
3
1

36-st repeat

SMALL INSTEP

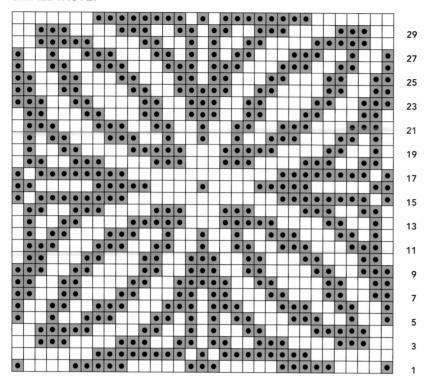

29
27
25
23
21
19
17
15
13
11
9
7
5
3
1

33 sts

	knit with MC
•	knit with CC
/	k2tog with CC
\	ssk with CC

TURN HEEL

Work short-rows as foll:

Short-row 1: (RS) K18 (20), ssk, k1, turn work.

Short-row 2: (WS) Sl 1, p6, p2tog, p1, turn work.

Short-row 3: Sl 1, knit to 1 st before gap formed on previous RS row, ssk (1 st each side of gap), k1, turn work.

Short-row 4: Sl 1, purl to 1 st before gap formed on previous WS row, p2tog (1 st each side of gap), p1, turn work.

Rep the last 2 rows 4 (5) more times—19 (21) heel sts rem.

SMALL GUSSET

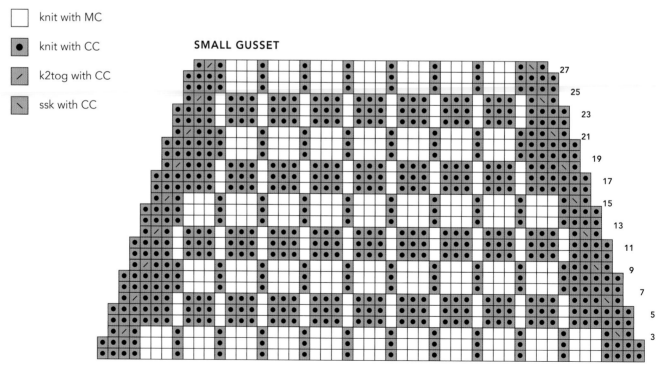

27
25
23
21
19
17
15
13
11
9
7
5
3

51 sts dec'd to 33 sts

SHAPE GUSSETS

Turn work so RS is facing and drop the strand of MC attached to beg of heel sts. Using the length of MC yarn cut and set aside before casting on to pick up sts along the first side of the heel flap as foll:

Set-up row: (RS) Using the cut length of MC and tip of heel needle and beg in the corner between the heel flap and instep sts on the right side of the flap, pick up and knit 16 (17) sts along right side of heel flap (1 st for each garter ridge), then drop the extra strand of yarn. Using the same cir needle and MC attached to beg of heel sts, k19 (21) heel sts, then pick up and knit 16 (17) sts (1 st for each garter ridge) along left side of heel flap—51 (55) heel and gusset sts on one cir needle (Needle 2).

Both MC and CC yarns are now at the start of the instep sts on Needle 1.

Work for your size as foll:

Size 5½–6½ only

Next rnd: On Needle 1, work Rnd 1 of Small Instep chart over 33 sts; on Needle 2, work Rnd 1 of Small Gusset chart over 51 gusset and sole sts—84 sts total.

Size 11–12 only

On Needle 1, work Rnd 1 of Large Instep chart over 37 sts; on Needle 2, work Rnd 1 of Large Gusset chart over 55 gusset and sole sts—92 sts total.

Cont in established patts until Rnd 27 (30) of instep and gusset charts for your size have been completed—66 (72) sts rem; 33 (37) instep sts on Needle 1; 33 (35) gusset and sole sts on Needle 2.

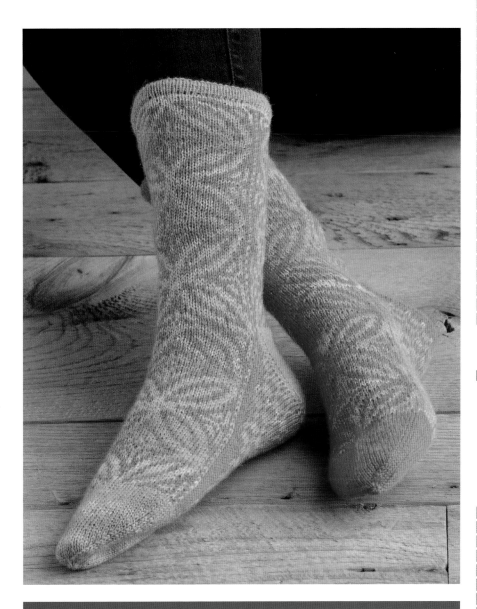

foot

Work for your size as foll:

Size 5½–6½ only

With Needle 1, work Rnd 28 of instep chart over 33 sts; on Needle 2, work Rnd 1 of Small Sole chart over 33 sts.

Work 17 more rnds, ending with Rnd 15 of instep chart and Rnd 6 of sole chart—foot measures about 6½" (16.5 cm) from center back heel (see Notes for adjusting foot length).

Size 11–12 only

Next rnd: With Needle 1, work Rnd 1 of instep chart over 37 sts; on Needle 2, work Rnd 1 of Large Sole chart over 35 sts.

Work 29 more rnds, ending with Rnd 30 of instep chart and Rnd 6 of sole chart—foot measures about 8½" (21.5 cm) from center back heel (see Notes for adjusting foot length).

LARGE INSTEP

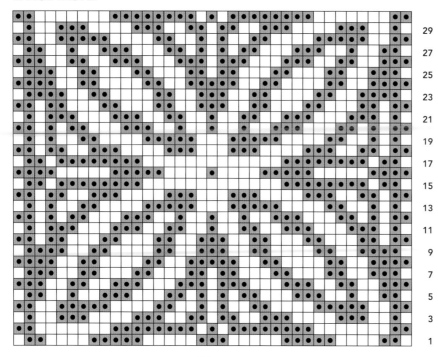

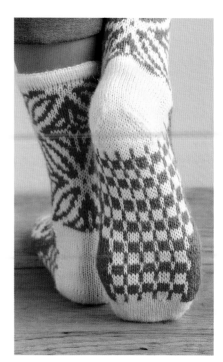

29
27
25
23
21
19
17
15
13
11
9
7
5
3
1

37 sts

LARGE GUSSET

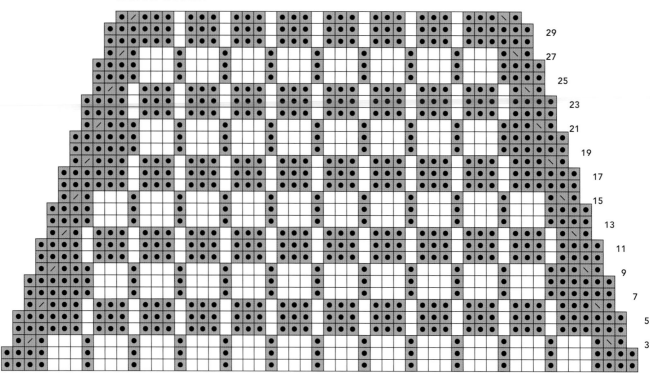

29
27
25
23
21
19
17
15
13
11
9
7
5
3
1

55 sts dec'd to 35 sts

Toe

Cut CC.

. .

Note: If adjusting the foot length, work even in St st with MC until foot measures 2¼ (2½)" (5.5 [6.5] cm) less than desired length.

. .

Cont for your size as foll:

Size 5½–6½ only

With MC, knit 1 rnd.

Next rnd: [K9, k2tog] 6 times—60 sts rem; 30 sts each needle.

Size 11–12 only

Sl last st from Needle 1 onto beg of Needle 2—36 sts each needle.

With MC, knit 1 rnd.

Next rnd: With Needle 1, *k8, k2tog, k16, k2tog, k8; with Needle 2, rep from *—68 sts rem; 34 sts each needle.

Both sizes

Knit 2 rnds even on 60 (68) sts.

Dec rnd: With Needle 1, *k1, ssk, knit to last 3 (4) sts, k2tog, k1 (2); with Needle 2, rep from *—4 sts dec'd; 2 sts dec'd each needle.

Knit 3 rnds even, then rep dec rnd—52 (60) sts rem; 26 (30) sts each needle.

[Knit 2 rnds even, then rep dec rnd] 2 (3) times—44 (48) sts rem; 22 (24) sts each needle.

[Knit 1 rnd even, then rep dec rnd] 3 (4) times— 32 sts rem for both sizes; 16 sts each needle.

Rep dec rnd every rnd 6 (5) times—8 (12) sts rem; 4 (6) sts each needle.

Size 11–12 only

With Needle 1, *k1, ssk, k2tog, k1; with Needle 2, rep from *—8 sts rem; 4 sts each needle.

Both sizes

Toe measures about 2¼ (2½)" (5.5 [6.5] cm).

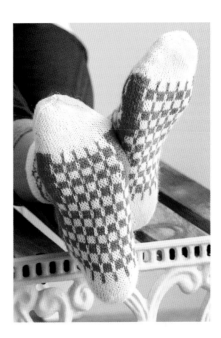

Finishing

Cut yarn, leaving an 8" (20.5 cm) tail. Thread tail onto tapestry needle, draw through rem sts, and pull tight to close hole. Fasten off on WS.

Weave in loose ends.

☐	knit with MC
⦿	knit with CC
╱	k2tog with CC
╲	ssk with CC

SMALL SOLE

33 sts

5
3
1

LARGE SOLE

35 sts

5
3
1

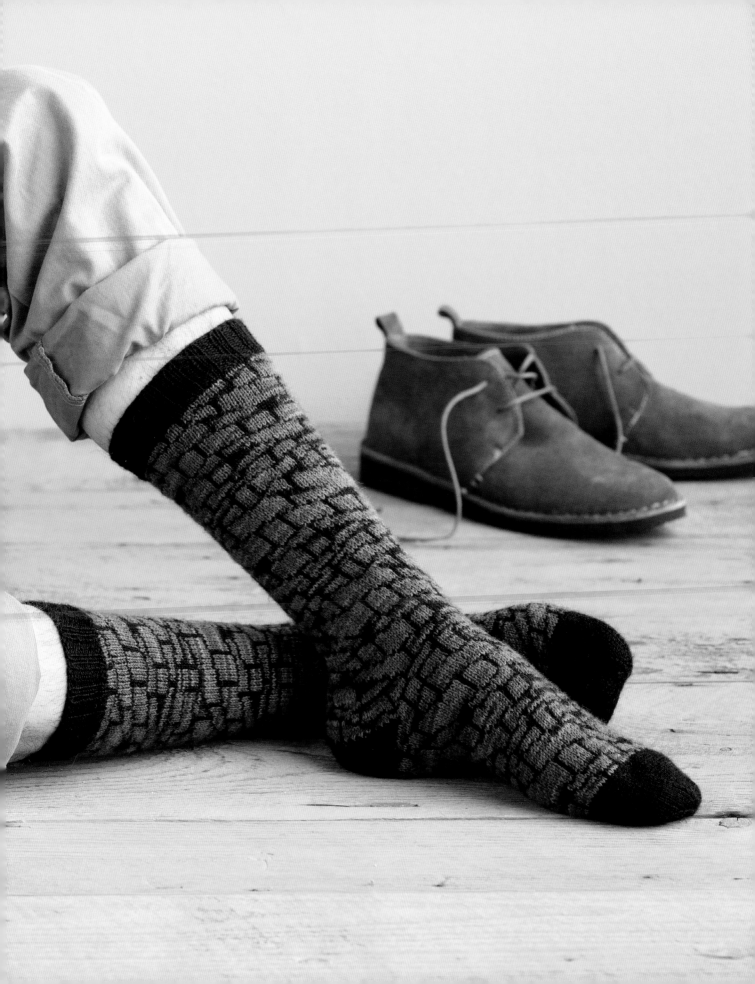

FINISHED SIZE
About 8¼ (9)" (21 [23] cm) foot circumference, unstretched, and 9¼ (11)" (23.5 [28] cm) foot length from back of heel to tip of toe (length is adjustable).

To fit U.S. women's shoe sizes 7–8 (men's 11½–12½); European shoe sizes 38–40 (45–46).

Brown-and-light-blue socks shown in women's size; black-and-variegated-brown socks shown in men's size.

Note: The model is wearing the women's right and left socks on the opposite feet.

YARN
Fingering weight (#1 Super Fine).

Shown here:
Trekking Sport 4-ply (75% new wool, 25% nylon; 459 yd [420 m]/100 g).

Trekking XXL (75% new wool, 25% nylon; 459 yd [420 m]/100 g).

Women's size shown in Sport 4-ply #1458 brown (MC) and #1497 light blue (CC), 1 ball each.

Men's size shown in Sport 4-ply #1437 black (MC) and Trekking XXL #493 variegated brown (CC), 1 ball each.

NEEDLES
Size U.S. 1 (2.25 mm): set of 5 double-pointed (dpn) and two 24" (60 cm) circular (cir).

Adjust needle size if necessary to obtain the correct gauge.

continued >>

Heinrich

Op art isn't restricted to just two-dimensional painting and graphics. In the middle of the previous century, more than a dozen companies in Germany produced op-art ceramics—particularly vases. Typically, they used bisque porcelain with a matte white or black finish that left the striking shapes unglazed and unadorned. Twentieth-century designers such as Heinrich Fuchs and Tapio Wirkkala focused on the way that light plays on the carved shapes of a cylinder. Over time, artists played with visuals and imitated nature in a surprising number of forms. Some vases suggest sea-pounded boulders, crystalline rock formations, tree bark, and shell and tide-pool structures.

The pattern in the socks shown here is reminiscent of the natural forms Heinrich Fuchs used in his art. These socks are worked with two circular needles, with the heel integrated into the leg pattern. The left and right socks are mirror images.

64

NOTIONS
Markers (m), tapestry needle.

GAUGE
32 sts and 40 rows/rnds = 4" (10 cm) in solid-color St st, after blocking; 32 sts and 48 rows/rnds = 4" (10 cm) in solid-color St st and relaxed after blocking.

35 sts and 40 rnds = 4" (10 cm) in charted patts worked in rnds after blocking and relaxed after blocking.

NOTE
× Different charts are used for the right and left socks.

Cuff
With MC, CO 64 (72) sts. Arrange sts evenly onto 4 dpn so that there are 16 (18) sts on each needle. Join for working in rnds, being careful not to twist sts.

Rib rnd: *K2, p2; rep from *.

Rep the rib rnd 13 (15) more times—14 (16) rnds total; piece measures 1 (1¼)" (2.5 [3.2] cm).

Leg
Cont for your size as foll:

Women's size only
Next rnd: With MC [k8, M1 (see Glossary)] 8 times—72 sts. Arrange sts evenly onto 3 dpn so that there are 24 sts on each needle.

Right sock: Work Rnds 1–34 of Women's Right Leg chart once.

Left sock: Work Rnds 1–34 of Women's Left Leg chart once.

Right and left socks: Piece measures 4½" (11.5 cm) from CO.

Men's size only
Next rnd: With MC, [k12, M1 (see Glossary)] 6 times—78 sts. Arrange sts evenly onto 3 dpn so that there are 26 sts on each needle.

Right sock: Work Rnds 1–34 of Men's Right Leg chart 2 times—68 chart rnds total.

Left sock: Work Rnds 1–34 of Men's Left Leg chart 2 times—68 chart rnds total.

Right and left socks: Piece measures 8" (20.5 cm) from CO.

× knit with MC

☐ knit with CC

☐ pattern repeat

WOMEN'S RIGHT LEG

WOMEN'S LEFT LEG

24-st repeat

24-st repeat

Heel Increases

Cont for your size as foll:

Women's size

Right sock: With Needle 1, work Rnd 1 of Women's Right Heel chart (page 66) over 24 sts; with Needles 2 and 3, cont in established patt from leg chart.

Left sock: With Needle 1, work Rnd 1 of Women's Left Heel chart (page 66) over 24 sts; with Needles 2 and 3, cont in established patt from leg chart.

Right and left socks: Cont in patt until Rnd 31 of heel chart has been completed, ending with Rnd 31 of leg chart—104 sts total; 56 heel sts on Needle 1, 24 sts each on Needles 2 and 3; piece measures 7½" (19 cm) from CO.

Men's size

Right sock: With Needle 1, work Rnd 1 of Men's Right Heel (page 68) chart over 26 sts; with Needles 2 and 3, cont in established patt from leg chart.

Left sock: With Needle 1, work Rnd 1 of Men's Left Heel chart (page 68) over 26 sts; with Needles 2 and 3, cont in established patt from leg chart.

Right and left socks: Cont in patt until Rnd 35 of heel chart has been completed, ending with Rnd 1 of leg chart—114 sts total; 62 heel sts on Needle 1, 26 sts each on Needles 2 and 3; piece measures 11½" (29 cm) from CO.

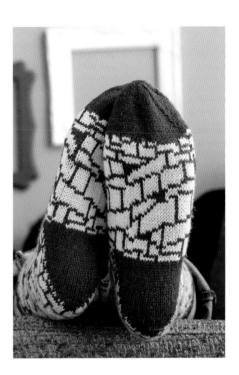

MEN'S RIGHT LEG

(colorwork chart, rows numbered at right: 1, 3, 5, 7, 9, 11, 13, 15, 17, 19, 21, 23, 25, 27, 29, 31, 33)

26-st repeat

MEN'S LEFT LEG

(colorwork chart, rows numbered at right: 1, 3, 5, 7, 9, 11, 13, 15, 17, 19, 21, 23, 25, 27, 29, 31, 33)

26-st repeat

WOMEN'S RIGHT HEEL

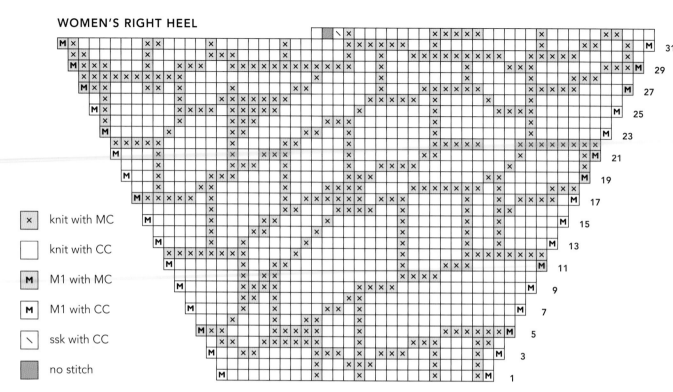

- × knit with MC
- ☐ knit with CC
- **M** M1 with MC
- M M1 with CC
- ＼ ssk with CC
- ☐ no stitch

24 sts inc'd to 56 sts

WOMEN'S LEFT HEEL

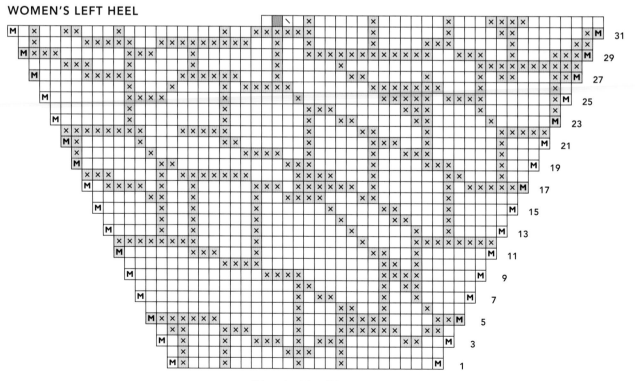

24 sts inc'd to 56 sts

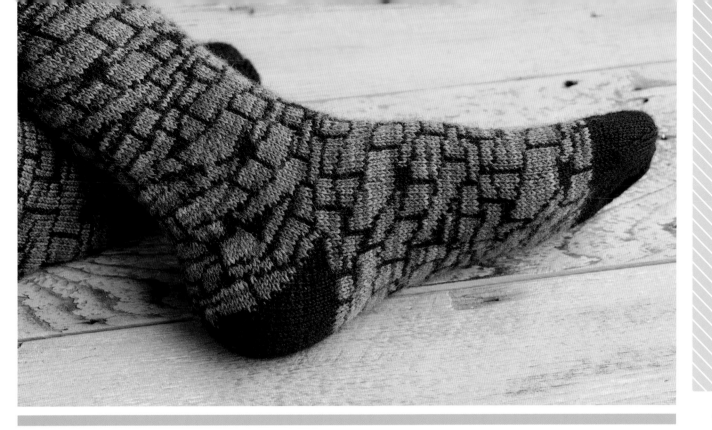

TURN HEEL (RIGHT AND LEFT SOCKS)

Set-up: Place 56 (62) heel sts on one cir needle. Sl the last 6 sts from Needle 3 onto the beg of heel needle, then sl the first 6 sts from Needle 2 onto the end of the heel needle. Place rem 18 (20) sts of Needle 2 and 18 (20) sts of Needle 3 onto a second cir needle to be worked later for instep—68 (74) sts on heel cir needle; 36 (40) instep sts on instep cir needle. The first slipped 6 sts on the heel needle were already worked at the end of the last complete rnd; MC and CC are attached to the 7th heel st.

Work short-rows as foll:

Short-row 1: (RS) Slip the first 6 heel sts purlwise without working them to where yarns are attached, then work Rnd 32 (36) of heel chart over next 32 (36) sts, dec them to 31 (35) sts as shown on chart, and stop there—37 (41) worked sts at beg of heel needle, 30 (32) unworked sts at end of heel needle. Cut CC and turn work.

Cont with MC only as foll:

Short-row 2: (WS) Sl 1, p3 (5), p2tog, p1, turn work—30 (32) sts rem unworked at end of needle.

Short-row 3: Sl 1, knit to 1 st before gap formed on previous RS row, ssk (1 st each side of gap), k1, turn work.

Short-row 4: Sl 1, purl to 1 st before gap formed on previous WS row, p2tog (1 st each side of gap), p1, turn work.

Rep the last 2 rows 14 (15) more times—36 (40) heel sts rem.

foot

Rearrange sts to resume knitting in the rnd on dpn for your size as foll:

Women's size

With RS facing, knit the first 6 heel sts with MC and slip them onto the end of the instep cir needle, knit the next 24 heel sts onto a single dpn, then slip the rem 6 heel sts onto the other end of instep cir needle—24 heel sts on one dpn; 48 instep sts on cir needle. Divide instep sts evenly onto 2 dpn—72 sts total; 24 sts each needle; MC is at end of heel needle; rejoin CC in the same place.

Right sock: With Needle 1, *work Rnd 32 of Women's Right Leg chart over 24 sts; rep from * 2 more times for Needle 2 and Needle 3.

Left sock: With Needle 1, *work Rnd 32 of Women's Left Leg chart over 24 sts; rep from * 2 more times for Needle 2 and Needle 3.

Men's size

With RS facing, knit the first 6 heel sts with MC and slip them onto the end of the instep cir needle; work the next 28 heel sts onto a single dpn as k6, k2tog, k12, k2tog, k6 to dec them to 26 sts; then slip the rem 6 heel sts onto other end of instep cir needle—26 heel sts on one dpn; 52 instep sts on cir needle. Divide instep sts evenly onto 2 dpn—78 sts total; 26 sts each needle. MC is at end of heel needle; rejoin CC in the same place.

MEN'S RIGHT HEEL

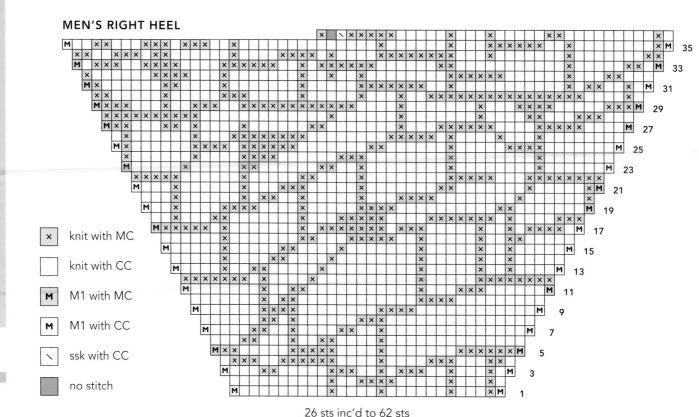

×		knit with MC
		knit with CC
M		M1 with MC
M		M1 with CC
\		ssk with CC
		no stitch

26 sts inc'd to 62 sts

MEN'S LEFT HEEL

26 sts inc'd to 62 sts

Right sock: With Needle 1, *work Rnd 2 of Men's Right Leg chart over 26 sts; rep from * 2 more times for Needle 2 and Needle 3.

Left sock: With Needle 1, *work Rnd 2 of Men's Left Leg chart over 26 sts; rep from * 2 more times for Needle 2 and Needle 3.

Both sizes

Right and left socks: Cont in established patt from leg chart until foot measures 7 (8¾)" (18 [22] cm) from center back heel, or 2¼" (5.5 cm) less than desired total length for both sizes.

Toe

Cut CC. Cont with MC only.

Knit 1 rnd.

Work according to your size as foll:

Women's size

Right and left socks, next rnd: [K12, place marker (pm), k12] 3 times—1 marker (m) in center of each dpn.

Men's size

Right sock, next rnd: [Ssk, k11, place marker (pm), ssk, k11] 3 times—72 sts rem; 24 sts each needle; 1 marker (m) in center of each dpn.

Left sock, next rnd: [K11, k2tog, pm, k11, k2tog] 3 times—72 sts rem; 24 sts each needle; 1 m in center of each dpn.

Both sizes

Knit 4 rnds even.

Right sock dec rnd: [Ssk, knit to m, slip marker (sl m), ssk, knit to end of needle] 3 times—6 sts dec'd: 2 sts dec'd each needle.

Left sock dec rnd: [Knit to 2 sts before m, k2tog, sl m, knit to last 2 sts on needle, k2tog] 3 times—6 sts dec'd: 2 sts dec'd each needle.

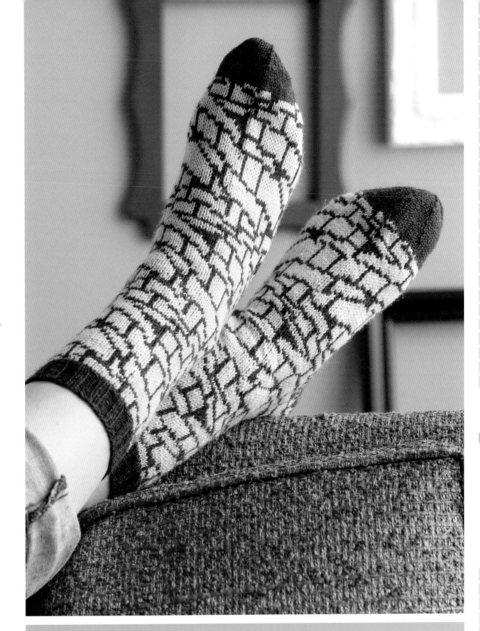

Right and left socks: Knit 3 rnds even, then rep dec rnd—60 sts rem for both sizes; 20 sts each needle.

[Knit 2 rnds even, then rep dec rnd] 2 times—48 sts rem; 16 sts each needle.

[Knit 1 rnd even, then rep dec rnd] 4 times—24 sts rem; 8 sts each needle.

Rep dec rnd every rnd 3 times—6 sts rem; 2 sts each needle; toe measures about 2¼" (5.5 cm) from last rnd of charted patt.

finishing

Cut yarn, leaving an 8" (20.5 cm) tail. Thread tail onto a tapestry needle, draw through rem sts, pull tight to close hole, and fasten off on WS.

Weave in loose ends.

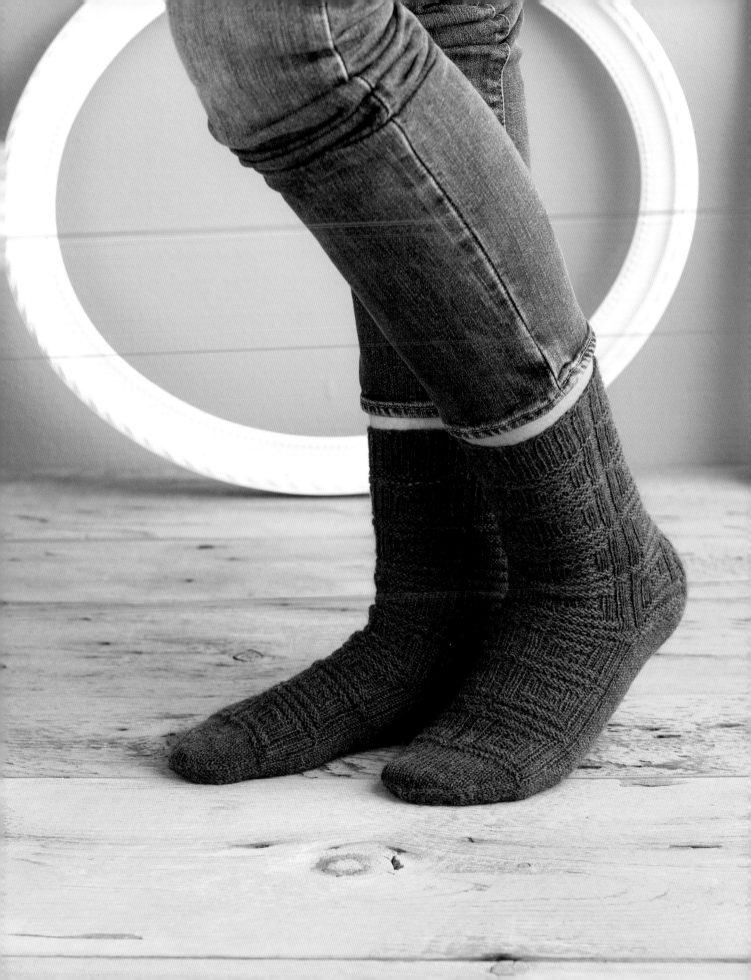

FINISHED SIZE
About 7½ (8)" (19 [20.5] cm) foot circumference, unstretched, and 9¾ (11)" (25 [28] cm) foot length from back of heel to tip of toe.

To fit U.S. women's shoe sizes 8–9 (men's U.S. shoe sizes 10½–11½); European shoe sizes 39–41 (45–46).

Gray socks shown in women's size; green socks shown in men's size.

YARN
Fingering weight (Super Fine #1).

Shown here: Trekking Sport 4-ply (75% new wool, 25% nylon; 459 yd [420 m]/100 g): 1 ball for either size. Shown in #1460 charcoal grey and #1465 pine green.

NEEDLES
Size U.S. 1 (2.25 mm): two 24" (60 cm) circular (cir).

Adjust needle size if necessary to obtain the correct gauge.

NOTIONS
Tapestry needle.

GAUGE
32 sts and 40 rows/rnds = 4" (10 cm) in St st and in charter textured patts, after blocking; 34 sts and 48 rows/rnds = 4" (10 cm) in St st and in charted textured patts and relaxed after blocking.

Bora

When stripes, curves, or figures filled with alternating black and white lines join up so that every black line of one figure meets a white line of another, the eye of the viewer creates a new line—either straight or curved, depending on how the artist fits the figures together. Victor Vasarely (1906–1997) used this effect in his Bora series in 1964.

For this sock design, named after Victor Vasarely's Bora series, I worked the pattern in knit and purl stitches, making the pair quite easy to knit. You can learn how to read charts *en passant* and create a stunning bit of op art for your feet!

Cuff

CO 64 (68) sts. Arrange sts evenly onto two cir needles—32 (34) sts on each needle. Join for working in rnds, being careful not to twist sts. Work cuff patt for your size as foll:

Women's size only

Next rnd: [P1, k2] 5 times, p2, [k2, p1] 5 times; rep from * once more.

Men's size only

Next rnd: *P1, [k2, p1] 4 times, k2, p3, k2, [p1, k2] 4 times, p2; rep from * once more.

Both sizes

Rep the last rnd 15 more times—16 cuff rnds total; piece measures 1½" (3.8 cm).

Leg

Cont in St st (knit all rnds), work leg for your size as foll:

Women's size only

Work Rnds 1–40 of Women's Leg and Instep chart (page 74) once—piece measures 4¾" (12 cm) from CO.

Men's size only

Work Rnds 1–42 of Men's Leg and Instep chart (page 74) once—piece measures 5" (12.5 cm) from CO.

Heel

Note: Work M1 increases in charts as M1L (left slant, see Glossary); work M1P increases as M1L purlwise (see Glossary).

Set up heel for your size as foll:

Women's size only

With Needle 1, work Rnd 1 of Women's Heel chart over 32 sts; with Needle 2, work Rnd 1 of Women's Leg and Instep chart as established over 32 sts.

MEN'S HEEL

34 sts inc'd to 75 sts

☐	knit
•	purl
M	M1
P	M1P
▨	no stitch
⌣	work [k1, p1, k1] all in same st

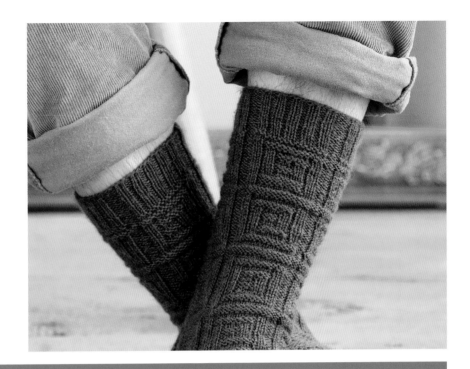

WOMEN'S HEEL

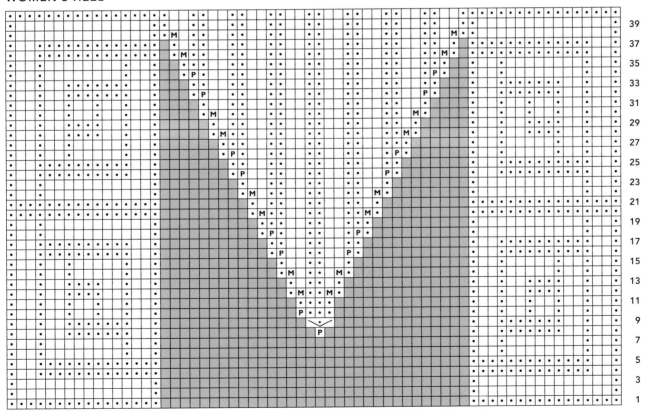

39
37
35
33
31
29
27
25
23
21
19
17
15
13
11
9
7
5
3
1

32 sts inc'd to 64 sts

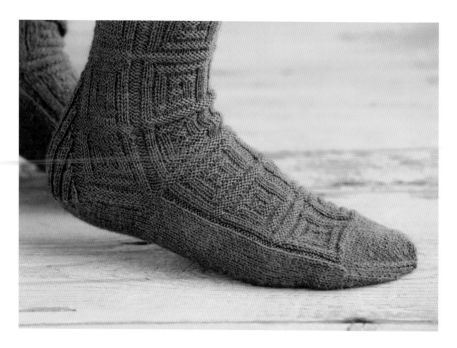

Men's size only

With Needle 1, work Rnd 1 of Men's Heel chart (page 72) over 34 sts; with Needle 2, work Rnd 1 of Men's Leg and Instep chart as established over 34 sts.

Both sizes

Cont in established patts until Rnd 40 (43) of the heel chart has been completed, ending with Rnd 40 (1) of the Leg and Instep chart—96 (109) sts total: 64 (75) heel sts on Needle 1, 32 (34) instep sts on Needle 2.

	knit
·	purl
	pattern repeat

WOMEN'S LEG AND INSTEP

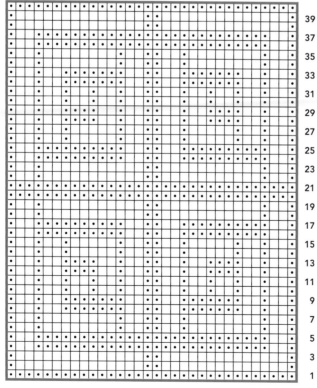

32-st repeat

MEN'S LEG AND INSTEP

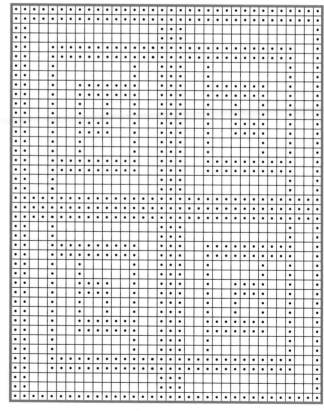

34-st repeat

Men's size only

Unknit the last st at end of Needle 2 and slip this st onto the beg of Needle 1—76 heel sts on Needle 1, 33 instep sts on Needle 2.

TURN HEEL

Work heel sts back and forth in rows on 64 (76) sts of Needle 1 for your size as foll:

Women's size only

Short-row 1: (RS) P17, [k2, p2] 4 times, k2, p1, ssk, k1, turn work.

Short-row 2: (WS) Sl 1, p9, p2tog, p1, turn work.

Short-row 3: Sl 1, knit to 1 st before gap formed by previous RS row, ssk, k1, turn work.

Short-row 4: Sl 1, purl to 1 st before gap formed by previous WS row, p2tog, p1, turn work.

Short-rows 5–22: Rep the last 2 rows 9 more times—42 heel sts rem.

Short-row 23: Sl 1, knit to 1 st before gap formed by previous RS row, ssk, turn work.

Short-row 24: Sl 1, purl to 1 st before gap formed by previous WS row, p2tog, turn work.

Short-rows 25–32: Rep the last 2 rows 4 more times—32 heel sts rem.

Men's size only

Short-row 1: (RS) P19, [k2, p2] 5 times, k2, ssk, k1, turn work.

Short-row 2: (WS) Sl 1, p7, p2tog, p1, turn work.

Short-row 3: Sl 1, knit to 1 st before gap formed by previous RS row, ssk, k1, turn work.

Short-row 4: Sl 1, purl to 1 st before gap formed by previous WS row, p2tog, p1, turn work.

Short-rows 5–22: Rep the last 2 rows 9 more times—54 heel sts rem.

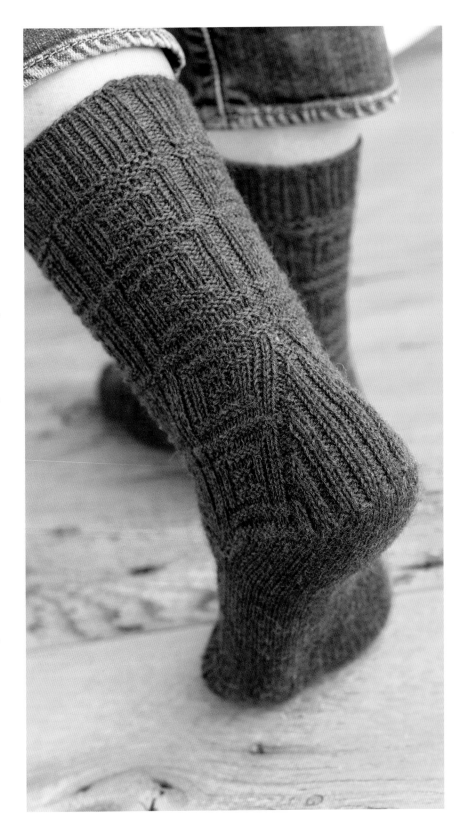

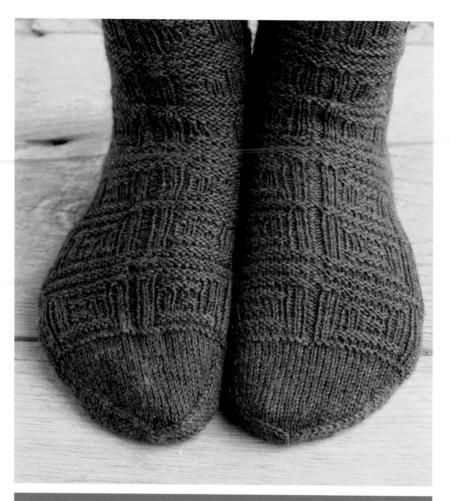

of Leg and Instep chart—140 (147) total rnds of Leg and Instep chart from beg; foot measures about 7¾ (8½)" (19.5 [21.5] cm) from center back heel.

Note: For a longer foot, work all sts even in St st until foot measures 2 (2½)" (5 [6.5] cm) less than desired length.

Toe

Men's size only

Next rnd: Knit 1 rnd even.

Next rnd: With Needle 1, k34; with Needle 2, k16, k2tog, k17—68 sts rem; 34 sts each needle.

Both sizes

Knit 1 rnd even.

Dec rnd: On Needle 1, *k1, ssk, knit to last 3 sts, k2tog, k1; on Needle 2, rep from * —4 sts dec'd; 2 sts dec'd each needle.

Knit 3 rnds even, then rep dec rnd—56 (60) sts rem: 28 (30) sts each needle.

[Knit 2 rnds even, then rep dec rnd] 2 times—48 (52) sts rem: 24 (26) sts each needle.

[Knit 1 rnd even, then rep dec rnd] 3 (4) times—36 sts rem for both sizes: 18 sts each needle.

Rep dec rnd every rnd 7 times—8 sts rem; 4 sts each needle; toe measures about 2 (2½)" (5 [6.5] cm).

finishing

Cut yarn, leaving an 8" (20.5 cm) tail. Thread tail onto tapestry needle, draw through rem sts, pull tight to close hole, and fasten off on WS.

Weave in loose ends.

Short-row 23: Sl 1, knit to 1 st before gap formed by previous RS row, ssk, turn work.

Short-row 24: Sl 1, purl to 1 st before gap formed by previous WS row, p2tog, turn work.

Short-rows 25–40: Rep last 2 rows 8 more times—36 heel sts rem.

Slip the last heel st at end of Needle 1 onto the beg of Needle 2, then unknit the first st at beg of Needle 1 and slip it onto the end of Needle 2—34 heel sts rem on Needle 1; 35 instep sts on Needle 2.

foot

Resume working in rnds as foll:

Next rnd: With Needle 1, k32 (34) sole sts; with Needle 2, p0 (1), work Rnd 1 (2) of Leg and Instep chart as established over 32 (34) instep sts—64 (69) sts; 32 (34) sole sts on Needle 1, 32 (35) instep sts on Needle 2.

Working the sole sts on Needle 1 in St st and working p0 (1) before chart patt at beg of instep sts on Needle 2, cont in established patts for 59 (61) more rnds, ending with Rnd 20 (21)

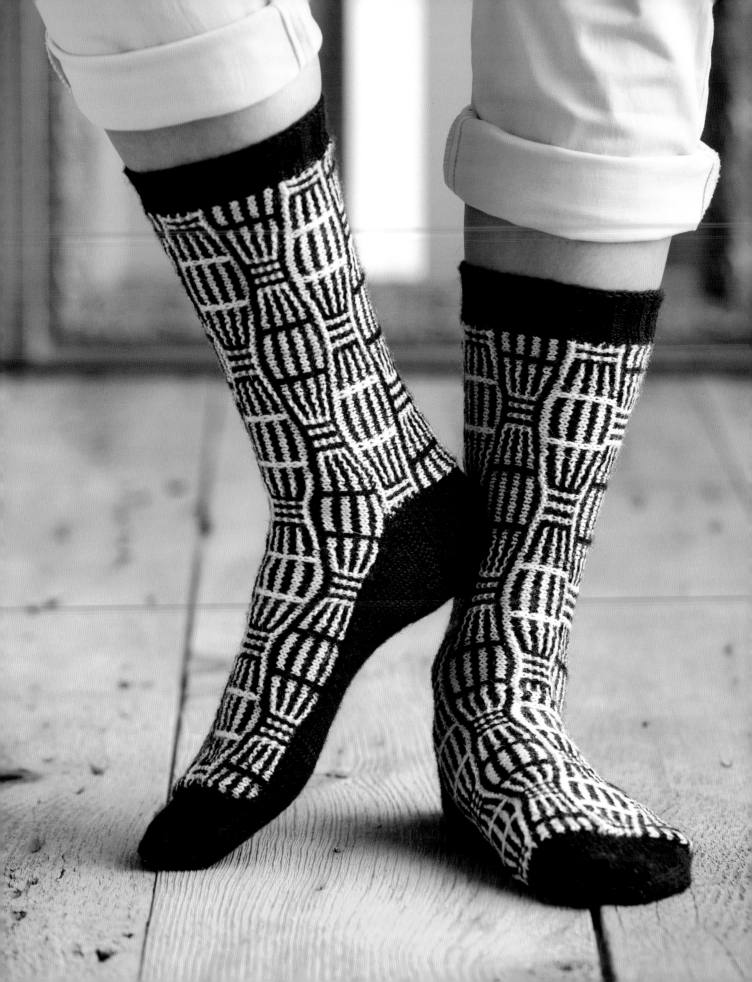

FINISHED SIZE

About 7¼ (7½, 7½, 7¾)" (18.5 [19, 19, 19.5] cm) foot circumference, unstretched, and 8¾ (9½, 9¾, 10½)" (22 [24, 25, 26.5] cm) foot length from back of heel to tip of toe (length is adjustable).

To fit U.S. women's shoe sizes 6–7 (7½–8, 8½–9½, men's 9–10); European shoe sizes 37–38 (39–40, 41–42, 43–44).

Socks shown measure 9½" (24 cm) in foot length.

YARN

Fingering weight (#1 Super Fine).

Shown here: Trekking Sport 4-ply (75% new wool, 25% nylon; 459 yd [420 m]/100 g): #1437 black (MC) and #1400 white (CC), 1 ball each for all sizes.

NEEDLES

Size U.S. 1 (2.25 mm): three 24" (60 cm) circular (cir).

Adjust needle size if necessary to obtain the correct gauge.

NOTIONS

Size C/2 (3 mm) crochet hook; tapestry needle.

GAUGE

32 sts and 40 rows/rnds = 4" (10 cm) in solid-color St st, after blocking; 36 sts and 46 rows/rnds = 4" (10 cm) in solid-color St st and relaxed after blocking.

34 sts and 72 rows = 4" (10 cm) in charted mosaic patt after blocking and relaxed after blocking.

When you modify a two-dimensional pattern so that at some points the lines are brought together and at others stretched apart, you can create a stunning three-dimensional effect. Victor Vasarely (1906–1997) used this effect in his 1963 work *Feny*.

For this sock pattern, named after Victor Vasarely's work *Feny*, I combined the slip-stitch mosaic technique—to compress the horizontal lines—with shadow knitting—to emphasize bright and clear lines that highlight where they're wide and stretched. The colorwork leg and instep are worked flat in rows, then the heel, sole, and toe are joined in the main color.

NOTES

- ✕ The leg and instep are worked from side to side according to the Mosaic chart, then the instep stitches are allowed to rest on one circular needle while the leg stitches continue in pattern on a second circular needle for the back of the leg; finally, the live leg stitches are grafted to the corresponding provisionally cast-on stitches to form the leg tube.

- ✕ The charted mosaic pattern alternates two rows of each color. The color of the first stitch indicates which color to use for the entire row. For the socks shown, the unused color was carried up along the edge of the work until it was needed again.

- ✕ To maintain a tidy edge when joining the sole and instep, be sure to keep the tension snug on the adjacent stitches.

Leg and Instep

With CC and crochet hook, make a very loose crochet chain (see Glossary) of about 124 sts. With MC, cir needle, and beg about 8 chain sts from one end, pick up and purl (see Glossary) 1 st from the "bump" in the back of the next 107 chain sts, taking care not to split CC yarn as you go—107 sts on cir needle (these sts reach all the way from the base of the ribbed cuff to the start of the toe and form the front of the leg and the instep).

FRONT OF LEG AND INSTEP

Beg with RS Row 3, work Rows 3–36 of Mosaic chart (see Notes) once, then work Rows 1–36 once more—70 total chart rows; piece measures about 4" (10 cm).

BACK OF LEG

Next row: (RS) Using a second cir needle, work Row 1 of Mosaic chart over first 54 sts, M1 (see Glossary), turn work—55 leg sts on new cir needle; 53 unworked sts rem on first cir needle to be worked later for the sole.

▨	with MC, knit on RS; purl on WS
·	with MC, knit on WS
V	sl 1 MC st pwise wyb on RS; pwise wyf on WS
☐	with CC, knit on RS; purl on WS
·	with CC, knit on WS
V	sl 1 CC st pwise wyb on RS; pwise wyf on WS
☐	pattern repeat

MOSAIC

26-st repeat

Cont in established patt on leg sts, work Rows 2–36 of chart, then work Rows 1–36 once more—142 total chart rows; piece measures about 8" (20.5 cm) from CO.

With RS facing, mark the selvedge at the beginning of the back-of-leg rows as the cuff edge and mark the selvedge at the end of the back-of-leg rows as the heel edge to indicate where to pick up sts for the cuff and heel later.

Cut CC, leaving an 8" (20.5 cm) tail, then cut MC, leaving a 32" (81.5 cm) tail for grafting the leg.

GRAFT LEG

Remove waste yarn from provisional CO and carefully place 106 exposed sts onto a third cir needle. Hold needles parallel with WS facing tog, the needle with the live back-of-leg sts in front, and the needle with the sts from the CO in back. With MC tail threaded on a tapestry needle, use Kitchener st (see Glossary) to join the 55 live leg sts on the front needle to the first 54 CO sts on the back needle, forming a tube for the leg—52 sts from CO rem on back needle.

Heel and Sole Set-up

Notes: *The heel and sole are worked back and forth in rows in solid-color stockinette. The heel stitches are picked up along the heel edge of the leg tube and worked with a conventional heel flap and heel turn. At the point where an in-the-round sock would resume working on all stitches, the sole stitches of this sock are worked back and forth in rows, joining one sole stitch to one live instep stitch at the end of each row until all the instep stitches have been used up.*

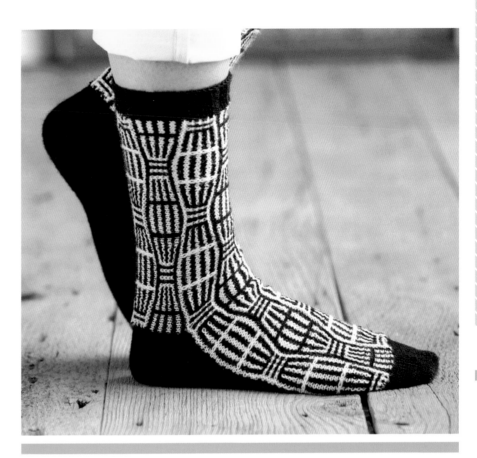

Hold piece horizontally with completed leg tube on your left and the instep flap extending to your right. With RS facing, mark the short selvedge of the instep extension as the toe edge to indicate where to pick up sts for the toe later.

With RS facing, join MC to beg of 52 sts on needle from provisional CO at toe edge. Working from the toe edge toward the leg tube, work across these sts for your size as foll:

U.S. Women's 6–7 only
Dec row: (RS) K1, *[k2tog] 2 times, k1 times; rep from * to last 6 sts, [k2tog] 3 times—31 sts rem.

U.S. Women's 7½–8 only
Dec row: (RS) K2, k2tog, k1, *[k2tog] 2 times, k1; rep from * to last 2 sts, k2—33 sts rem.

U.S. Women's 8½–9½ only
Dec row: (RS) *K1, k2tog; rep from * to last st, k1—35 sts rem.

U.S. Men's 9–10 only
Dec row: (RS) K2, *k2tog, k2, [k2tog, k1] 3 times; rep from * to last 11 sts, k2tog, k2, [k2tog, k1] 2 times, k1—37 sts rem.

All sizes
With RS still facing and using an empty cir needle, pick up and knit 30 (32, 32, 34) sts evenly spaced along back-of-leg selvedge marked as the heel edge.

With RS still facing and using the same cir needle holding the live sts, knit across the 53 live sts from last row of instep—31 (33, 35, 37) sts on first needle for left side of instep; 30 (32, 32, 34) sts on second needle for heel; 53 sts on third needle for right side of instep.

Turn work so WS is facing. Working from the toe edge toward the leg tube, dec the sts on the right instep needle for your size as foll:

U.S. Women's 6–7 only
Dec row: (WS) [P2tog] 3 times, *p1, [p2tog] 2 times; rep from * to last 2 sts, p2tog—31 sts rem.

U.S. Women's 7½–8 only
Dec row: (WS) P1, p2tog, *p1, [p2tog] 2 times; rep from * to last 5 sts, p1, p2tog, p2—33 sts rem.

U.S. Women's 8½–9½ only
Dec row: (WS) P2tog, *p1, p2tog; rep from *—35 sts rem.

U.S. Men's 9–10 only
Dec row: (WS) *[P1, p2tog] 3 times, p2, p2tog; rep from * to last st, p1—37 sts rem.

All sizes
Stop after completing the WS dec row on right instep needle—92 (98, 102, 108) sts total: 31 (33, 35, 37) sts on each instep needle, 30 (32, 32, 34) heel sts on center needle.

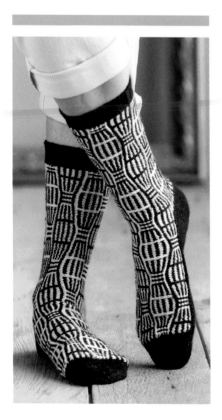

Heel

Work back and forth in rows on 30 (32, 32, 34) sts of heel needle as foll:

HEEL FLAP
Set-up row: (WS) K3, purl to last 3 sts, k3.

Row 1: (RS) Knit.

Row 2: (WS) K3, purl to last 3 sts, k3.

Rep the last 2 rows 13 (14, 14, 15) more times—29 (31, 31, 33) total heel-flap rows; 15 (16, 16, 17) garter ridges along each selvedge.

TURN HEEL
Work short-rows as foll:

Short-row 1: (RS) K17 (17, 17, 19), ssk, k1, turn work.

Short-row 2: (WS) Sl 1, p5 (3, 3, 5), p2tog, p1, turn work.

Short-row 3: Sl 1, knit to 1 st before gap formed on previous RS row, ssk (1 st each side of gap), k1, turn work.

Short-row 4: Sl 1, purl to 1 st before gap formed on previous WS row, p2tog (1 st each side of gap), p1, turn work.

Rep the last 2 rows 4 (5, 5, 5) more times—18 (18, 18, 20) heel sts rem.

Gussets

Set-up Row 1: (RS) With heel nee-dle, work 18 (18, 18, 20) heel sts as sl 1, k17 (17, 17, 19), then pick up and knit 15 (16, 16, 17) sts along side of heel flap (1 st for each garter ridge), turn work.

Set-up Row 2: (WS) Sl 1, purl to end of heel sts, then pick up and purl (see Glossary) 15 (16, 16, 17) sts along other side of heel flap (1 st for each garter ridge), turn work—48 (50, 50, 54) sole sts on center needle; 31 (33, 35, 37) sts on each instep needle.

Work back and forth in rows on sole sts, dec for gussets and joining to instep sts as foll:

Row 1: (RS) Sl 1, k1, ssk, knit to last 4 sole sts, k2tog, k1, ssk (last sole st tog with first st from instep needle), turn work—2 sole sts dec'd, 1 st joined from right instep needle.

Row 2: (WS) Sl 1, purl to last sole st, p2tog (last sole st tog with first st from left instep needle), turn work—1 st joined from left instep needle.

Rep these 2 rows 8 (8, 8, 9) more times—30 (32, 32, 34) sole sts rem on center needle; 22 (24, 26, 27) sts rem on each instep needle.

Sole

Work even in rows on sole sts while cont to join instep sts as foll:

Row 1: (RS) Sl 1, knit to last sole st, ssk (last sole st tog with first st of instep needle), turn work—1 st joined from right instep needle.

Row 2: (WS) Sl 1, purl to last sole st, p2tog (last sole st tog with first st of instep needle), turn work—1 st joined from left instep needle.

Rep these 2 rows 21 (23, 25, 26) more times—30 (32, 32, 34) sole sts rem; all instep sts have been joined; foot measures about 6½ (7¼, 7½, 8)" (16.5 [18.5, 19, 20.5] cm) from center back heel.

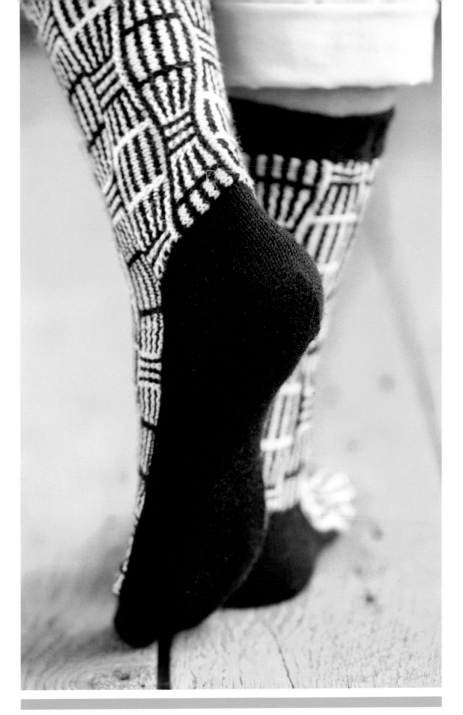

Note: *For a longer foot, work more rounds even here before beginning the toe decreases; every 3 rounds added will lengthen the foot by about ¼" (6 mm).*

Dec rnd: With Needle 1, *k1, ssk, knit to last 3 sts, k2tog, k1; with Needle 2, rep from *—4 sts dec'd.

Knit 3 rnds even, then rep dec rnd—52 (56, 56, 60) sts rem; 26 (28, 28, 30) sts each needle.

[Knit 2 rnds even, then rep dec rnd] 2 (2, 2, 3) times—44 (48, 48, 48) sts rem; 22 (24, 24, 24) sts each needle.

[Knit 1 rnd, then rep dec rnd] 3 (4, 4, 4) times—32 sts rem for all sizes; 16 sts each needle.

Rep dec rnd every rnd 6 times—8 sts rem; 4 sts each needle.

Finishing

Cut yarn, leaving an 8" (20.5 cm) tail. Thread tail onto tapestry needle, draw through rem sts, pull tight to close hole, and fasten off on WS.

CUFF

With MC and RS facing, pick up and knit 60 (64, 64, 68) sts evenly spaced around cuff edge of leg opening. Arrange sts as 30 (32, 32, 34) sts each on two cir needles and join for working in rnds.

Rib rnd: *K2, p2; rep from *.

Rep the rib rnd 13 (15, 15, 17) more times—14 (16, 16, 18) rnds total; cuff measures about 1¼ (1½, 1½, 1¾)" (3.2 [3.8, 3.8, 4.5] cm) from pick-up rnd.

BO loosely as foll: K1, *yo, k1, use left needle tip to pull yo and first st over the second st and off the needle; rep from * until 1 st rem, then fasten off last st.

Weave in loose ends.

Toe

Note: *The toe is worked in solid-color stockinette in rounds on the live sole stitches and stitches picked up along the toe edge of the instep.*

Set-up rnd: With RS facing and using an empty cir needle (Needle 1), k30 (32, 32, 34) sole sts, then with another cir needle (Needle 2), pick up and knit 30 (32, 32, 34) sts evenly along toe edge of instep—60 (64, 64, 68) sts total; 30 (32, 32, 34) sts each needle.

Join for working in rnds.

Knit 2 rnds even.

FINISHED SIZE
About 8" (20.5 cm) foot circumference, unstretched, and 9½ (10¼)" (24 [26] cm) foot length from back of heel to tip of toe (length is adjustable).

To fit U.S. women's shoe sizes 7½–8½ (9½–10½); European shoe sizes 39–40 (41–43).

Socks shown measure 10¼" (26 cm) in foot length.

YARN
Fingering weight (Super Fine #1).

Shown here: Trekking Sport 4-ply (75% new wool, 25% nylon; 459 yd [420 m]/100 g): #1430 navy blue (MC) and #1423 violet (CC), 1 ball each for both sizes.

NEEDLES
Size U.S. 1 (2.25 mm): two 24" (60 cm) circular (cir).

Adjust needle size if necessary to obtain the correct gauge.

NOTIONS
Tapestry needle.

GAUGE
32 sts and 40 rnds = 4" (10 cm) in solid-color St st worked in rnds, after blocking; 32 sts and 49 rnds = 4" (10 cm) in solid-color St st worked in rnds and relaxed after blocking.

35 sts and 40 rnds = 4" (10 cm) in charted patts worked in rnds, after blocking; 36 sts and 46 rnds = 4" (10 cm) in charted patts worked in rnds and relaxed after blocking.

Bridget

This pattern is generated with diagonally shifted recurring waves (not recommended viewing for those who suffer from motion sickness). As your eye focuses on the design, the flat surface appears to heave and ripple. After a while, the whole world seems to shift like a ship at sea. This effect is intensified by the degree of contrast between the two colors. Bridget Riley (born 1931), one of the most famous op-art artists, used this effect for her Arrest series in 1965.

The socks shown here, named after Bridget Riley, are worked in stranded colorwork in rounds. The pattern unit is mirrored horizontally at the ankle and vertically for the right and left socks.

STITCH GUIDE

K2, P2 Cuff Pattern (multiple of 4 sts)

All rnds: *K2, p2; rep from *.

NOTE

× Different charts are used for the right and left sock. The diagonal slant of the waves reverses direction when you switch from the leg chart to the foot chart for each sock.

Cuff

Cut a 40" (100.5 cm) length of CC and set aside to use later for marking the position of the afterthought heel.

With MC, CO 64 sts for both sizes. Arrange sts evenly onto two cir needles—32 sts on each needle. Join for working in rnds, being careful not to twist sts.

Work in k2, p2 cuff patt (see Stitch Guide) for 16 rnds—piece measures 1½" (3.8 cm).

Leg

Set-up rnd: With MC, [k8, M1 (see Glossary)] 8 times—72 sts; 36 sts each needle.

Join CC and cont for right or left sock as foll:

Right sock only
Work Rnds 1–18 of Right Leg chart 4 times—72 rnds total.

Left sock only
Work Rnds 1–18 of Left Leg chart 4 times—72 rnds total.

Both socks
Leg measures about 7¾" (19.5 cm) from CO.

Heel

Using the cut length of CC, knit the 36 sts on Needle 1 to mark the position of the afterthought heel. Slide the sts back to the other end of the needle, ready to resume working with the main strands of MC and CC that are still attached at the beg of the needle.

Foot

Work each sock as foll:

Right sock only
Rep Rnds 1–18 of Right Foot chart until foot measures 5¼ (6)" (13.5 [15] cm) from marked heel sts, or 4¼" (11 cm) less than desired total foot length.

Left sock only
Rep Rnds 1–18 of Left Foot chart until piece measures 5¼ (6)" (13.5 [15] cm) from marked heel sts, or 4¼" (11 cm) less than desired total foot length.

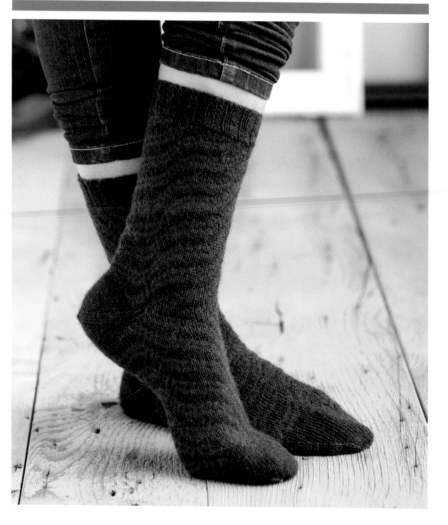

Toe

Cut CC. With MC, knit 1 rnd. Cont as foll:

Set-up rnd: [K7, k2tog] 8 times—64 sts rem; 32 sts each needle.

Dec rnd: On Needle 1, *k1, ssk, knit to last 3 sts, k2tog, k1; on Needle 2, rep from *—4 sts dec'd; 2 sts dec'd each needle.

Knit 3 rnds even, then rep dec rnd—56 sts rem; 28 sts each needle.

[Knit 2 rnds even, then rep dec rnd] 2 times—48 sts rem; 24 sts each needle.

[Knit 1 rnd even, then rep dec rnd] 3 times—36 sts rem; 18 sts each needle.

Rep dec rnd every rnd 7 times—8 sts rem; 4 sts each needle; toe measures about 2" (5 cm).

Cut yarn, leaving an 8" (20.5 cm) tail. Thread tail onto tapestry needle, draw through rem sts, pull tight to close hole, and fasten off on WS.

Bridget

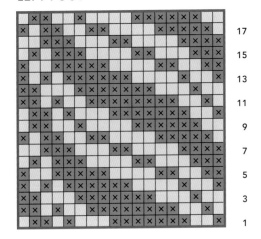

	knit with MC
	knit with CC
	pattern repeat

RIGHT FOOT

18-st repeat

LEFT FOOT

18-st repeat

RIGHT LEG

18-st repeat

LEFT LEG

18-st repeat

Heel

Carefully remove CC yarn marking the heel position and place 36 exposed leg sts on Needle 1 and 35 exposed sole sts on Needle 2—71 sts total.

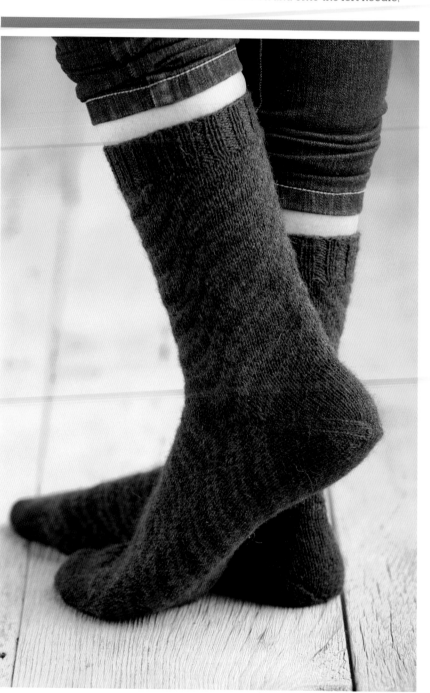

With RS facing, join MC to beg of sts on Needle 1. Cont as foll:

Set-up rnd: With Needle 1, k35, sl 1 kwise, insert the left needle tip from back to front under the horizontal strand between the two needles and lift the strand onto the left needle,

return the slipped st to the left needle and k2tog (slipped st tog with lifted strand); with Needle 2, k35, then insert the left needle tip from front to back under the horizontal strand between the two needles and knit the lifted strand through its back loop—72 sts: 36 sts each needle.

Knit 1 rnd even.

Dec rnd: With Needle 1, *k1, ssk, knit to last 3 sts, k2tog, k1; with Needle 2, rep from *—4 sts dec'd; 2 sts dec'd each needle.

[Knit 3 rnds even, then rep dec rnd] 2 times—60 sts rem; 30 sts each needle.

[Knit 2 rnds even, then rep dec rnd] 2 times—52 sts rem; 26 sts each needle.

[Knit 1 rnd even, then rep dec rnd] 3 times—40 sts rem; 20 sts each needle.

Rep dec rnd every rnd 5 times—20 sts rem; 10 sts each needle.

Next rnd: On Needle 1, *ssk, knit to last 2 sts, k2tog; on Needle 2, rep from *—16 sts rem: 8 sts each needle; heel measures about 2¼" (5.5 cm).

Cut yarn, leaving an 8" (20.5 cm) tail. Thread tail onto tapestry needle, draw through rem sts, pull tight to close hole, and fasten off on WS.

Finishing

Weave in loose ends. Block lightly.

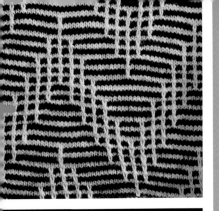

Ludwig

Mosaic knitting patterns play with two-colored grids and overlapping lines, which predestines them for easy op-art interpretation. Single slipped stitches (worked in the main color) form vertical interruptions to a background of simple horizontal stripes that alternate two rounds each of a main color and a contrasting color. Ludwig Wilding (1927–2010) used similar effects in his retrospective exhibit Visual Phenomena.

In this sock design, named after Ludwig Wilding, the vertical lines that the slipped stitches produce are arranged in chevrons that travel to the toe of each sock. This simple pattern is ideal for beginning sock knitters.

FINISHED SIZE
About 7½ (8¾)" (19 [22] cm) foot circumference, unstretched, and 9¼ (10¾)" (23.5 [27.5] cm) foot length from back of heel to tip of toe (length is adjustable).

To fit U.S. women's shoe sizes 7–8 (men's 9½–10½); European shoe sizes 40–41 (43–45).

Socks shown measure 9¼" (23.5 cm) in foot length.

YARN
Fingering weight (#1 Super Fine).

Shown here: Trekking Sport 4-ply (75% new wool, 25% nylon; 459 yd [420 m]/100 g): #1498 grey (MC), 1 ball for both sizes.

Trekking XXL (75% superwash wool, 25% nylon; 459 yd [420 m]/100 g): #515 multicolored blue (CC), 1 ball for both sizes.

NEEDLES
Size U.S. 1 (2.25 mm): two 24" (60 cm) circular (cir).

Adjust needle size if necessary to obtain the correct gauge.

NOTIONS
Tapestry needle.

GAUGE
32 sts and 40 rnds = 4" (10 cm) in solid-color St st worked in rnds, after blocking; 38 sts and 51 rnds = 4" (10 cm) in solid-color St st worked in rnds and relaxed after blocking.

continued >>

GAUGE

36 sts and 56 rnds = 4" (10 cm) in charted patts worked in rnds, after blocking; 38 sts and 54 rnds = 4" (10 cm) in charted patts worked in rnds and relaxed after blocking.

<div>

Chart legend:

- ☐ knit with MC
- ☒ knit with CC
- ☑ (V) sl 1 MC st pwise wyb
- ☑ (/) k2tog with CC
- ☑ (\) ssk with CC
- ▨ no stitch
- ☐ pattern repeat

</div>

Cuff

Cut a 24" (61 cm) length of MC and set aside. This will be used to pick up sts along the right side of the heel flap so that the working yarn won't need to be cut.

With MC, CO 64 (72) sts. Arrange sts evenly onto two cir needles so that there are 32 (36) sts on each needle. Join for working in rnds, being careful not to twist sts.

NOTES

✕ The charted mosaic patterns alternate two rounds of each color. The color of the first stitch indicates which color to use for the entire round. For the socks shown, the unused color was carried up along the WS of the work until it was needed again.

✕ The gusset stitches are picked up with just one color while the instep stitches are worked with two. To avoid having to cut the working yarns, before you cast on for the cuff, cut a length of yarn to be used for picking up gusset stitches. Use this length to pick up and knit stitches along the right side of the heel flap (the side that usually would be worked last), then use the attached yarn to work across the heel stitches and to pick up and knit stitches along the left side of heel flap. You'll then have both working yarns in position to work in rounds, and the rounds will begin between the sole and instep stitches, instead of at the center of the sole.

WOMEN'S LEG AND INSTEP

36-st repeat

Rib rnd: *K2, p2; rep from *.

Rep the rib rnd 15 (19) more times—16 (20) rnds total; piece measures 1 (1¼)" (2.5 [3.2] cm).

LEG
Work for your size as foll:

Women's size only
With CC, knit 1 rnd.

Next rnd: With CC and Needle 1, *k4, M1 (see Glossary), [k8, M1] 3 times, k4; with Needle 2, rep from *—72 sts; 36 sts each needle.

Next rnd: With Needle 1, *work Rnd 1 of Women's Leg and Instep chart (see Notes) over 36 sts; with Needle 2, rep from *.

Men's size only
With CC, knit 1 rnd.

Next rnd: With CC and Needle 1, *[k6, M1 (see Glossary)] 6 times; with Needle 2, rep from *—84 sts; 42 sts each needle.

Next rnd: With Needle 1, *work Rnd 1 of Men's Leg and Instep chart (see Notes) over 42 sts; with Needle 2, rep from *.

Both sizes
Cont in established patt, work Rnds 2–52 of chart once, then work Rnds 1–28 once more—80 chart rnds total; piece measures 7 (7¼)" (18 [18.5] cm) from CO.

Heel
The heel is worked back and forth in rows on the sts at the end of the rnd (Needle 2); sts on Needle 1 will be worked later for the instep. Do not cut CC; leave the working strand of CC attached to use later when rejoining in the rnd for the gussets.

HEEL FLAP
With MC, work heel sts back and forth in rows for your size as foll:

Women's size only
Set-up Row 1: (WS) Turn work so WS is facing, p36 sts on Needle 2.

Set-up Row 2: (RS) K2, [sl 1, k1] 16 times, k2tog—35 heel sts rem.

Men's size only
Set-up Row 1: (WS) Turn work so WS is facing, p42 sts on Needle 2.

Set-up Row 2: (RS) K2tog, k1, [sl 1, k1] 8 times, sl 1, k2tog, [sl 1, k1] 8 times, sl 1, k1, k2tog—39 heel sts rem.

Both sizes
Cont on 35 (39) heel sts as foll:

Row 1: (WS) K1, purl to last st, k1.

Row 2: (RS) K2, *sl 1, k1; rep from * to last st, k1.

MEN'S LEG AND INSTEP

42-st repeat

Ludwig

Rep the last 2 rows 14 (15) more times, then work WS Row 1 once more—33 (35) rows total including set-up rows; 17 (18) garter selvedge

☐ knit with MC

☒ knit with CC

☑ sl 1 MC st pwise wyb

▨ k2tog with CC

▨ ssk with CC

▩ no stitch

ridges at each side; heel measures about 2 (2¼)" (5 [5.5] cm) from last rnd of chart patt.

TURN HEEL

Work short-rows as foll:

Short-row 1: (RS) K2, [sl 1, k1] 6 (7) times, k6, ssk, k1, turn work.

Short-row 2: (WS) Sl 1, p6, p2tog, p1, turn work.

Short-row 3: Sl 1, knit to 1 st before gap formed on previous row, ssk (1 st each side of gap), k1, turn work.

Short-row 4: Sl 1, purl to 1 st before gap formed on previous row, p2tog (1 st each side of gap), p1, turn work.

Rep the last 2 rows 5 (6) more times—21 (23) heel sts rem.

SHAPE GUSSETS

Turn work so RS is facing and drop the strand of MC attached to beg of heel sts. Use the length of MC yarn cut and set aside before casting on to pick up sts along the first side of the heel flap as foll:

Set-up row: (RS) With the cut length of MC, tip of heel needle, and beg in

WOMEN'S GUSSET

39
37
35
33
31
29
27
25
23
21
19
17
15
13
11
9
7
5
3
1

55 sts dec'd to 36 sts

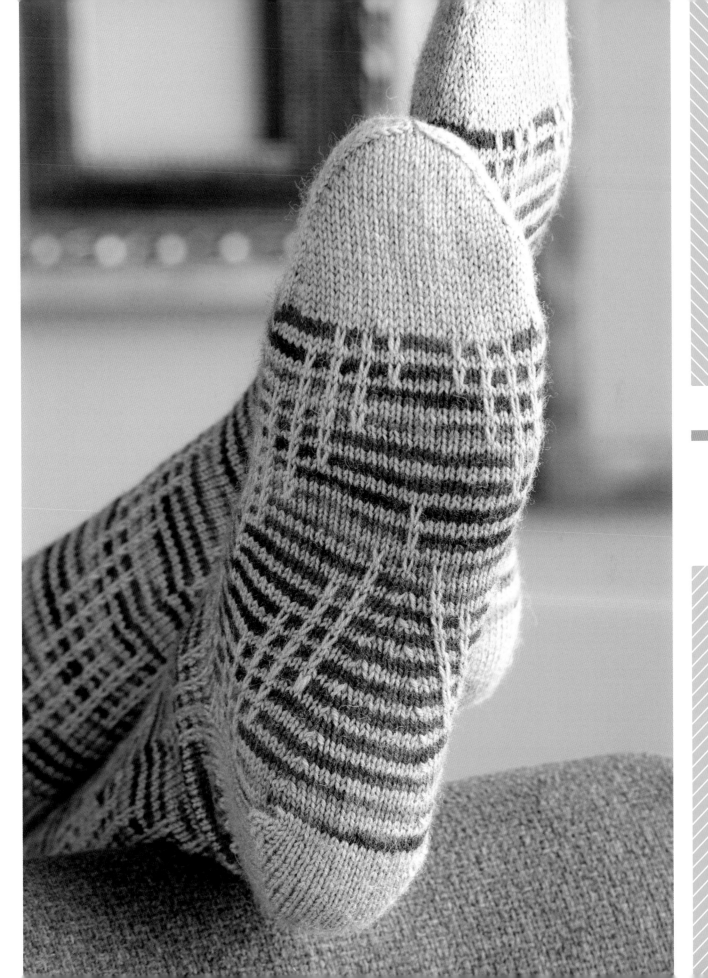

the corner between the heel flap and instep sts on the right side of the flap, pick up and knit 17 (18) sts along right side of heel flap (1 st for each garter selvedge ridge), then drop the extra strand of yarn. With the same cir needle and MC attached to beg of heel sts, k21 (23) heel sts, then pick up and knit 17 (18) sts (1 st for each garter selvedge ridge) along left side of heel flap—55 (59) heel and gusset sts on one cir needle (Needle 2).

Both MC and CC yarns are now at the start of the instep sts on Needle 1.

Work for your size as foll:

Women's size only
Next rnd: With Needle 1, work Rnd 29 of Women's Leg and Instep chart over 36 sts; with Needle 2, work Rnd 1 of Women's Gusset chart over 55 gusset and sole sts—91 sts total.

Men's size only
Next rnd: With Needle 1, work Rnd 29 of Men's Leg and Instep chart over 42 sts; with Needle 2, work Rnd 1 of Men's Gusset chart over 59 gusset and sole sts—101 sts total.

Both sizes
Cont in established patts until Rnd 40 (36) of gusset chart for your size has been completed, ending with Rnd 16 (12) of leg and instep chart—72 (84) sts rem; 36 (42) instep sts on Needle 1; 36 (42) gusset and sole sts on Needle 2.

foot

Next rnd: With Needle 1, *work Rnd 17 (13) of leg and instep chart for your size over 36 (42) sts; with Needle 2, rep from *.

Cont in patt until foot measures about 7 (8¼)" (18 [21] cm) from center back heel, or 2¼ (2½)" (5.5 [6.5] cm) less than desired foot length, ending after having completed 2 chart rnds using CC. Cut CC.

Legend:

- ☐ knit with MC
- ☒ knit with CC
- V sl 1 MC st pwise wyb
- ╱ k2tog with CC
- ╲ ssk with CC
- ▨ no stitch

MEN'S GUSSET

Chart rounds (odd numbers right side): 1, 3, 5, 7, 9, 11, 13, 15, 17, 19, 21, 23, 25, 27, 29, 31, 33, 35

59 sts dec'd to 42 sts

Toe

With MC, cont for your size as foll:

Women's size only

Knit 1 rnd.

Next rnd: With Needle 1, *k3, k2tog, [k7, k2tog] 3 times, k4; with Needle 2, rep from *—64 sts rem; 32 sts each needle.

Men's size only

Knit 1 rnd.

Next rnd: With Needle 1, *[k4, k2tog] 7 times; with Needle 2, rep from *—70 sts rem; 35 sts each needle.

Both sizes

Knit 2 rnds even.

Dec rnd: With Needle 1, *k1, ssk, knit to last 3 sts, k2tog, k1; with Needle 2, rep from *—4 sts dec'd; 2 sts dec'd each needle.

Knit 3 rnds even, then rep dec rnd—56 (62) sts rem; 28 (31) sts each needle.

[Knit 2 rnds even, then rep dec rnd] 2 (3) times—48 (50) sts rem; 24 (25) sts each needle.

[Knit 1 rnd even, then rep dec rnd] 4 times—32 (34) sts rem; 16 (17) sts each needle.

Rep dec rnd every rnd 6 more times—8 (10) sts rem; 4 (5) sts each needle; toe measures about 2¼ (2½)" (5.5 [6.5] cm).

Finishing

Cut yarn, leaving an 8" (20.5 cm) tail. Thread tail on a tapestry needle, draw through rem sts, pull tight to close hole, and fasten off on WS.

Weave in loose ends.

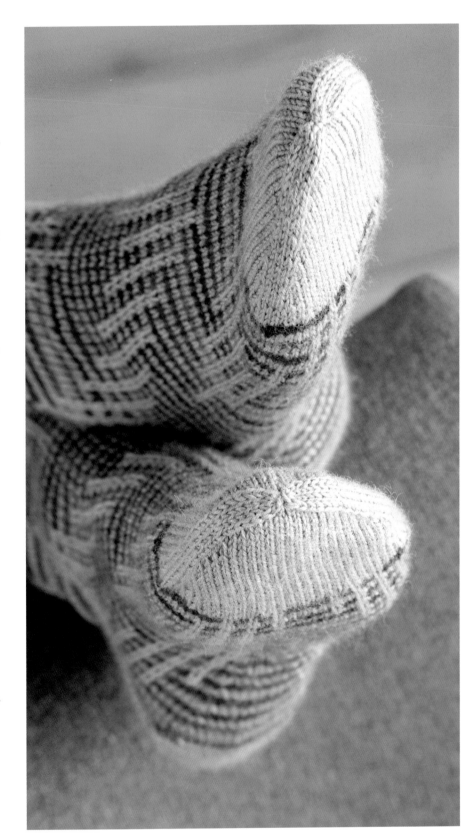

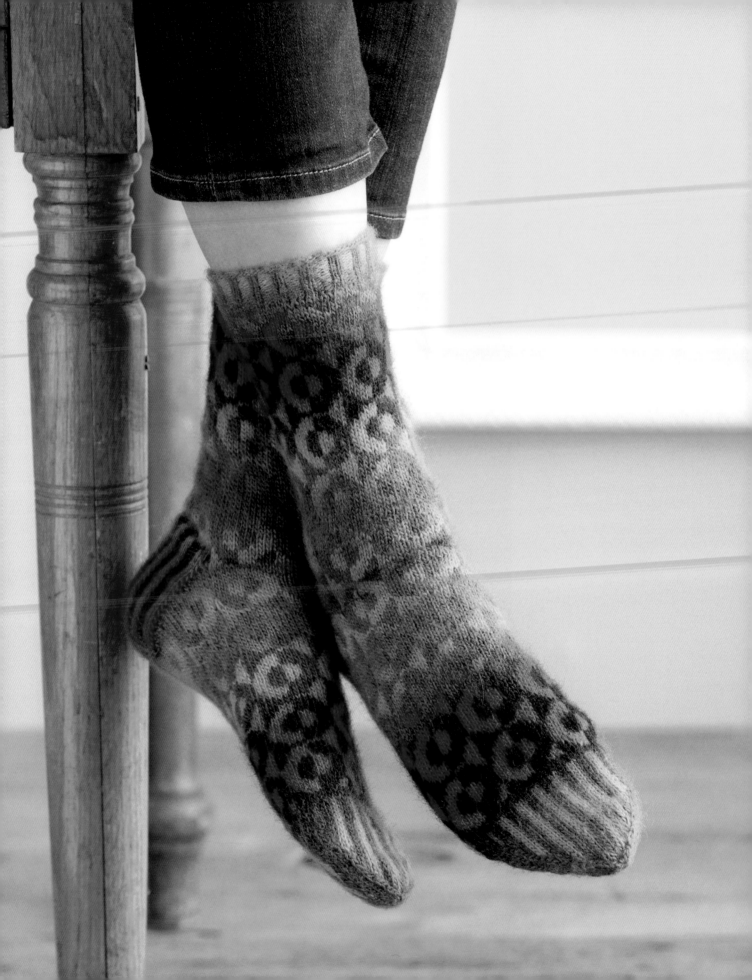

Yaacov

FINISHED SIZE

About 8" (20.5 cm) foot circumference, unstretched, and 10 (10½, 11)" (25.5 [26.5, 28] cm) foot length from back of heel to tip of toe (minor length adjustments possible).

To fit U.S. women's shoe sizes 8–9 (10–11, 11½–12½); European shoe sizes 39–41 (42–44, 45–46).

Socks shown measure 10½" (26.5 cm) in foot length.

YARN

Fingering (Super Fine #1).

Shown here: Lang Jawoll Magic Dégradé (75% new wool, 25% nylon; 437 yd [400 m]/100 g): #85.0050 rainbow, 2 balls.

Note: This project takes advantage of the yarn's long stripe sequence by using the same color for both A and B and starting each ball at a different point in the stripe sequence to create the effect of two contrasting colors.

NEEDLES

Size U.S. 1 (2.25 mm): two 24" (60 cm) circular (cir).

Adjust needle size if necessary to obtain the correct gauge.

NOTIONS

Tapestry needle.

GAUGE

35 sts and 40 rnds = 4" (10 cm) in charted patts worked in rnds, after blocking; 36 sts and 42 rnds = 4" (10 cm) in charted patts worked in rnds and relaxed after blocking.

Sometimes op art will toy with the confusing way that the eye and brain strive to make sense of what isn't there. Although we realize the visual trick, we can't ignore it. In this typical pattern, positive and negative forms give the clear impression of circles, an effect that Yaacov Agam (born 1928) capitalized on for some of his op-art works.

The socks shown here, named after Yaacov Agram, are knitted in the stranded technique with two balls of the same color-striping yarn. For the effect to work, the individual stripes should continue over ten or more rounds. Work with two balls of yarn, beginning each at the start of a different color and be sure work both balls from either the outside or inside. Doing so prevents the same color from appearing from both balls at the same time. The shifted color stripes of two balls of the same yarn add to the confusing effect of the positive/negative circles.

NOTES

✕ This project is worked using two balls of the same yarn, shifting the start of the stripe sequence in one of the two balls to produce the effect of two different colors. Designate one ball as A and the other as B and be careful to use the two balls consistently as A and B throughout. Be particularly careful in a section where the colors become similar because it will become difficult to tell them apart. If you accidentally switch balls, the mistake will be very clear when the colors diverge again.

✕ When you knit socks in a self-striping yarn, the heel typically disrupts the stripe sequence. To prevent this from happening, one option is to use an afterthought heel. When you reach the heel position, drop the working yarns and use a length of contrasting waste yarn (about 24" [61 cm] long) to knit the heel stitches. Slide the stitches back to the beginning of the needle and continue the established pattern in the round with the main yarns. When it's time to work the heel, carefully remove the waste yarn and place the exposed stitches on two circular needles. A short-rowed afterthought heel can be worked using a single strand of yarn, or in a colorwork pattern, joining the yarn(s) at the desired point in the stripe sequence.

Cuff

With A, CO 68 sts. Arrange sts evenly onto two cir needles so that there are 34 sts on each needle. Join for working in rnds, being careful not to twist sts.

Rnd 1: *K2 with A, k2 with B; rep from *.

Rnd 2: *K2A, p2B; rep from *.

Rep Rnd 2 until piece measures 1" (2.5 cm) from CO.

Leg

Set-up rnd: With A and Needle 1, [*k17, M1 (see Glossary)] 2 times; with Needle 2, rep from *—72 sts total; 36 sts each needle.

Work Rnds 1–12 of Leg chart 4 (5, 5) times—48 (60, 60) chart rnds completed; piece measures 5½ (6¾, 6¾)" (14 [17, 17] cm) from CO.

Heel

The heel is worked back and forth in rows on the 36 sts of Needle 1; the 36 sts on Needle 2 will be worked later for the instep.

HEEL FLAP

Row 1: (RS) K3A, [k2B, k2A] 7 times, k2B, k3A.

Row 2: (WS) P3A, [k2B, p2A] 7 times, k2B, p3A.

Row 3: K3A, [p2B, k2A] 7 times, p2B, k3A.

Rep Rows 2 and 3 fourteen more times, then work WS Row 2 once more—32 rows total; heel measures about 3" (7.5 cm) from last rnd of Leg chart.

TURN HEEL

Work short-rows as foll:

Short-row 1: (RS) [K1A, k1B] 9 times, then with A only, k1, ssk, k1, turn work.

Short-row 2: (WS) With A, sl 1, p3, p2tog, p1, turn work.

Short-row 3: With B, sl 1, knit to 1 st before gap formed on previous RS row, ssk (1 st each side of gap), k1, turn work.

Short-row 4: With B, sl 1, purl to 1 st before gap formed on previous WS row, p2tog (1 st each side of gap), p1, turn work.

	knit with A
	knit with B
/	k2tog with A
\	ssk with A
/	k2tog with B
\	ssk with B
	no stitch
	pattern repeat

LEG

12-st repeat

Short-row 5: With A, rep Short-row 3.

Short-row 6: With A, rep Short-row 4.

Rep the last 4 short-rows 2 more times, then rep Short-rows 3 and 4 once more—20 heel sts rem.

SHAPE GUSSETS

Pick up sts along sides of heel flap and rejoin for working in rnds as foll:

Set-up row: (RS) With heel needle (now Needle 2), work across 20 heel sts as [k2A, k2B] 5 times, being careful to maintain even tension, then pick up and knit 16 sts (1 st for every 2 rows) along left edge of heel flap as 4 sts B, 6 sts A, and 6 sts B.

Set-up rnd: With instep needle (now Needle 1), work Rnd 1 of Leg chart

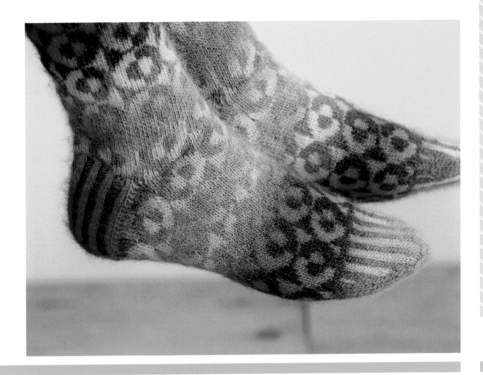

RIGHT GUSSET

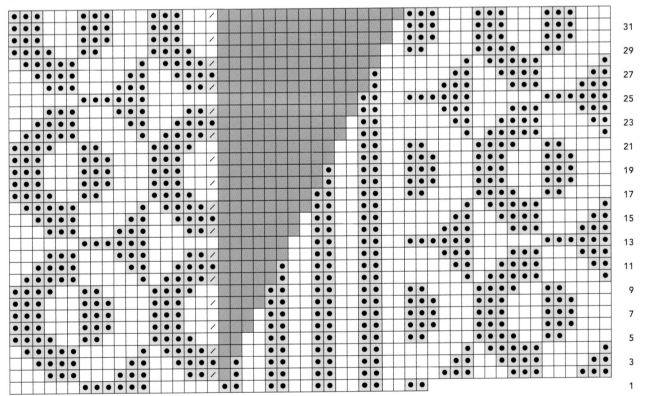

52 sts dec'd to 36 sts

TOE

●	knit with A
☐	knit with B
╱	k2tog with A
╲	ssk with A
╱	k2tog with B
╲	ssk with B
▨	no stitch
☐	pattern repeat

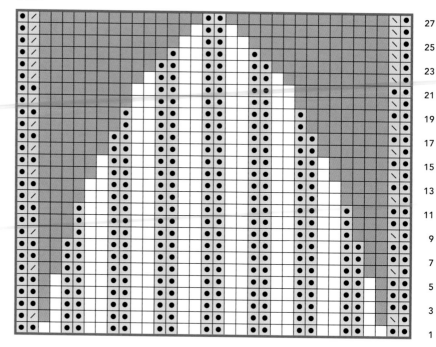

34-st repeat dec'd to 6-st repeat

LEFT GUSSET

52 sts dec'd to 36 sts

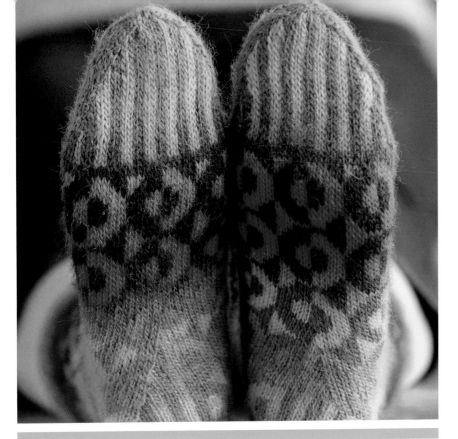

over 36 sts as established; with Needle 2, pick up and knit 16 sts (1 st for every 2 rows) along right edge of heel flap as 6 sts A, 6 sts B, 4 sts A, then cont to end of Needle 2 for right or left sock as foll:

Right sock: Work Rnd 1 of Right Gusset chart as a partial rnd over last 36 sts of Needle 2.

Left sock: Work Rnd 1 of Left Gusset chart as a partial rnd over last 36 sts of Needle 2.

Right and left socks: 88 sts total; 36 instep sts on Needle 1, 52 heel and gusset sts on Needle 2.

Both A and B yarns are now at the start of the instep sts on Needle 1.

Cont in established patts until Rnd 32 of Gusset chart has been completed, ending with Rnd 8 of Leg chart—72 sts rem; 36 instep sts on Needle 1; 36 gusset and sole sts on Needle 2.

foot

Next rnd: With Needle 1, *work Rnd 9 of Leg chart over 36 sts; with Needle 2, rep from *.

Cont in established patt for your size as foll:

Size 10" (25.5 cm) only
Work Rnds 10–12 once, work Rnds 1–12 once, then work Rnds 1–6 once more—22 rnds completed from end of Gusset chart; foot measures about 7¼" (18.5 cm) from center back heel.

Size 10½" (26.5 cm) only
Work Rnds 10–12 once, then work Rnds 1–12 two times—28 rnds completed from end of Gusset chart; foot measures about 7¾" (19.5 cm) from center back heel.

Size 11" (28 cm) only
Work Rnds 10–12 once, work Rnds 1–12 two times, then work Rnds 1–6 once more—34 rnds completed from end of Gusset chart; foot measures about 8¼" (21 cm) from center back heel.

All sizes
Significant length adjustments are not recommended because the proportions of the sock may not match the ones shown. For a slightly longer foot, work even in St st with A until foot measures 2¾" (7 cm) less than desired length; every 3 rounds added will increase the foot length by about ¼" (6 mm). Carry the unused strand of B up along the inside of the sock until it is needed again.

Toe

Cont for your size as foll.

Size 10" (25.5 cm) only
With A, knit 1 rnd.

Next rnd: With A and Needle 1, *[k16, k2tog] 2 times; with Needle 2, rep from *—68 sts rem; 34 sts each needle.

Sizes 10½ and 11" (26.5 and 28 cm) only
With A, knit 1 rnd.

Next rnd: With A and Needle 1, *k8, k2tog, k16, k2tog, k8; with Needle 2, rep from *—68 sts rem; 34 sts each needle.

All sizes
Next rnd: With Needle 1, *work Rnd 1 of Toe chart over 34 sts; with Needle 2, rep from *.

Cont in established patt until Rnd 27 of Toe chart has been completed—12 sts rem: 6 sts each needle; toe measures about 2¾" (7 cm).

finishing

Cut yarn, leaving an 8" (20.5 cm) tail. Thread tail onto tapestry needle, draw through rem sts, pull tight to close hole, and fasten off on WS.

Weave in loose ends. Block if desired.

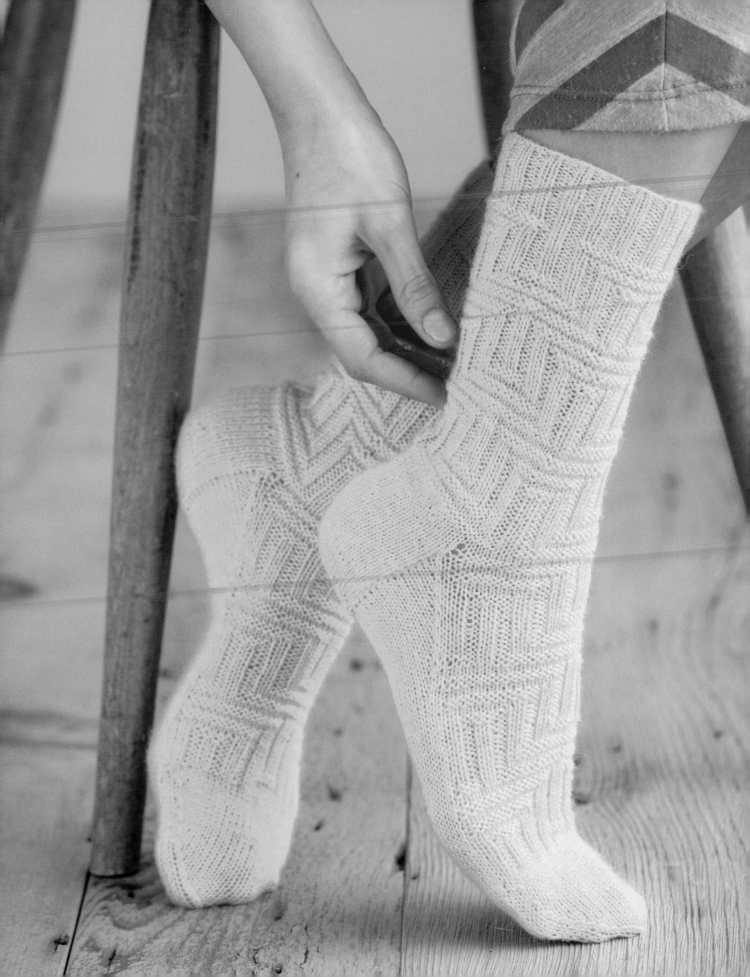

FINISHED SIZE

About 7½ (8)" (19 [20.5] cm) foot circumference, unstretched, and 9¾ (10½)" (25 [26.5] cm) foot length from back of heel to tip of toe (length is adjustable).

To fit U.S. women's shoe sizes 8–9 (men's 9–10); European shoe sizes 39–41 (42–43).

Yellow socks shown in women's size; gray socks shown in men's size.

YARN

Fingering weight (#1 Super Fine).

Shown here: Trekking Sport 4-Ply (75% new wool, 25% nylon; 459 yd [420 m]/100 g): 1 ball for both sizes. Shown in #1490 yellow and #1484 grey.

NEEDLES

Size U.S. 1 (2.25 mm): set of 4 double-pointed (dpn) and two 24" (60 cm) circular (cir).

Adjust needle size if necessary to obtain the correct gauge.

NOTIONS

Tapestry needle.

GAUGE

32 sts and 40 rows/rnds = 4" (10 cm) in St st, after blocking; 35 sts and 48 rows/rnds = 4" (10 cm) in St st and relaxed after blocking.

33 sts and 40 rnds = 4" (10 cm) in charted patt worked in rnds, after blocking; 37 sts and 48 rnds = 4" (10 cm) in charted patt worked in rnds and relaxed after blocking.

A meander is a design formed by a continuous line that's shaped into a repeated motif. It can be seen as a small labyrinth. If two meander stripes are used in a mirrored arrangement, new lines arise along the edges and square angles to create new figures. Anni Albers (1899–1994) used this effect for her 1970 work titled *Yellow Meander*.

For this sock pattern, named for Anni Albers, I chose a simple meander that's symmetrical around a vertical axis. The socks are worked in knit and purl stitches in a single color that makes the socks easy for even beginning knitters. For a completely different look, try mirroring the pattern around a horizontal axis by working Rounds 1–14 of the pattern first, then repeating those rounds in reverse order (Rounds 12–1), followed by Rounds 3–14.

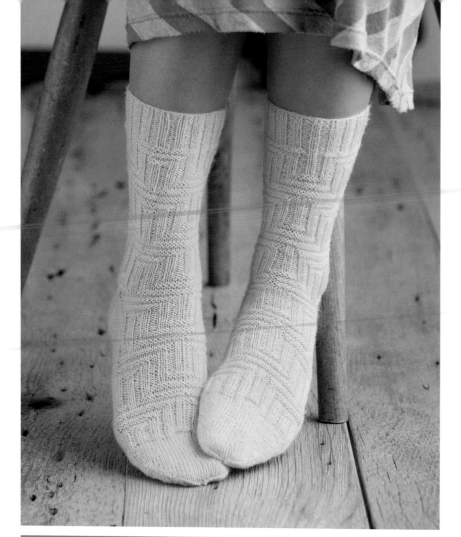

Cuff

With dpn, CO 72 sts for both sizes. Arrange sts evenly onto 3 dpn so that there are 24 sts on each needle. Join for working in rnds, being careful not to twist sts.

Rib rnd: *K2, p2; rep from *.

Rep rib rnd 15 more times—16 rnds total, piece measures 1½" (3.8 cm).

Leg

Work Rnds 1–24 of Leg chart 3 times (for both sizes)—72 rnds total; piece measures about 7½" (19 cm) from CO.

Heel

Set-up row: (RS) With RS facing, knit the first 20 (18) sts from Needle 1 onto a dpn for heel. Place the last 4 (6) sts of Needle 1, all 24 sts of Needle 2, and the first 6 (8) sts of Needle 3 onto a single cir needle to work later for instep. Slip the rem 18 (16) sts of Needle 3 onto the beg of the Needle 1 heel dpn—38 (34) heel sts on dpn; 34 (38) instep sts on cir needle.

Work heel sts back and forth in rows for your size as foll:

Women's size only
Row 1: (WS) P6, [p2tog, p6] 4 times —34 heel sts rem.

Men's size only
Row 1: (WS) P34.

Both sizes
Row 2: (RS) Knit.

Row 3: (WS) K1, p32, k1.

Rep the last 2 rows 15 (16) more times—33 (35) rows, not counting set-up row; 16 (17) garter selvedge ridges at each side.

LEG

☐	knit	
⊡	purl	
☐	pattern repeat	

23
21
19
17
15
13
11
9
7
5
3
1

24-st repeat

knit

· purl

WOMEN'S INSTEP

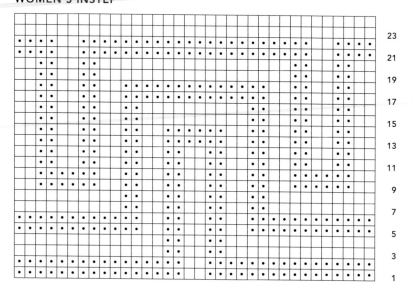

34 sts

MEN'S INSTEP

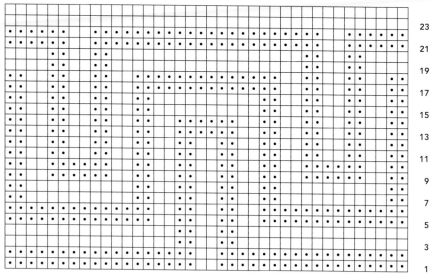

38 sts

TURN HEEL

Work short-rows as foll:

Short-row 1: (RS) K19, ssk, k1, turn work.

Short-row 2: (WS) Sl 1, p5, p2tog, p1, turn work.

Short-row 3: Sl 1, knit to 1 st before gap formed by previous RS row, ssk (1 st each side of gap), k1, turn work.

Short-row 4: Sl 1, purl to 1 st before gap formed by previous WS row, p2tog (1 st each side of gap), p1, turn work.

Rep the last 2 rows 5 more times—20 heel sts rem.

SHAPE GUSSETS

Set-up Rnd 1: With an empty cir needle (Needle 1), k20 heel sts, then pick up and knit 16 (17) sts along left side of heel flap (1 st for each garter selvedge ridge); with cir needle holding instep sts (Needle 2), work Rnd 1 of Instep chart for your size over 34 (38) sts.

Set-up Rnd 2: With Needle 1, pick up and knit 16 (17) sts along right side of heel flap (1 st for each garter selvedge ridge), then k36 (37) to end of Needle 1; with Needle 2, work Rnd 2 of Instep chart for your size—86 (92) sts total; 52 (54) heel and gusset sts on Needle 1, 34 (38) instep sts on Needle 2.

Dec rnd: With Needle 1, k1, ssk, knit to last 3 sts, k2tog, k1; with Needle 2, cont as charted—2 sts dec'd on Needle 1.

Working all sts on Needle 1 in St st, [work 2 rnds even, then rep the dec rnd] 8 (9) times, ending with Rnd 3 (6) of Instep chart—68 (72) sts rem; 34 sole sts on Needle 1 for both sizes; 34 (38) instep sts on Needle 2.

Foot

Working the sts on Needle 1 in St st, cont as foll for your size:

Women's size only

Work Rnds 4–24 of Women's Instep chart once, then work Rnds 1–16 once more—64 instep rnds total; foot measures about 7¼" (18.5 cm) from center back heel.

Men's size only

Work Rnds 7–24 of Men's Instep chart once, then work Rnds 1–20 once more—68 instep rnds total; foot measures about 7¾" (19.5 cm) from center back heel.

Toe

Note: *To adjust the foot length, work even in St st on all sts until foot measures 2½ (2¾ [7]) cm) less than desired length before starting the toe shaping.*

Cont for your size as foll:

Women's size only

Knit 1 rnd.

Next rnd: [K15, k2tog] 4 times—64 sts rem; 32 sts each needle.

Men's size only

Knit 1 rnd.

Next rnd: With Needle 1, k34; with Needle 2, [k7, k2tog, k8, k2tog] 2 times—68 sts rem; 34 sts each needle.

Both sizes

Knit 2 rnds even.

Dec rnd: With Needle 1, *k1, ssk, knit to last 3 sts, k2tog, k1; with Needle 2, rep from *—4 sts dec'd; 2 sts dec'd each needle.

Knit 3 rnds even, then rep dec rnd—56 (60) sts rem; 28 (30) sts each needle.

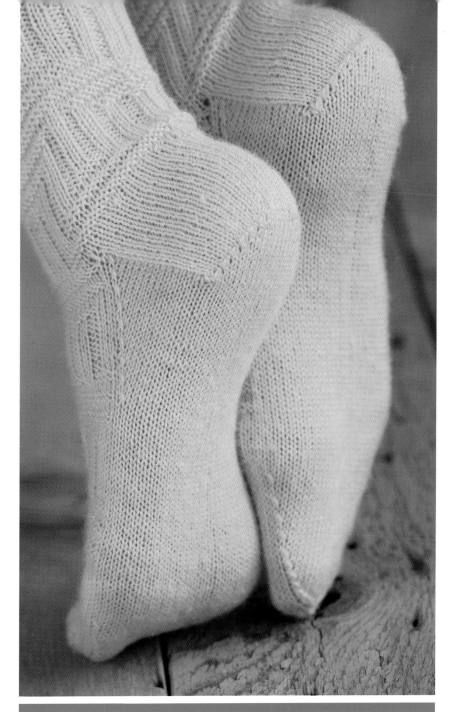

[Knit 2 rnds even, then rep dec rnd] 3 times—44 (48) sts rem; 22 (24) sts each needle.

[Knit 1 rnd even, then rep dec rnd] 4 (5) times—28 sts rem for both sizes; 14 sts each needle.

Rep dec rnd every rnd 5 times—8 sts rem; 4 sts each needle; toe measures about 2½ (2¾ [7]) cm).

Finishing

Cut yarn, leaving an 8" (20.5 cm) tail. Thread tail onto tapestry needle, draw through rem sts, pull tight to close hole, and fasten off on WS.

Weave in loose ends.

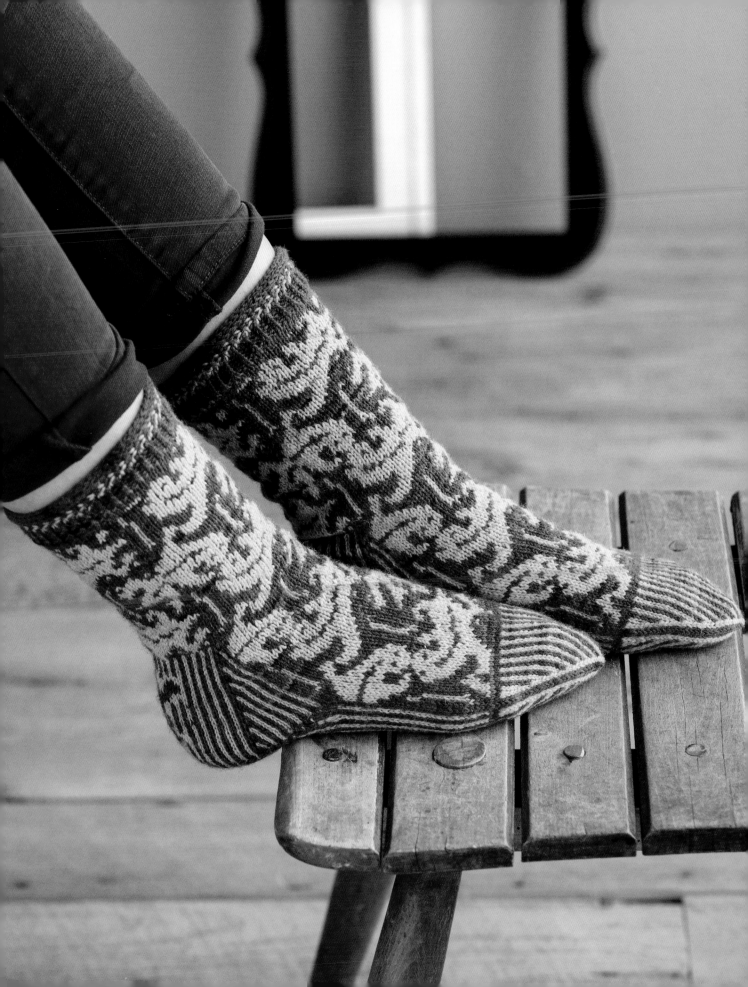

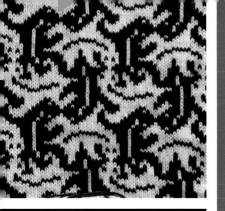

FINISHED SIZE

About 9" (23 cm) foot circumference, unstretched, and 9½ (10)" (24 [25.5] cm) foot length from back of heel to tip of toe (length is adjustable).

To fit U.S. women's shoe sizes 7½–8½ (9–10); European shoe sizes 39–40 (41–42).

Socks shown measure 9½" (24 cm) in foot length.

YARN

Fingering weight (#1 Super Fine).

Shown here: Trekking XXL (75% new wool, 25% nylon; 459 yd [420 m]/100 g): #494 brown (MC), 1 ball for both sizes.

Trekking XXL Tweed (75% new wool, 25% nylon; 459 yd [420 m]/100 g): #202 yellow (CC), 1 ball for both sizes.

NEEDLES

Size U.S. 1 (2.25 mm): two 24" (60 cm) circular (cir) and set of 4 double-pointed (dpn).

Adjust needle size if necessary to obtain the correct gauge.

NOTIONS

Tapestry needle.

GAUGE

35 sts and 40 rnds = 4" (10 cm) in charted patts worked in rnds, after blocking; 33 sts and 38 rnds = 4" (10 cm) in charted patts worked in rnds and relaxed after blocking.

Maurits

Maurits Cornelis Escher (1898–1972) was a great master of tessellation—geometric forms or figures in contrasting colors that fit together in repetitive patterns. Escher described his symmetrical designs and planar tesselations as congruent, convex polygons joined together. Brick or tile floors or walls are the most common and simplest examples of tessellations. In op-art designs, these forms trick the eye into focusing back and forth between the images created by the two contrasting colors.

The socks shown here, named after Maurits Escher, feature simple lizard forms in brown and yellow. Choose colors with even more contrast for a more striking optical effect.

STITCH GUIDE

Baltic Braid

(worked over an even number of sts)

Note: Always bring each color to the back of the work to knit, then bring it to the front before exchanging the colors.

Rnd 1: Starting with both colors in front of work, *bring MC over CC and to the back, k1 MC, then bring MC to front and drop it; bring CC over MC and to back, k1 CC, then bring CC to front and drop it; rep from *.

Rnd 2: Starting with both colors in front of work, *bring MC under CC and to the back, k1 MC, then bring MC to front and drop it; bring CC under MC and to back, k1 CC, then bring CC to front and drop it; rep from *.

LEG

Legend:
- ☒ knit with MC
- ☐ knit with CC
- Ⓜ M1 with MC
- Ⓜ M1 with CC
- ╱ k2tog with CC
- ╲ ssk with CC
- ▨ no stitch
- ☐ pattern repeat

25-st repeat

Cuff

With MC, CO 70 sts for both sizes. Arrange sts evenly onto two cir needles so that there are 35 sts on each needle. Join for working in rnds, being careful not to twist sts.

Rnd 1: With MC, knit.

Rnds 2 and 3: Work Rnds 1 and 2 of Baltic Braid (see Stitch Guide).

Rnd 4: With MC, knit.

Rnds 5–9: With MC, on Needle 1 [k1 through back loop (tbl), p1] 17 times, k1tbl; on Needle 2, [p1, k1 tbl] 17 times, p1.

Rnd 10: With MC, knit—piece measures about 1" (2.5 cm).

Leg

Next rnd: With MC, on Needle 1, k4, M1 (see Glossary), [k14, M1] 2 times, k3; on Needle 2, k11, M1, k14, M1, k10—75 sts; 38 sts on Needle 1, 37 sts on Needle 2.

Next rnd: Rearrange sts onto 3 dpn and establish patt from Leg chart as foll: With Needle 1, *work Rnd 1 of Leg chart over 25 sts; rep from * for sts of Needle 2, then rep from * for sts of Needle 3—25 sts each on 3 dpn.

Work Rnds 2–29 of chart once, then work Rnds 1–15 once more—44 chart rnds completed; piece measures 5¾" (14.5 cm) from CO.

Heel

Next rnd: Rearrange sts onto two cir needles and establish new chart patts for right or left sock as foll:

Right sock: With Needle 1, work Rnd 1 of Instep chart (page 114) over 38 sts; with Needle 2, work Rnd 1 of Right Heel chart over 37 sts, inc them to 39 sts as shown on chart.

Left sock: With Needle 1, work Rnd 1 of Instep chart (page 114) over 38 sts; with Needle 2, work Rnd 1 of Left Heel chart over 37 sts, inc them to 39 sts as shown on chart.

Right and left socks: 77 sts total; 38 instep sts on Needle 1, 39 heel sts on Needle 2.

Cont in established patts until Rnd 30 of heel chart has been completed, ending with Rnd 30 of Instep chart—105 sts: 38 front-of-leg sts on Needle 1 and 67 back-of-leg heel sts on Needle 2.

Next rnd: With Needle 1, work Rnd 31 of Instep chart; with Needle 2, work

RIGHT HEEL

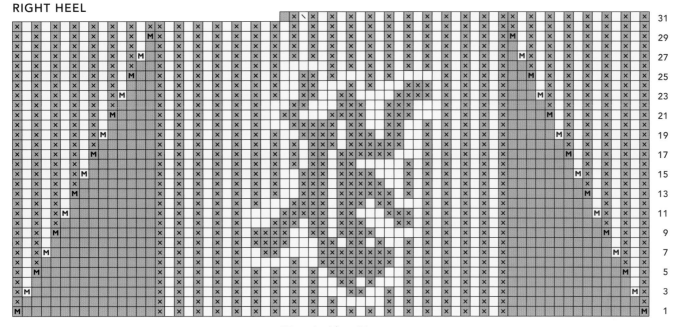

37 sts inc'd to 67 sts

LEFT HEEL

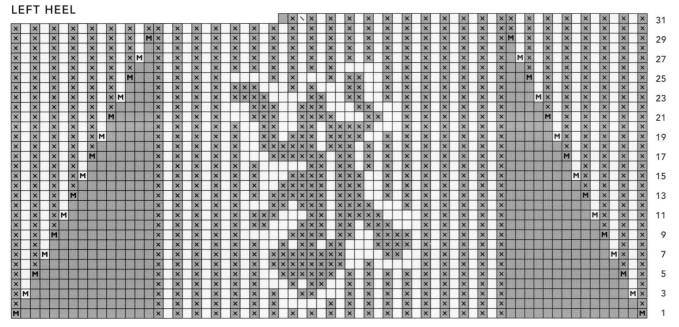

37 sts inc'd to 67 sts

partial Rnd 31 of heel chart over first 39 sts, dec them to 38 sts as shown, and stop there—66 heel sts rem; 38 worked sts at beg of heel needle, and 28 unworked sts at end of heel needle.

TURN HEEL

The heel turn is worked back and forth on the sts of Needle 2; the 38 sts on Needle 1 will continue later for the instep.

Turn work so WS of heel needle is facing. Work short-rows as foll:

Short-row 1: (WS) Sl 1, p2 MC, [p1 CC, p1 MC] 2 times, p2tog with MC, p1 CC, turn work—28 unworked sts rem at end of heel.

Short-row 2: (RS) Sl 1, k1 MC, *k1 MC, k1 CC; rep from * to 1 st before gap formed on previous row, ssk with MC (1 st each side of gap), k1 MC, turn work.

Short-row 3: Sl 1, *p1 MC, p1 CC; rep from * to 1 st before gap formed on previous row, p2tog with MC (1 st each side of gap), p1 CC, turn work.

Short-row 4: Sl 1, k1 MC, *k1 CC, k1 MC; rep from * to 1 st before gap, ssk with MC, k1 MC, turn work.

Short-row 5: Sl 1, p2 MC, *p1 CC, p1 MC; rep from * to 1 st before gap, p2tog with MC, p1 CC, turn work.

Rep Short-rows 2–5 (do not rep Short-row 1) six more times—37 heel sts rem.

foot

Next rnd: Resume working in rnds for right or left sock as foll:

Right sock: With Needle 1, work Rnd 32 of Instep chart over 38 sts; with Needle 2, work Rnd 1 of Right Sole chart over 37 sts.

Left sock: With Needle 1, work Rnd 32 of Instep chart over 38 sts;

INSTEP

(colorwork chart, rows labeled at right: 59, 57, 55, 53, 51, 49, 47, 45, 43, 41, 39, 37, 35, 33, 31, 29, 27, 25, 23, 21, 19, 17, 15, 13, 11, 9, 7, 5, 3, 1)

38 sts

Legend

- × knit with MC
- ☐ knit with CC
- ℳ M1 with MC
- ℳ M1 with CC
- / k2tog with CC
- \ ssk with CC
- ▓ no stitch

RIGHT SOLE

37 sts

LEFT SOLE

37 sts

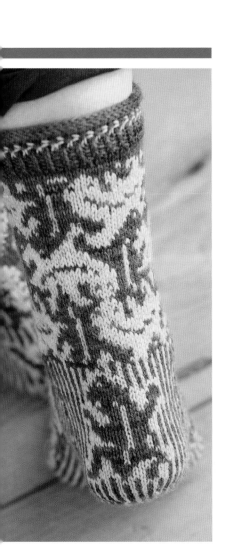

Maurits

×	knit with MC
	knit with CC
/	k2tog with CC
\	ssk with CC
	no stitch
	pattern repeat

TOE

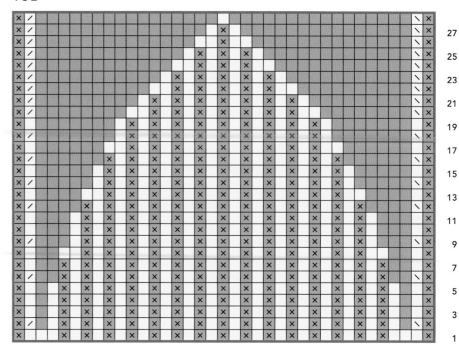

37-st repeat dec'd to 5-st repeat

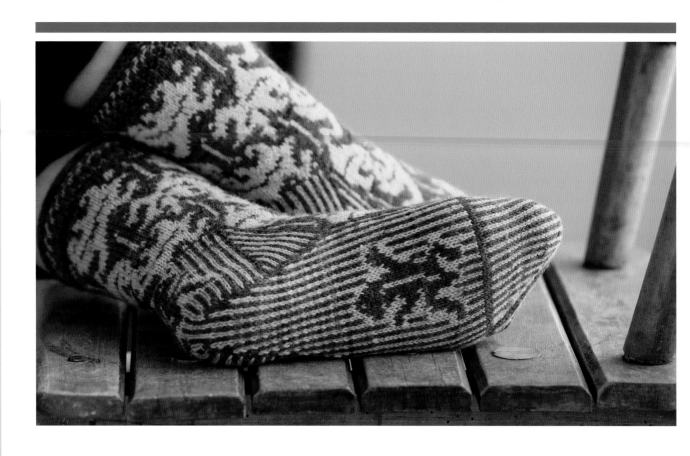

with Needle 2, work Rnd 1 of Left Sole chart over 37 sts.

Right and left socks: 75 sts total; 38 instep sts on Needle 1, 37 sole sts on Needle 2.

Cont in established patts until Rnd 29 of sole chart has been completed, ending with Rnd 60 of Instep chart—29 foot rnds completed from end of heel turn; foot measures 6½" (16.5 cm) from center back heel.

. .

Note: *Because the foot is planned to contain an exact number of chart rounds, any foot length adjustments should be made in the next section, before beginning the toe decreases.*

. .

Toe

Cut CC and cont with MC only.

Knit 1 rnd.

Next rnd: With Needle 1, k35, k2tog, k1; with Needle 2, knit—74 sts rem; 37 sts each needle.

. .

Note: *To adjust foot length, repeat Rnd 1 of the Toe chart until foot measures 2¾" (7 cm) less than desired length before starting the toe decreases in Rnd 2; every 2 or 3 rounds added will lengthen the foot by about ¼" (6 mm).*

. .

Next rnd: With Needle 1, *work Rnd 1 of Toe chart over 37 sts; with Needle 2, rep from *.

Size 10"(25.5 cm) only
Rep Rnd 1 of Toe chart 4 more times.

Both sizes
Cont in established patt, work Rnds 2–28 of chart—10 sts rem; 5 sts each needle; 30 (34) toe rnds completed; toe measures about 3 (3½)" (7.5 [9] cm) from end of instep and sole charts.

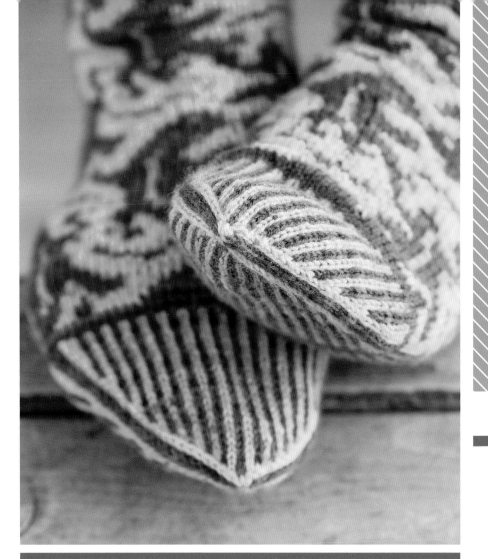

Finishing
Cut yarn, leaving an 8" (20.5 cm) tail. Thread tail onto a tapestry needle, draw through rem sts, pull tight to close hole, and fasten off on WS.

I-CORD CUFF EDGING
With MC, pick up and knit 70 sts evenly spaced around CO edge of cuff opening. Divide sts onto two cir needles so that there are 35 sts on each needle. Join for working in rnds. With Needle 1, use the cable method (see Glossary) to CO 3 more sts onto the left needle tip at the start of the rnd—73 sts total.

Work I-cord BO as foll: *K3, k2tog tbl, hold yarn in back and sl 4 sts pwise from right needle back to left needle; rep from * until 4 sts rem.

Cut yarn, leaving an 8" (20.5 cm) tail. Thread tail onto a tapestry needle and use it to sew live sts from end of I-cord to base of CO sts at beg of I-cord, then fasten off tail on inside of cord.

Weave in loose ends.

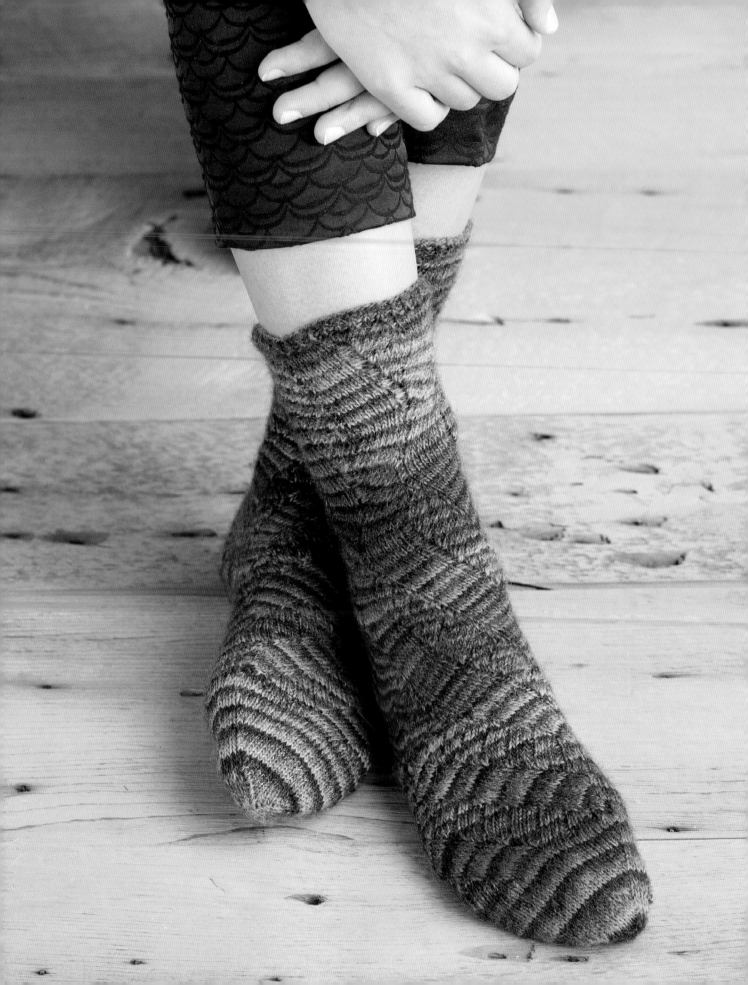

Günter

Modified grids, chessboards, or figures filled with alternating black and white lines are often used for spatial sensation in op art. Tilted lines and grids are as effective as rectangular ones. Günter Fruhtrunk (1923–1982) used this effect for some of his works in the 1960s.

For this sock pattern, named after Günter Fruhtrunk, I worked a striped yarn in a simple k3, p1 rib pattern that's truncated with decreases and increases to form a strong diagonal pattern. The direction is reversed on the right and left socks.

FINISHED SIZE

About 7 (7½)" (18 [19] cm) foot circumference, unstretched, and 10 (11)" (25.5 [28] cm) foot length from back of heel to tip of toe (length is adjustable).

To fit U.S. women's shoe sizes 8½–9½ (men's 10½–11½); European shoe sizes 40–41 (45–46).

Pink/gold/purple striped socks shown in women's size; blue/yellow/brown striped socks shown in men's size.

YARN

Fingering (#1 Super Fine).

Shown here: Lang Jawoll Magic 4-ply (75% new wool, 25% nylon; 437 yd [400 m]/100 g): 1 (2) ball(s).

Shown in women's size in #84.0053 pink/gold/purple and shown in men's size in #84.0026 blue/yellow/brown.

NEEDLES

Size 2.5 mm (no U.S. equivalent; between size 1 and size 2): two 24" (60 cm) circular (cir).

Adjust needle size if necessary to obtain the correct gauge.

NOTIONS

Tapestry needle.

GAUGE

32 sts and 40 rnds = 4" (10 cm) in St st worked in rnds, after blocking; 34 sts and 48 rnds = 4" (10 cm) in St st worked in rnds and relaxed after blocking.

continued >>

GAUGE (CONTINUED)

35 sts and 42 rnds = 4" (10 cm) in charted patts worked in rnds, after blocking; 41 sts and 43 rnds = 4" (10 cm) in charted patts worked in rnds and relaxed after blocking.

NOTE

✕ As you work the charted patterns, if a round contains an increase that's separated from its companion decrease by a needle boundary, it may be necessary to shift the stitches between needles after completing the round to maintain the correct number of stitches on each needle.

Cuff

CO 72 (76) sts. Arrange sts evenly onto two cir needles so that there are 36 (38) sts on each needle. Join for working in rnds, being careful not to twist sts.

Rib rnd: *K1 through back loop (tbl), p1; rep from *.

Rep the last rnd 3 (11) more times— 4 (12) rib rnds total; piece measures about ½ (1¼)" (1.3 [3.2] cm) from CO.

WOMEN'S RIGHT LEG

Needle 1 36 sts

Needle 2 36 sts

WOMEN'S LEFT LEG

knit

ℓ k1tbl

• purl

○ yo

╱ k2tog

╲ ssk

needle boundaries

17 15 13 11 9 7 5 3 1

Needle 1 38 sts

Needle 2 38 sts

MEN'S RIGHT LEG

17 15 13 11 9 7 5 3 1

Needle 1 38 sts

Needle 2 38 sts

MEN'S LEFT LEG

Günter

knit

§ k1tbl

• purl

○ yo

∕ k2tog

＼ ssk

M M1

no stitch

│ needle boundaries

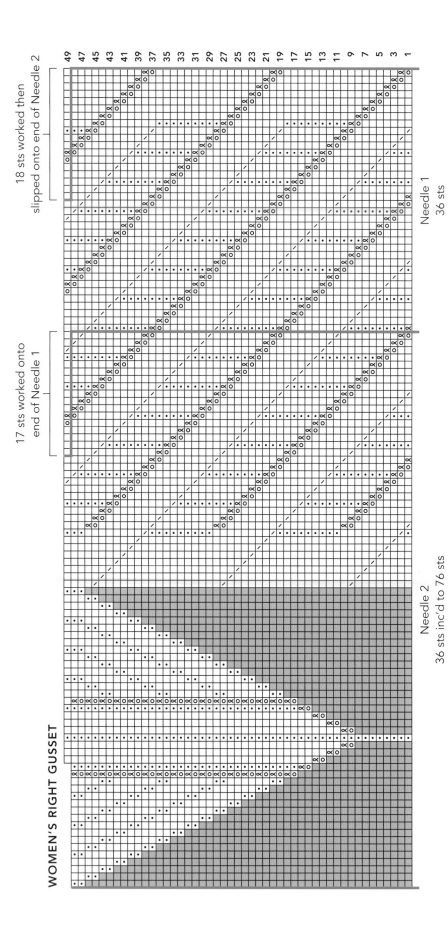

18 sts worked then slipped onto end of Needle 2

17 sts worked onto end of Needle 1

Needle 1
36 sts

Needle 2
36 sts inc'd to 76 sts

WOMEN'S RIGHT GUSSET

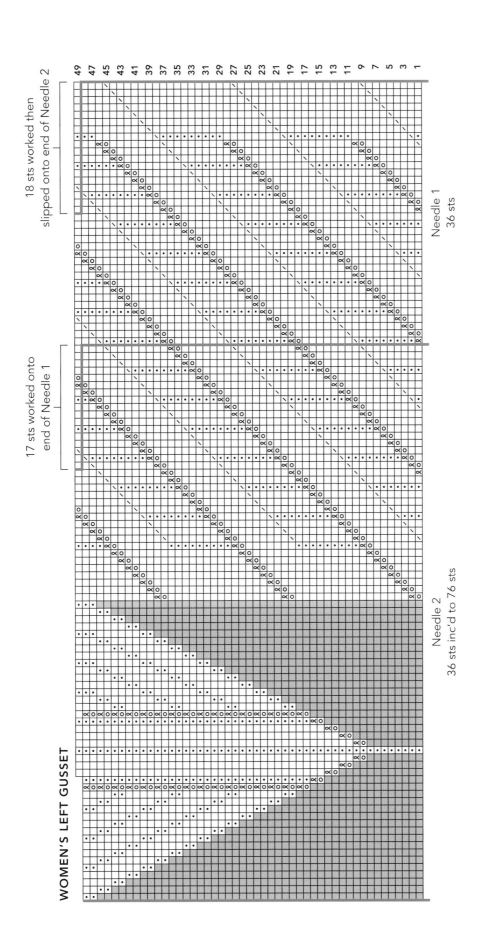

WOMEN'S LEFT GUSSET

18 sts worked then slipped onto end of Needle 2

17 sts worked onto end of Needle 1

Needle 1
36 sts

Needle 2
36 sts inc'd to 76 sts

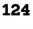

knit

ʎ k1tbl

• purl

o yo

⟋ k2tog

⟍ ssk

M M1

no stitch

needle boundaries

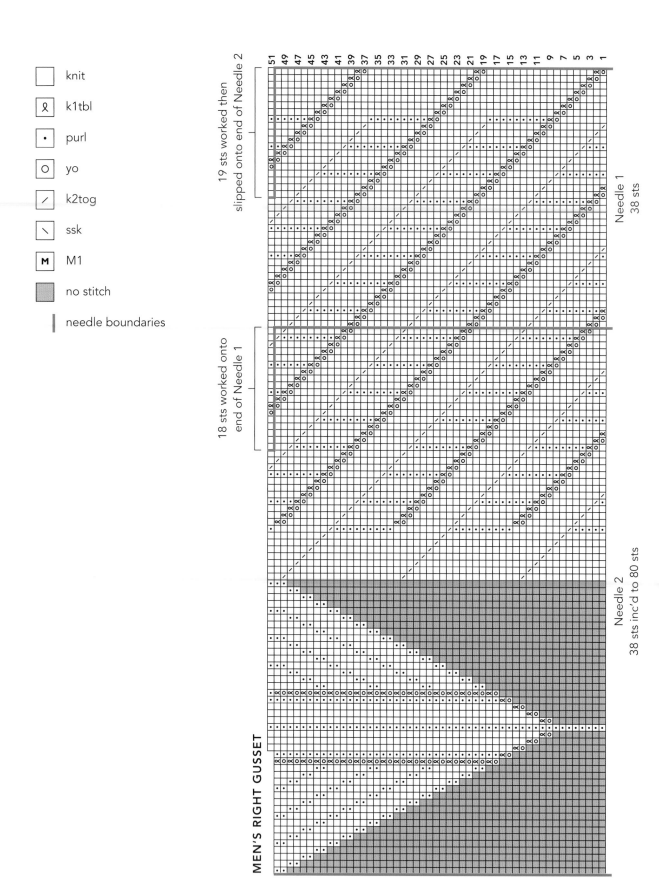

19 sts worked then
slipped onto end of Needle 2

18 sts worked onto
end of Needle 1

Needle 1
38 sts

Needle 2
38 sts inc'd to 80 sts

MEN'S RIGHT GUSSET

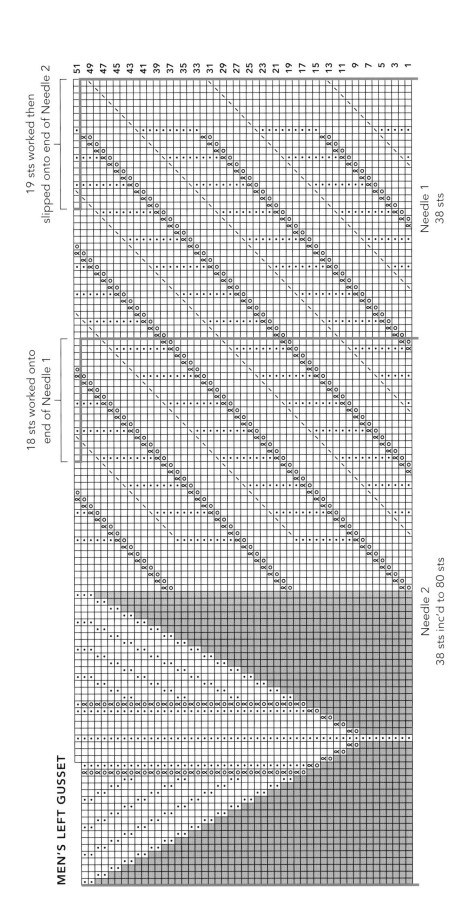

MEN'S LEFT GUSSET

19 sts worked then slipped onto end of Needle 2

18 sts worked onto end of Needle 1

Needle 1
38 sts

Needle 2
38 sts inc'd to 80 sts

51 49 47 45 43 41 39 37 35 33 31 29 27 25 23 21 19 17 15 13 11 9 7 5 3 1

Günter

125

Leg

Cont for your size as foll:

Women's size only

Right sock: Work Rnd 1 of Women's Right Leg chart (see Note).

Left sock: Work Rnd 1 of Women's Left Leg chart (see Note).

Men's size only

Right sock: Work Rnd 1 of Men's Right Leg chart (see Note).

Left sock: Work Rnd 1 of Men's Left Leg chart (see Note).

Both sizes

Right and left socks: Work Rnds 2–18 of chart once, then work Rnds 1–18 two more times—54 chart rnds completed for both sizes; piece measures 5½ (6¼)" (14 [16] cm) from CO.

Heel Increases

Cont for your size as foll:

Women's size

Right sock: With Needle 1, work first 36 sts of Women's Right Gusset chart; with Needle 2, work last 36 sts of chart.

Left sock: With Needle 1, work first 36 sts of Women's Left Gusset chart; with Needle 2, work last 36 sts of chart.

Men's size

Right sock: With Needle 1, work first 38 sts of Men's Right Gusset chart; with Needle 2, work last 38 sts of chart.

Left sock: With Needle 1, work first 38 sts of Men's Left Gusset

Legend:

- ☐ knit
- k1tbl
- • purl
- ○ yo
- ╱ k2tog
- ╲ ssk
- M M1
- ▨ no stitch
- │ needle boundaries

WOMEN'S RIGHT INSTEP

35 sts

WOMEN'S LEFT INSTEP

35 sts

chart; with Needle 2, work last 38 sts of chart.

Both sizes

Cont in established patt until Rnd 48 (50) of chart has been completed—112 (118) sts; 36 (38) sts on Needle 1; 76 (80) sts on Needle 2; piece measures 10 (11)" (25.5 [28] cm) from CO.

TURN HEEL (RIGHT AND LEFT SOCKS)

Set-up: With Needle 1, work the first 18 (19) sts from Rnd 49 (51)

of chart and slip these sts onto the end of Needle 2, work the next 18 (19) chart sts, then work the first 17 (18) sts of chart from Needle 2 onto the end of Needle 1, and stop there—35 (37) instep sts on Needle 1, 77 (81) sts on Needle 2; working yarn is at the start of the heel sts on Needle 2.

Work heel sts back and forth in rows on 77 (81) sts of Needle 2 as foll:

Short-row 1: (RS) Work rem 42 (44) sts from Rnd 49 (51) of gusset chart, ssk, k1, turn work.

Short-row 2: (WS) Sl 1, p8, p2tog, p1, turn work.

Short-row 3: Sl 1, knit to 1 st before gap formed on previous row, ssk (1 st each side of gap), k1, turn work.

Short-row 4: Sl 1, purl to 1 st before gap formed on previous row, p2tog (1 st each side of gap), p1, turn work.

Rep the last 2 rows 9 (10) more times—55 (57) heel sts rem.

Cont as foll, turning the work immediately after the dec (do not work 1 st after the dec as in previous short-rows):

Short-row 5: (RS) Sl 1, knit to 1 st before gap formed on previous row, ssk, turn work.

Short-row 6: (WS) Sl 1, purl to 1 st before gap formed on previous row, p2tog, turn work.

Rep the last 2 rows 11 more times—31 (33) heel sts rem.

Next row: (RS) Knit to end of 31 (33) heel sts.

foot

Resume working in rnds for your size as foll:

Women's size

Right sock: With Needle 1, work Rnd 1 of Women's Right Instep chart over 35 sts; with Needle 2, knit to end.

Left sock: With Needle 1, work Rnd 1 of Women's Left Instep chart over 35 sts; with Needle 2, knit to end.

Right and left socks: 66 sts: 35 instep sts on Needle 1; 31 sole sts on Needle 2.

Men's size

Right sock: With Needle 1, work Rnd 1 of Men's Right Instep chart over 37 sts; with Needle 2, knit to end.

MEN'S RIGHT INSTEP

37 sts

MEN'S LEFT INSTEP

37 sts

Left sock: With Needle 1, work Rnd 1 of Men's Left Instep chart over 37 sts; with Needle 2, knit to end.

Right and left socks: 70 sts total; 37 instep sts on Needle 1; 33 sole sts on Needle 2.

Both sizes

Working the sole sts on Needle 2 in St st, cont in established patt until foot measures 7½ (8¼)" (19 [21] cm) from center back heel, or 2½ (2¾)" (6.5 [7] cm) less than desired total foot length.

Toe

Next rnd: Knit all sts, knitting any yarnovers through the back loop.

Next rnd: With Needle 1, k3 (4), [k2tog, k7] 3 times, k2tog, k3 (4); with Needle 2, knit—62 (66) sts rem; 31 (33) sts each needle.

Knit 2 rnds even.

Dec rnd: With Needle 1, k1, ssk, knit to last 3 sts, k2tog, k1; with Needle 2, rep from *—4 sts dec'd; 2 sts dec'd each needle.

Knit 3 rnds even, then rep dec rnd—54 (58) sts rem; 27 (29) sts each needle.

[Knit 2 rnds even, then rep dec rnd] 2 (3) times—46 sts rem for both sizes; 23 sts each needle.

[Knit 1 rnd even, then rep dec rnd] 4 times—30 sts rem; 15 sts each needle.

Rep dec rnd every rnd 5 times—10 sts rem; 5 sts each needle

Next rnd: With Needle 1, *k1, k2tog, k2; with Needle 2, rep from *—8 sts rem; 4 sts each needle; toe measures 2½ (2¾)" (6.5 [7] cm).

Finishing

Cut yarn, leaving an 8" (20.5 cm) tail. Thread tail onto tapestry needle, draw through rem sts, pull tight to close hole, and fasten off on WS.

Weave in loose ends.

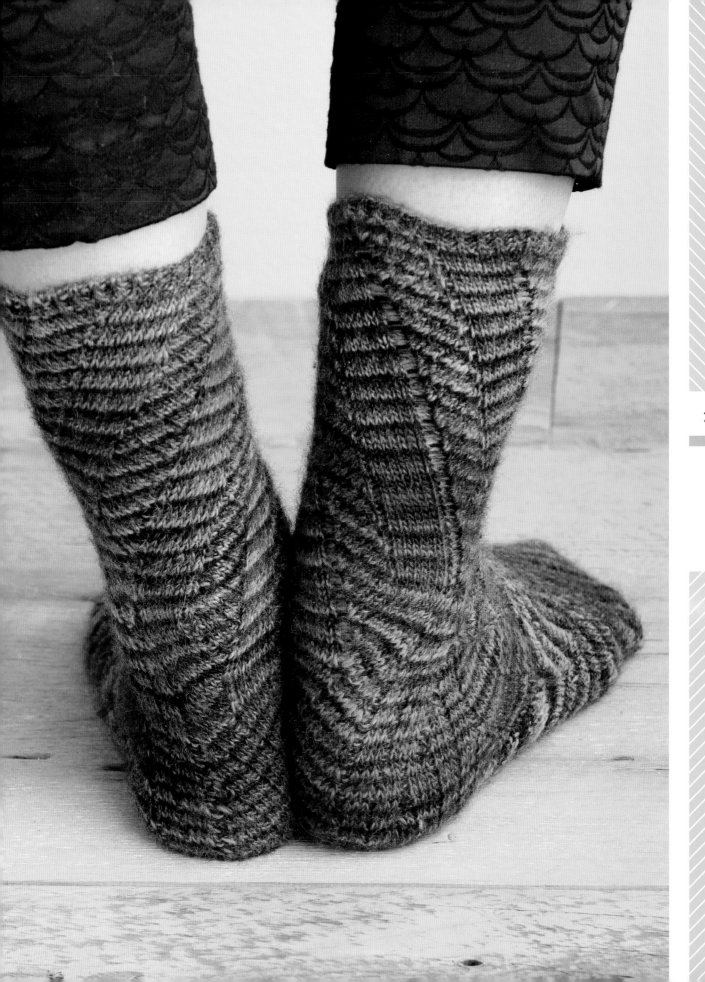

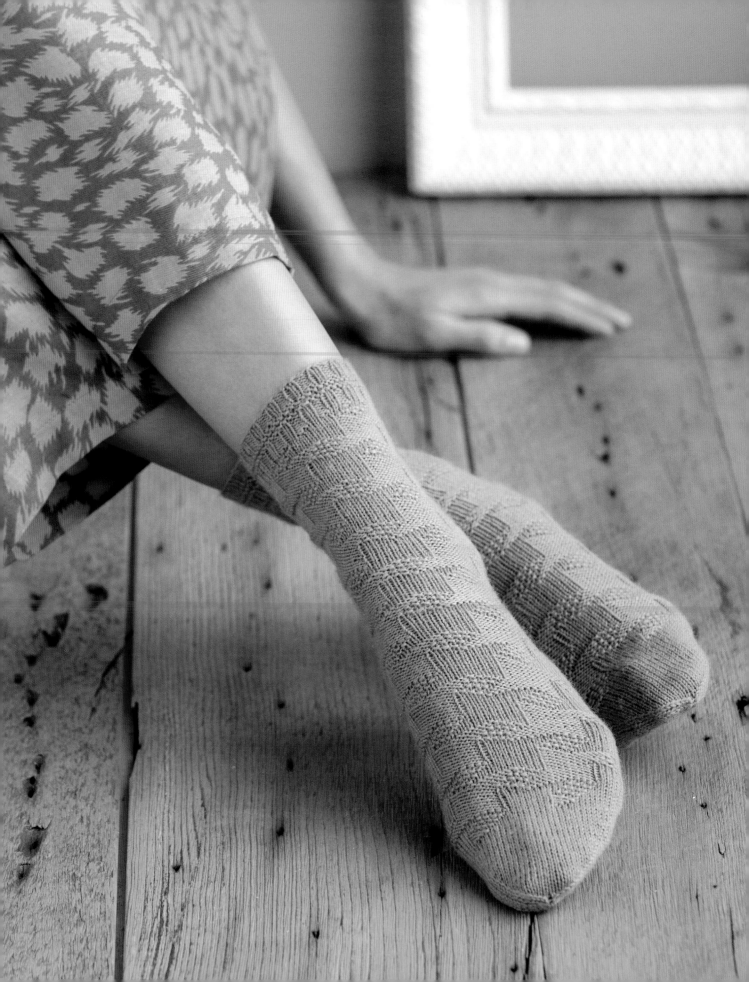

Starlet

FINISHED SIZE
About 7 (7¼)" (18 [18.5] cm) foot circumference, unstretched, and 9½ (10)" (24 [25.5] cm) foot length from back of heel to tip of toe (length is adjustable).

To fit U.S. women's shoe sizes 7–8 (8½–9½); European shoe sizes 38–39 (40–41).

Socks shown measure 10" (25.5 cm) in foot length.

YARN
Fingering weight (#1 Super Fine).

Shown here: Trekking Sport 4-ply (75% new wool, 25% nylon; 459 yd [420 m]/100 g): #1468 green, 1 ball for both sizes.

NEEDLES
Size U.S. 1 (2.25 mm): two 24" (60 cm) circular (cir).

Adjust needle size if necessary to obtain the correct gauge.

NOTIONS
Stitch marker; tapestry needle.

GAUGE
32 sts and 40 rows/rnds = 4" (10 cm) in St st, after blocking; 36 sts and 54 rows/rnds = 4" (10 cm) in St st and relaxed after blocking.

33 sts and 42 rnds = 4" (10 cm) in charted patts worked in rnds, after blocking; 37 sts and 59 rnds = 4" (10 cm) in charted patts worked in rnds and relaxed after blocking.

In addition to the eye candy of harmonic symmetry, the intriguing effect of tessellation is that your focus flips back and forth between different motifs that may appear as pieces in a puzzle. The motifs are often shown in two colors that give the impression of positive and negative forms.

For this sock pattern, I chose a tessellation of stars and small squares worked in different stitch patterns. Because I chose a single yarn, the optical effect is subtle. For a more prominent effect, use the stranded colorwork technique to work each section in a different color.

Cuff

CO 60 (64) sts. Arrange sts evenly onto two cir needles so that there are 30 (32) sts on each needle. Join for working in rnds, being careful not to twist sts.

Rib rnd: K1, *p2, k2; rep from * to last 3 sts, p2, k1.

Work rib rnd 4 (5) more times—5 (6) rnds completed.

Knit 1 rnd.

Purl 1 rnd.

Knit 2 rnds.

Purl 1 rnd.

Knit 1 rnd.

Work rib rnd 5 (6) times.

Knit 1 rnd—17 (19) rnds completed; piece measures about 1 (1¼)" (2.5 [3.2] cm) from CO.

Leg

Work for your size as foll:

Size 9½" (24 cm) only
Set-up rnd: With Needle 1, *[k15, M1 (see Glossary)] 2 times; with Needle 2, rep from *—64 sts; 32 sts each needle.

Next rnd: With Needle 1, *work 16-st repeat from Chart A 2 times; with Needle 2, rep from *.

Size 10" (25.5 cm) only
Set-up rnd: With Needle 1, [k13, M1 (see Glossary)] 2 times, k6; with Needle 2, k6, M1, [k13, M1] 2 times—69 sts; 34 sts on Needle 1, 35 sts on Needle 2.

Slip the last 2 sts from the end of Needle 1 onto the beg of Needle 2—32 sts on Needle 1, 37 sts on Needle 2.

Next rnd: With Needle 1, work 16-st repeat from Chart A 2 times; with Needle 2, work 37 sts of Chart B once.

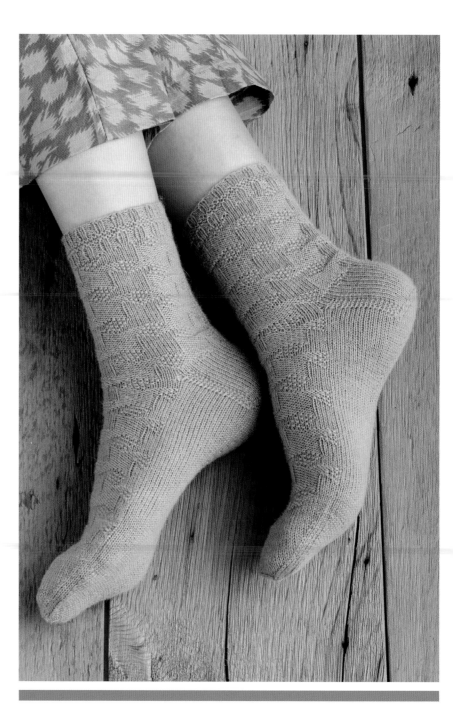

Both Sizes
Working in established patts, work Rnds 2–16 of chart(s) once, work Rnds 1–16 two times, then work Rnds 1–15 once more—63 chart rnds total; piece measures 5¼ (5½)" (13.5 [14] cm) from CO.

Heel

Work set-up for your size as foll:

Size 9½" (24 cm) only

Set-up rnd: With Needle 1, work Rnd 16 of Chart A 2 times; with Needle 2, k32—still 64 sts; 32 instep sts to work later on Needle 1, 32 heel sts on Needle 2.

Size 10" (25.5 cm) only

Set-up rnd: With Needle 1, work Rnd 16 of Chart A 2 times; with Needle 2, [k8, k2tog] 3 times, k7—66 sts rem; 32 instep sts to work later on Needle 1, 34 heel sts on Needle 2.

HEEL FLAP

Work heel flap back and forth on 32 (34) sts of Needle 2 as foll:

Row 1: (WS) K3, p26 (28), k3.

Row 2: (RS) K32 (34).

Rep the last 2 rows 13 (14) more times, then work WS Row 1 once more—29 (31) heel rows total; 15 (16) garter ridges at each side.

TURN HEEL

Work short-rows as foll:

Short-row 1: (RS) K19, ssk, k1, turn work.

Short-row 2: (WS) Sl 1, p7 (5), p2tog, p1, turn work.

Short-row 3: Sl 1, knit to 1 st before gap formed by previous RS row, ssk, k1, turn work.

Short-row 4: Sl 1, purl to 1 st before gap formed by previous WS row, p2tog, p1, turn work.

Rep the last 2 rows 4 (5) more times—20 heel sts rem for both sizes.

SHAPE GUSSETS

Set-up Rnd 1: With Needle 2, k20 heel sts, then pick up and knit 15

(16) sts (1 st for each garter ridge) along left side of heel flap.

Set-up Rnd 2: With Needle 1, work Rnd 1 of Chart A 2 times across 32 instep sts; with Needle 2, pick up and knit 15 (16) sts (1 st for each garter ridge) along right side of heel flap, k35 (36) to end of Needle 2—82 (84) sts total; 32 instep sts on Needle 1 for both sizes, 50 (52) heel and gusset sts on Needle 2.

Next rnd: With Needle 1, cont as charted; with Needle 2, knit.

Next rnd: With Needle 1, cont as charted; with Needle 2, k25 (26), pm, k25 (26).

Dec rnd: With Needle 1, cont as charted; with Needle 2, knit to 3 sts before m, ssk, k1, slip marker (sl m), k1, k2tog, knit to end—2 sts dec'd on Needle 2.

Cont in patt on Needle 1, [work 2 rnds even, then rep the dec rnd] 8 times, ending with Rnd 12 of Chart A—64 (66) sts rem; 32 instep sts on Needle 1 for both sizes, 32 (34) sole sts on Needle 2.

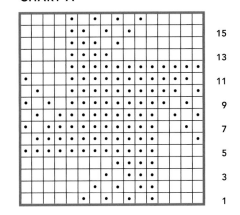

CHART A

- ☐ knit
- ⊡ purl
- ☐ pattern repeat

16-st repeat

CHART B

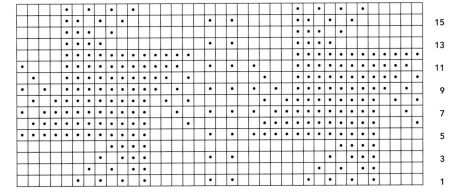

37 sts

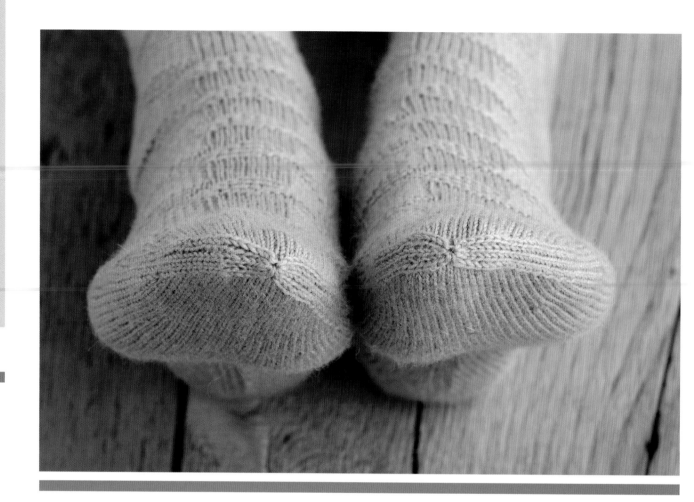

Foot

Working the sole sts on Needle 2 in St st, cont in chart patt on Needle 1 until foot measures 7½ (8)" (19 [20.5] cm) from center back heel, or 2" (5 cm) less than desired foot length.

Toe

Work for your size as foll:

Size 9½" (24 cm) only
Knit 3 rnds.

Size 10" (25.5 cm) only
Knit 1 rnd.

Next rnd: With Needle 1, knit; with Needle 2, k7, k2tog, k16, k2tog, k7—64 sts rem; 32 sts on each needle.

Knit 1 rnd.

Both sizes
Dec rnd: With Needle 1, *k1, ssk, knit to last 3 sts, k2tog, k1; with Needle 2, rep from *—4 sts dec'd; 2 sts dec'd each needle.

Knit 3 rnds even, then rep dec rnd—56 sts rem for both sizes; 28 sts each needle.

[Knit 2 rnds, rep dec rnd] 2 times—48 sts rem; 24 sts each needle.

[Knit 1 rnd, rep dec rnd] 4 times—32 sts rem; 16 sts each needle.

Rep dec rnd every rnd 6 times—8 sts rem; 4 sts each needle; toe measures about 2" (5 cm).

Finishing

Cut yarn, leaving an 8" (20.5 cm) tail. Thread tail onto tapestry needle, draw through rem sts, pull tight to close hole, and fasten off on WS.

Weave in loose ends. Block lightly.

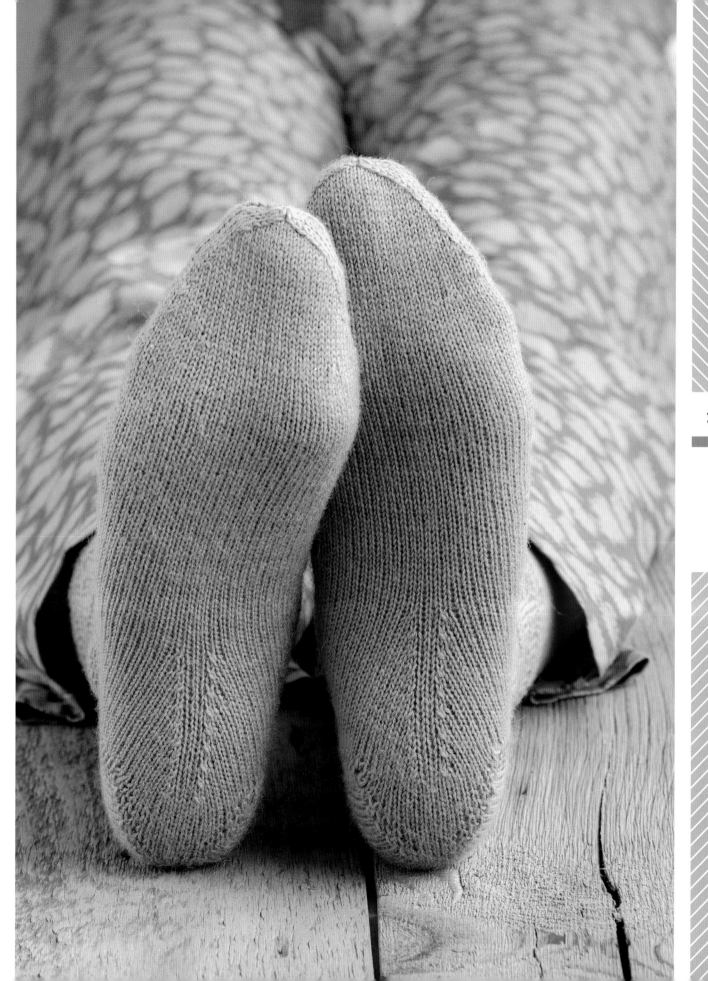

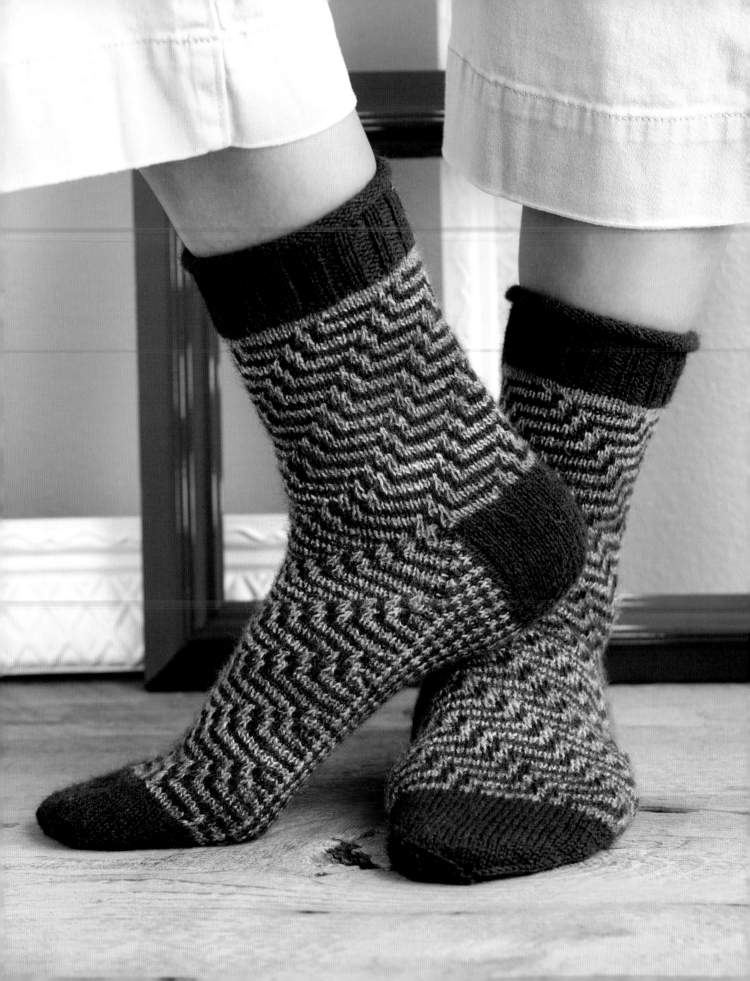

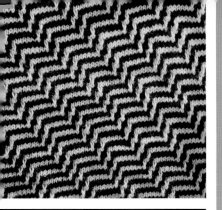

Symmetry

Op art remains popular for its absorbing and provocative sensory impressions. When the visual provocation is subtle, the viewer looks more closely to make sense of it.

In the socks shown here, narrow stripes of a variegated yarn are transversed by stripes in a darker color. This project is simple and can be easily worked by beginners. For added visual play, the right and left socks are mirror images.

FINISHED SIZE
About 7½ (8)" (19 [20.5] cm) foot circumference, unstretched, and 9¾ (10½)" (25 [26.5] cm) foot length from back of heel to tip of toe (length is adjustable).

To fit U.S. women's shoe sizes 7½–8½ (men's 9–10; European shoe sizes 39– 40 (42–44).

Navy and violet socks shown in women's size; charcoal and gray/brown socks shown in men's size.

Note: The model is wearing the women's right and left socks on the opposite feet.

YARN
Fingering weight (#1 Super Fine).

Shown here: Trekking Sport 4-ply (75% new wool, 25% nylon; 459 yd [420 m]/100 g).

Trekking XXL Maxima (75% superwash wool, 25% nylon; 459 yd [420 m]/100) g).

Trekking XXL (75% superwash wool, 25% nylon; 459 yd [420 m]/100) g).

Shown in women's size using Sport 4-ply #1430 navy (MC) and Trekking Maxima #906 variegated violet (CC), 1 ball each.

Shown in men's size using Sport 4-ply #1460 charcoal (MC) and Trekking Maximum #902 variegated grey/brown (CC), 1 ball each.

NEEDLES
Size U.S. 1 (2.25 mm): two 24" (60 cm) circular (cir).

Adjust needle size if necessary to obtain the correct gauge.

continued >>

NOTIONS
Tapestry needle.

GAUGE
32 sts and 40 rnds = 4" (10 cm) in solid-color St st worked in rnds, after blocking; 36 sts and 50 rnds = 4" (10 cm) in solid-color St st worked in rnds and relaxed after blocking.

33 sts and 44 rnds = 4" (10 cm) in charted patt worked in rnds, after blocking; 35 sts and 58 rnds = 4" (10 cm) in charted patts worked in rnds and relaxed after blocking.

NOTES

× Different charts are used for the right and left socks.

× The charted mosaic patterns alternate two rounds of each color. The color of the knit stitches in each chart round indicates which color to use for that entire round. For the socks shown, the unused color was carried up along the WS of the work until it was needed again.

× In the leg charts, work the set-up rounds only once, then repeat the indicated chart rounds for the pattern.

× The gusset stitches are picked up with just one color while the instep stitches are worked with two. To avoid having to cut the working yarns, before you cast on for the cuff, cut a length of yarn to be used for picking up gusset stitches. Use this length to pick up and knit stitches along the right side of the heel flap (the side that usually would be worked last), then use the attached yarn to work across the heel stitches and to pick up and knit stitches along the left side of heel flap. You'll then have both working yarns in position to work in rounds, and the rounds will begin between the sole and instep stitches, instead of at the center of the sole.

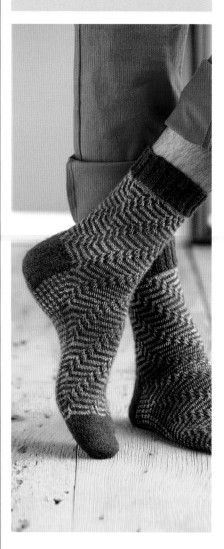

Cuff

Cut a 24" (60 cm) length of MC and set aside. This will be used to pick up sts along the right side of the heel flap so that you won't need to cut the working yarn.

With MC, CO 64 (68) sts. Arrange sts evenly onto two cir needles so that there are 32 (34) sts on each needle. Join for working in rnds, being careful not to twist sts.

Women's size only
Knit 10 rnds for rolled edge.

Both sizes
Rib rnd: *K2, p2; rep from *.

Rep the rib rnd 13 (15) more times—14 (16) rib rnds total; piece measures about 1½" (3.8 cm) from beg for both sizes, with edge of women's cuff allowed to roll.

Leg

Work for your size as foll:

Women's size only
Inc rnd: With CC and Needle 1, *k32, M1 (see Glossary); with Needle 2, rep from *—66 sts; 33 sts each needle.

Next rnd: With CC, knit.

Right sock: Work Set-up Rnds 1 and 2 of Women's Right Leg chart.

Left sock: Work Set-up Rnds 1 and 2 of Women's Left Leg chart.

Right and left socks: Cont chart as established, work Rnds 1–44 once, then work Rnds 1–20 once more.

Next 2 rnds: With Needle 1, work Rnds 21 and 22 of chart as established; with Needle 2, knit all sts with MC—68 chart rnds completed; 70 leg rnds total; piece measures 6¼" (16 cm) from CO with edge of cuff allowed to roll.

Men's size only

Inc rnd: With CC and Needle 1, [k17, M1 (see Glossary)] 2 times; with Needle 2, rep from *—72 sts; 36 sts each needle.

Next rnd: With CC, knit.

Right sock: Work Set-up Rnds 1 and 2 of Men's Right Leg chart (page 140).

Left sock: Work Set-up Rnds 1 and 2 of Men's Left Leg chart (page 140).

Right and left socks: Cont chart as established, work Rnds 1–24 two times, then work Rnds 1–22 once more—72 chart rnds completed; 74 leg rnds total; piece measures about 6½" (16.5 cm) from CO.

Heel

The heel is worked back and forth in rows on the sts at the end of the rnd (Needle 2); sts on Needle 1 will be worked later for the instep. Do not cut CC; leave the working strand of CC attached to use later when rejoining in the rnd for the gussets.

Legend:

- ● knit with MC
- □ knit with CC
- V (shaded) sl 1 MC st pwise wyb
- V knit sl 1 CC st pwise wyb
- □ pattern repeat

WOMEN'S RIGHT LEG

11-st repeat

Rows: 43, 41, 39, 37, 35, 33, 31, 29, 27, 25, 23, 21, 19, 17, 15, 13, 11, 9, 7, 5, 3, 1, set-up 1, set-up 2

repeat for pattern

work once

WOMEN'S LEFT LEG

11-st repeat

Rows: 43, 41, 39, 37, 35, 33, 31, 29, 27, 25, 23, 21, 19, 17, 15, 13, 11, 9, 7, 5, 3, 1, set-up 1, set-up 2

repeat for pattern

work once

Legend:

- ● knit with MC
- ☐ knit with CC
- V sl 1 MC st pwise wyb
- V sl 1 CC st pwise wyb
- ☐ pattern repeat

MEN'S LEFT LEG

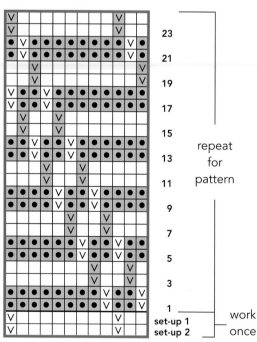

23 21 19 17 15 13 11 9 7 5 3 1
set-up 1
set-up 2

repeat for pattern

work once

12-st repeat

MEN'S RIGHT LEG

23 21 19 17 15 13 11 9 7 5 3 1
set-up 1
set-up 2

repeat for pattern

work once

12-st repeat

HEEL FLAP

With MC, work heel sts back and forth in rows for your size as foll:

Women's size only

Set-up row: (WS) Turn work so WS is facing, p33 sts on Needle 2.

Men's size only

Set-up row: (WS) Turn work so WS is facing, work sts on Needle 2 as p34, k2tog—35 heel sts rem.

Both sizes

Cont on 33 (35) heel sts as foll:

Row 1: (RS) K2, *sl 1, k1; rep from * to last st, k1.

Row 2: (WS) K1, purl to last st, k1.

Rep the last 2 rows 15 (16) more times—33 (35) rows total including set-up row; 16 (17) garter selvedge ridges at each side; heel measures about 2 (2¼)" (5 [5.5] cm) from last rnd of chart patt.

TURN HEEL

Work short-rows as foll:

Short-row 1: (RS) K2, [sl 1, k1] 6 times for both sizes, k4 (6), ssk, k1, turn work.

Short-row 2: (WS) Sl 1, p4 (6), p2tog, p1, turn work.

Short-row 3: Sl 1, knit to 1 st before gap formed by previous RS row, ssk (1 st each side of gap), k1, turn work.

Short-row 4: Sl 1, purl to 1 st before gap formed by previous WS row, p2tog (1 st each side of gap), p1, turn work.

Rep the last 2 rows 5 more times— 19 (21) heel sts rem.

SHAPE GUSSETS

Turn work so RS is facing and drop the strand of MC attached to beg of heel sts. Use the length of MC yarn cut and set aside before casting on to

pick up sts along the first side of the heel flap as foll:

Set-up row: (RS) With the cut length of MC, tip of heel needle, and beg in the corner between the heel flap and instep sts on the right side of the flap, pick up and knit 16 (17) sts along right side of heel flap (1 for each garter selvedge ridge), then drop the extra strand of yarn. With the same cir needle and MC attached to beg of heel sts, k19 (21) heel sts, then pick up and knit 16 (17) sts (1 st for each garter selvedge ridge) along left side of heel flap—51 (55) heel and gusset sts on one cir needle (Needle 2).

Both MC and CC yarns are now at the start of the instep sts on Needle 1.

Work for your size as foll:

Women's size only

Right sock: With Needle 1, work Rnd 23 of Women's Right Leg chart over 33 sts; with Needle 2, work Rnd 1 of Women's Gusset chart (page 143) over 51 gusset and sole sts—84 sts total.

Left sock: With Needle 1, work Rnd 23 of Women's Left Leg chart over 33 sts; with Needle 2, work Rnd 1 of Women's Gusset chart (page 143) over 51 gusset and sole sts—84 sts total.

Men's size only

Right sock: With Needle 1, work Rnd 23 of Men's Right Leg chart over 36 sts; with Needle 2, work Rnd 1 of Men's Gusset chart (page 143) over 55 gusset and sole sts—91 sts total.

Left sock: With Needle 1, work Rnd 23 of Men's Left Leg chart over 36 sts; with Needle 2, work Rnd 1 of Men's Gusset chart over 55 gusset and sole sts—91 sts total.

Both sizes

Right and left socks: Cont in established patts until Rnd 20 of gusset

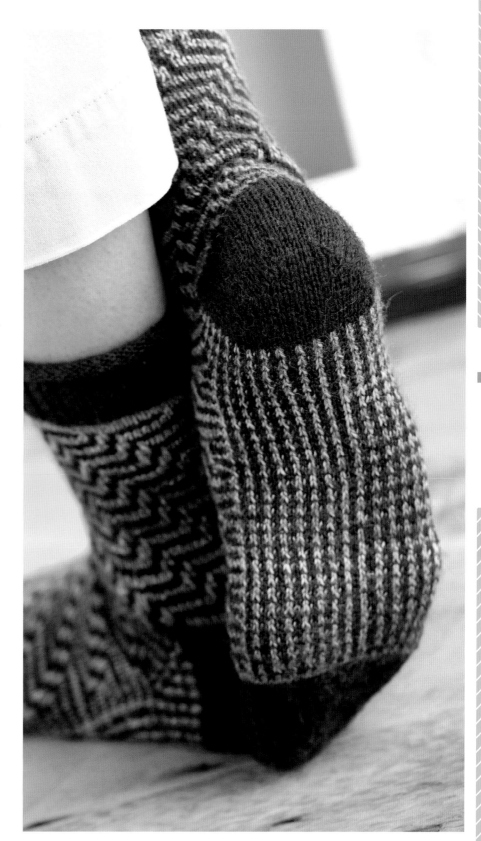

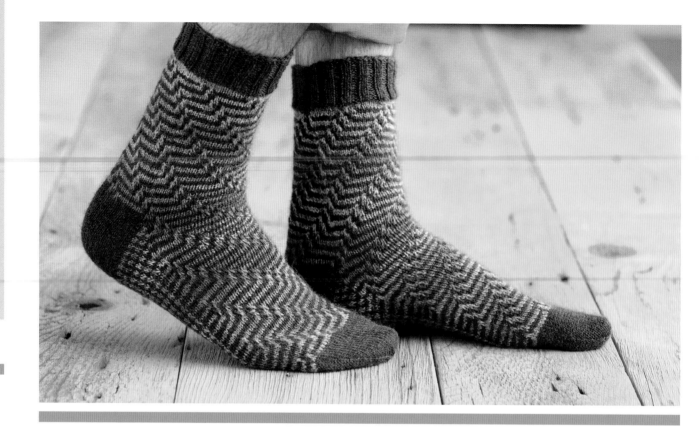

chart has been completed for both sizes, ending with Rnd 42 (18) of leg chart—66 (71) sts rem; 33 (36) instep sts on Needle 1; 33 (35) gusset and sole sts on Needle 2.

Foot

Next rnd: With Needle 1, work Rnd 43 (19) of leg chart over 33 (36) sts; with Needle 2, work Rnd 1 of Sole chart for your size over 33 (35) sts.

Cont in established patts until foot measures 7½ (8)" (19 [20.5] cm) from center back heel, or 2¼ (2½)" (5.5 [6.5] cm) less than desired total foot length, ending after having completed 2 chart rnds using CC. Cut CC.

Toe

With MC, cont for your size as foll:

Women's size only

Next rnd: With Needle 1, *k31, k2tog; with Needle 2, rep from *—64 sts rem; 32 sts each needle.

Men's size only

Next rnd: With Needle 1, [k16, k2tog] 2 times; with Needle 2, k16, k2tog, k17—68 sts rem; 34 sts each needle.

Both sizes

Knit 2 rnds even.

Dec rnd: With Needle 1, *k1, ssk, knit to last 3 sts, k2tog, k1; with Needle 2, rep from *—4 sts dec'd; 2 sts dec'd each needle.

Knit 3 rnds even, then rep dec rnd—56 (60) sts rem; 28 (30) sts each needle.

[Knit 2 rnds even, then rep dec rnd] 2 (3) times—48 sts rem for both sizes; 24 sts each needle.

[Knit 1 rnd even, then rep dec rnd] 3 times—36 sts rem; 18 sts each needle.

Rep dec rnd every rnd 7 times—8 sts rem; 4 sts each needle; toe measures about 2¼ (2½)" (5.5 [6.5] cm).

Finishing

Cut yarn, leaving an 8" (20 cm) tail. Thread tail onto a tapestry needle, draw through rem sts, and pull tight to close hole. Fasten off on WS.

Weave in loose ends.

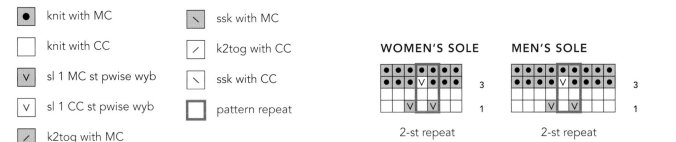

- ● knit with MC
- □ knit with CC
- Ⅴ sl 1 MC st pwise wyb
- Ⅴ sl 1 CC st pwise wyb
- ╱ k2tog with MC
- ╲ ssk with MC
- ╱ k2tog with CC
- ╲ ssk with CC
- ▢ pattern repeat

WOMEN'S SOLE

2-st repeat

MEN'S SOLE

2-st repeat

WOMEN'S GUSSET

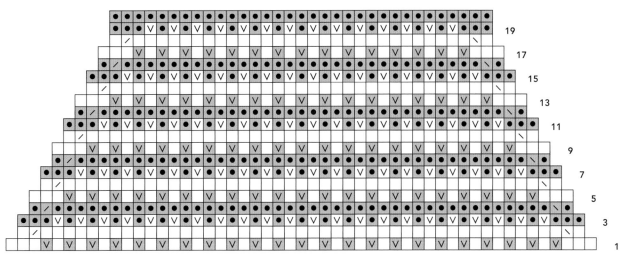

51 sts dec'd to 33 sts

MEN'S GUSSET

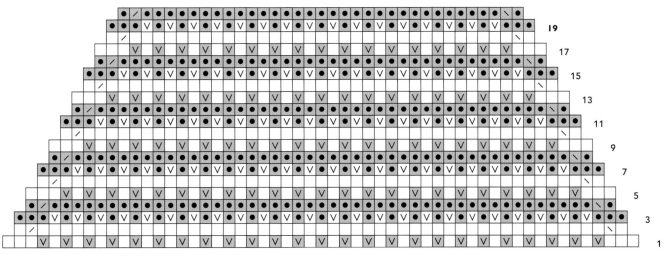

55 sts dec'd to 35 sts

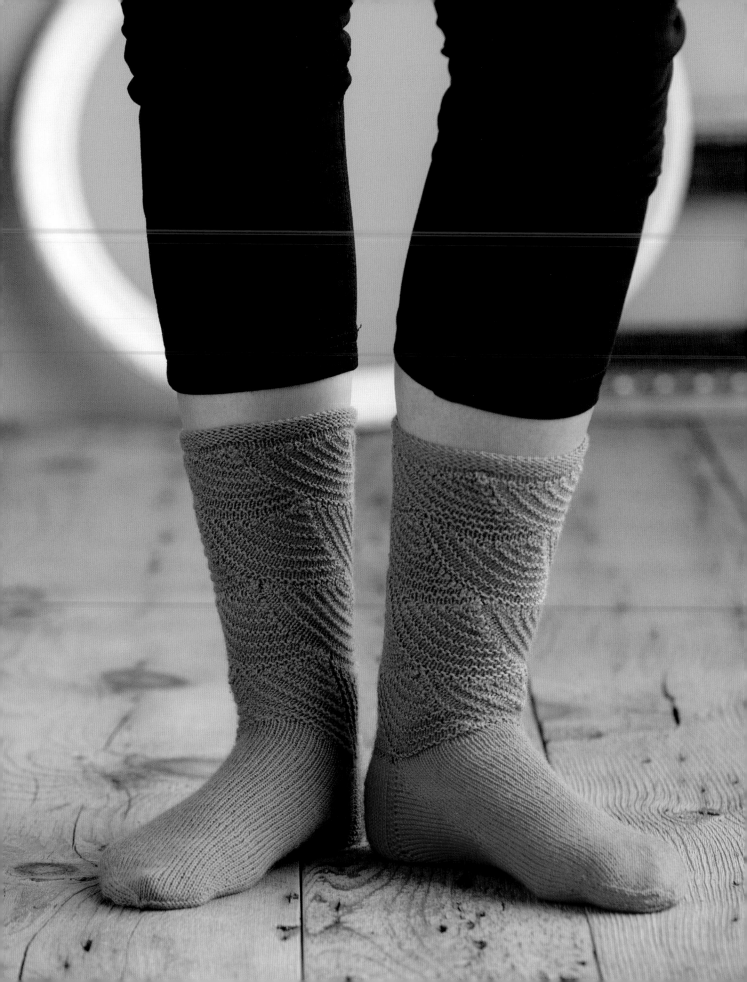

FINISHED SIZE

About 7 (7½)" (18 [19] cm) foot circumference, unstretched, and 9½ (10)" (24 [25.5] cm) foot length from back of heel to tip of toe (length is adjustable).

To fit U.S. women's shoe sizes 7½–8½ (9–10); European shoe sizes 39–40 (41–42).

Socks shown measure 9½" (24 cm) in foot length.

YARN

Fingering (#1 Super Fine).

Shown here: Lang Jawoll Superwash 4-ply (75% new wool, 18% nylon, 7% acrylic; 229 yd [210 m]/50 g): #83.0274 bakelite green (A) and #83.0184 cerise (B), 2 balls each for both sizes (colors exchange places in second sock).

NEEDLES

U.S. size 1 (2.25 mm): three 24" (60 cm) circular (cir).

Adjust needle size if necessary to obtain the correct gauge.

NOTIONS

Size D/3 (3.25 mm) crochet hook and smooth waste yarn for provisional cast-on; markers (m); safety pin; tapestry needle.

GAUGE

32 sts and 40 rnds = 4" (10 cm) in solid-color St st worked in rnds, after blocking; 36 sts and 48 rnds = 4" (10 cm) in solid-color St st worked in rnds and relaxed after blocking.

continued >>

Heinz

Op-art artists, such as Heinz Mack (born 1931), evoke the impression of lines and curves by the juxtaposition of alternating black and white lines. This concept is also used in shadow knitting in which garter ridges in one color alternate with single rows of stockinette stitch in a contrasting color.

For this sock design, named for Heinz Mack, the color of the garter ridges alternates between adjacent blocks (or crescents) of pattern to produce visual movement. The op-art shapes are worked one on top of another in brick fashion in rows, then joined to form tubes. For fun, the colors are reversed between the two socks.

GAUGE (CONTINUED)

30 (34)-st crescent units measure about 2¼ (2½)" (5.5 [6.5] cm) high (measured straight up along center st) and 3½ (4)" (9 [10] cm) across at widest part of base.

Four diagonal strips of 30 (34)-st crescents measure about 8 (9)" (20.5 [23] cm) in circumference after being joined into a tube.

NOTE

✕ The instructions correspond to the colors in the sock with the green foot; the colors are reversed in the sock with the pink foot. Reversing the colors in this manner is optional, but if you choose to do so, use the opposite colors for A and B when following the directions for the second sock.

Op-Art Socks

STITCH GUIDE

Pattern One (garter ridges in A; St st stripes in B)

Note: The first row of each crescent is worked differently depending on its position. Follow the directions for the first row, then continue with the basic instructions below.

Row 1: (RS) With A, work 30 (34) sts according to directions.

Row 2: (WS) With A, knit to last 2 sts, k2tog—1 st dec'd.

Row 3: With B, knit to last 2 sts, k2tog—1 st dec'd.

Row 4: With B, purl to last 2 sts, p2tog—1 st dec'd.

Rows 5 and 6: With A, knit to last 2 sts, k2tog—1 st dec'd in each row.

Rep Rows 3–6 six (seven) more times—1 st rem for both sizes.

Pattern Two (St st stripes in A; garter ridges in B)

Note: As for Pattern One, the first row of the crescent is worked differently depending on its position; follow the directions for the first row, then continue with the basic instructions below.

Row 1: (RS) With A, work 30 (34) sts according to directions.

Row 2: (WS) With A, purl to last 2 sts, p2tog—1 st dec'd.

Rows 3 and 4: With B, knit to last 2 sts, k2tog—1 st dec'd in each row.

Row 5: With A, knit to last 2 sts, k2tog—1 st dec'd.

Row 6: With A, purl to last 2 sts, p2tog—1 st dec'd.

Rep Rows 3–6 six (seven) more times—1 st rem for both sizes.

leg

The leg is worked from the ankle upward in four diagonal strips. After completing Strip One, each strip is joined to the strip before as it is worked, creating a parallelogram that slants on the diagonal. The sides of the parallelogram are joined into a tube to form the leg.

STRIP ONE

With crochet hook and waste yarn, make a very loose chain (see Glossary) of about 80 (90) sts. With A and beg about 2 chain sts from one end, pick up and knit 1 st from the "bump" in the back of the next 75 (85) chain sts, taking care not to split the waste yarn as you go—75 (85) sts on cir needle.

Work as foll:

First crescent

Row 1: (RS) With A, k30 (34), turn work—30 (34) worked sts for first crescent; 45 (51) CO sts rem unworked.

Beg with Row 2 and taking care to work only the sts for this crescent, work Pattern One (see Stitch Guide) until 1 st rem on needle. Attach a safety pin in the center of the RS of this crescent to mark it for the start of the next strip.

Second crescent

Refer to **Figure 1**; the second crescent is shown in white and the completed first crescent is shaded gray. Cast-on stitches are indicated by green lines, picked-up stitches by a red line, and the k1f&b in the stitch at the top of the first crescent by a short blue line.

Row 1: (RS) With A and RS facing, work k1f&b (see Glossary) in st on needle, pick up and knit 13 (15) sts evenly spaced along the left selvedge of the previous crescent beginning with a St st stripe and ending with a garter ridge, then knit the next 15 (17) provisional CO sts,

turn work—30 (34) worked sts for this crescent; 30 (34) CO sts rem unworked.

Beg with Row 2, and taking care to work only the sts of this crescent, work Pattern Two (see Stitch Guide) until 1 st rem on needle.

Third crescent

Refer to **Figure 2** for the third and fourth crescents, which are shown in white; the completed first and second crescents are shaded gray.

Row 1: With A and RS facing, work k1f&b in st on needle, pick up and knit 13 (15) sts evenly spaced along the left selvedge of previous crescent beginning with a garter ridge and ending with a St st stripe, then knit the next 15 (17) provisional CO sts, turn—30 (34) worked sts for third crescent; 15 (17) CO sts rem unworked.

Beg with Row 2, and taking care to work only the sts of this crescent, work Pattern One until 1 st rem on needle.

Fourth crescent

Row 1: (RS) With A and RS facing, work k1f&b in st on needle, pick up and knit 13 (15) sts evenly spaced along the left selvedge of the previous crescent beginning with a St st stripe and ending with a garter ridge, then knit the next 15 (17) provisional CO sts, turn work—30 (34) worked sts for fourth crescent; no unworked CO sts rem.

Beg with Row 2, work Pattern Two until 1 st rem on needle. Break yarns and fasten off last st.

STRIP TWO

With crochet hook and waste yarn, make a very loose chain of about 20 (22) sts. With A and beg about 2 chain sts from one end, pick up and

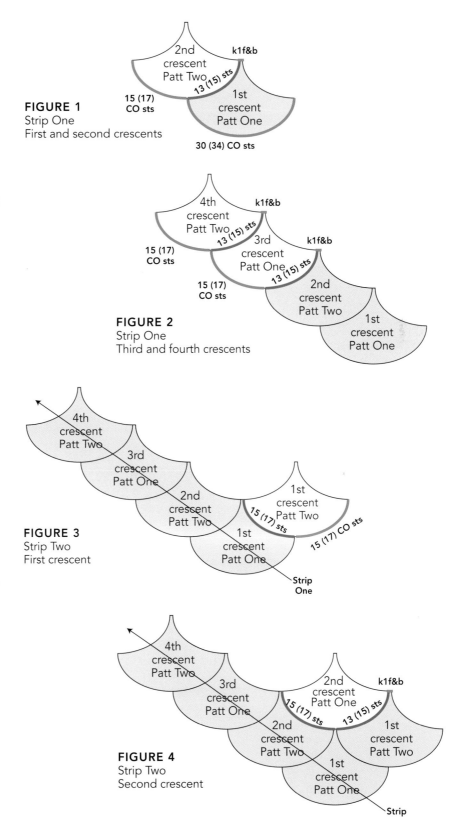

FIGURE 1
Strip One
First and second crescents

FIGURE 2
Strip One
Third and fourth crescents

FIGURE 3
Strip Two
First crescent

FIGURE 4
Strip Two
Second crescent

knit 1 st from the "bump" in the back of the next 15 (17) chain sts, taking care not to split the waste yarn as you go—15 (17) sts on cir needle.

Work as foll:

First crescent

Refer to **Figure 3**; the four completed crescents of Strip One are shaded gray, cast-on stitches are indicated by the green line, and picked-up stitches by a red line.

Row 1: (RS) With A and RS facing, pick up and knit 15 (17) sts evenly spaced along right selvedge of first crescent in the previous strip (indicated by the safety pin) beginning with a garter ridge and ending with a St st stripe, turn work—30 (34) sts.

Beg with Row 2, work Pattern Two until 1 st rem on needle.

Attach a safety pin in the center of the RS of this crescent to mark it for the start of the next strip.

Second crescent

Refer to **Figure 4**; the completed first crescent of this strip is shaded gray.

Row 1: With A and RS facing, work k1f&b in st on needle, pick up and knit 13 (15) sts evenly spaced along the left selvedge of previous crescent beginning with a garter ridge and ending with a St st stripe, then pick up and knit 15 (17) sts from the right selvedge of the second crescent of Strip One, turn work—30 (34) sts.

Beg with Row 2, work Pattern One until 1 st rem on needle.

Third crescent

Row 1: (RS) With A and RS facing, work k1f&b in st on needle, pick up and knit 13 (15) sts evenly spaced along the left selvedge of the previous crescent beginning with a St st stripe and ending with a garter ridge, then pick up and knit 15 (17) sts from the right selvedge of the third crescent in the previous strip, turn work—30 (34) sts.

Beg with Row 2, work Pattern Two until 1 st rem on needle.

Fourth crescent

Work as for second crescent of this strip, picking up sts from the right selvedge of the fourth crescent of Strip One—1 st rem on needle.

Break yarns and fasten off last st.

STRIP THREE

With crochet hook and waste yarn, CO 15 (17) sts as for beg of Strip Two.

Work as foll:

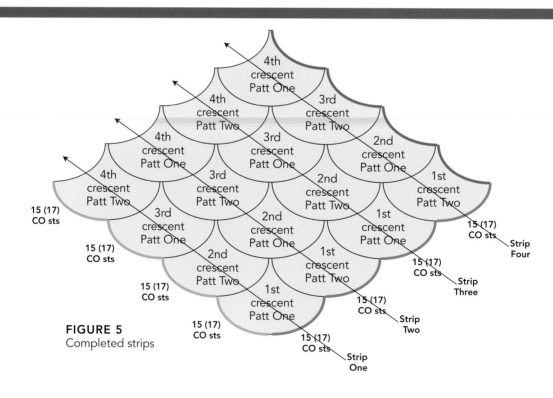

FIGURE 5
Completed strips

First crescent

Row 1: (RS) With A and RS facing, pick up and knit 15 (17) sts evenly spaced along right selvedge of first crescent in the previous strip (indicated by the safety pin) beginning with a garter ridge and ending with a St st stripe, turn work—30 (34) sts.

Beg with Row 2, work Pattern One until 1 st rem on needle.

Attach a safety pin in the center of the RS of this crescent to mark it for the start of the next strip.

Second crescent

Row 1: With A and RS facing, work k1f&b in st on needle, pick up and knit 13 (15) sts evenly spaced along the left selvedge of previous crescent beginning with a St st stripe and ending with a garter ridge, then pick up and knit 15 (17) sts from the right selvedge of the second crescent of Strip Two, turn work—30 (34) sts.

Beg with Row 2, work Pattern Two until 1 st rem on needle.

Third Crescent

Row 1: (RS) With A and RS facing, work k1f&b in st on needle, pick up and knit 13 (15) sts evenly spaced along the left selvedge of the previous crescent beginning with a garter ridge and ending with a St st stripe, then pick up and knit 15 (17) sts from the right selvedge of the third crescent in the previous strip, turn work—30 (34) sts.

Beg with Row 2, work Pattern One until 1 st rem on needle.

Fourth crescent

Work as for second crescent of this strip, picking up sts from the right selvedge of the fourth crescent of Strip Two—1 st rem on needle.

Break yarns and fasten off last st.

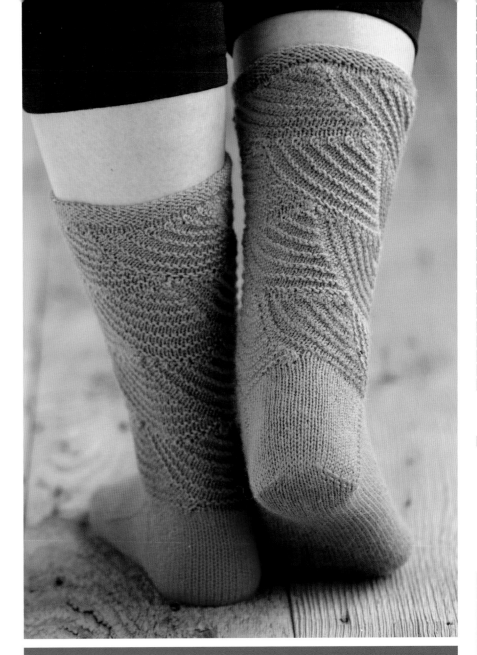

STRIP FOUR

Work as for Strip Two, picking up sts from the right selvedges of the crescents in Strip Three. See **Figure 5** for arrangement of the completed strips.

Join leg

Referring to **Figure 5**, remove waste yarn from the 15 (17) provisional CO sts outlined in green at the base Strip Three and Strip Four, and place the exposed sts on one cir needle (Needle 1) to be worked later for foot—30 (34) sts on Needle 1.

Remove waste yarn from the 15 (17) provisional CO sts outlined in green at the base Strip Two and the 15 (17) sts in one half of the provisional CO sts at the base of Strip One, also outlined in green, and place the exposed sts on one cir needle (Needle 2) to be worked later for foot—30 (34) sts on Needle 2.

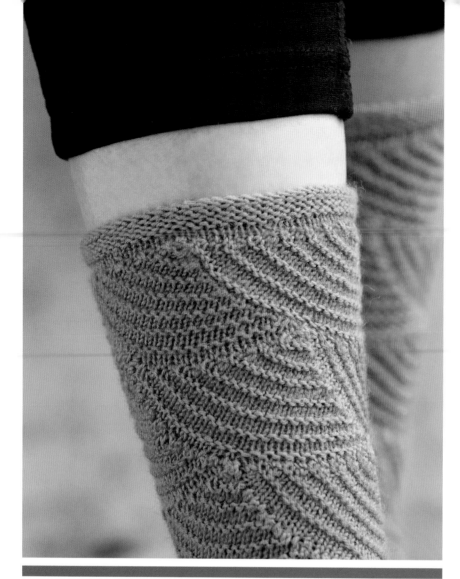

Remove waste yarn from the rem 15 (17) provisional CO sts outlined in orange at the base of Strip One, and then from the 15 (17) provisional CO sts also outlined in orange at the sides of the 2nd, 3rd, and 4th crescents in Strip One, and place these sts on one cir needle (Needle 3)—60 (68) sts on Needle 3.

Thread a strand of A on a tapestry needle and use the invisible vertical-to-horizontal seam (see Glossary) to join the 60 (68) live sts on Needle 3 to the edge of the piece outlined in purple, joining about 1 live st for every garter ridge or St st stripe along the selvedge of Strip Four outlined in purple.

foot

SET-UP

Rejoin A to beg of sts on Needle 1 and join for working in rnds—60 (68) sts: 30 (34) sts each on Needle 1 and Needle 2.

Knit 1 rnd.

Work for your size as foll.

Size 9½" (24 cm) only

Next rnd: With Needle 1, *k9, M1 (see Glossary), k12, M1, k9; with Needle 2, rep from *—64 sts; 32 sts each needle.

Size 10" (25.5 cm) only

Next rnd: Knit—still 68 sts; 34 sts each needle.

HEEL FLAP

The heel flap is worked back and forth in rows on the 32 (34) sts of Needle 2; the 32 (34) sts on Needle 1 will be worked later for the instep. Turn work so WS is facing.

Row 1: (WS) K3, p26 (28), k3.

Row 2: (RS) K32 (34).

Rep the last 2 rows 14 (15) more times, then work WS Row 1 once more—31 (33) heel-flap rows completed; 16 (17) garter ridges at each selvedge; flap measures 2½ (2¾)" (6.5 [7] cm).

TURN HEEL

Work short-rows as foll:

Short-row 1: (RS) K19, ssk, k1, turn work.

Short-row 2: (WS) Sl 1, p7 (5), p2tog, p1, turn work.

Short-row 3: Sl 1, knit to 1 st before gap formed by previous row, ssk (1 st each side of gap), k1, turn work.

Short-row 4: Sl 1, purl to 1 st before gap formed by previous row, p2tog (1 st each side of gap), p1, turn work.

Rep the last 2 rows 4 (5) more times—20 heel sts rem for both sizes.

SHAPE GUSSETS

Joining rnd: With RS facing and Needle 2, k20 heel sts, then pick up and knit 16 (17) sts (1 st for each garter selvedge ridge) along left side of heel flap; with Needle 1, k32 (34) instep sts; with Needle 2 again, pick up and knit 16 (17) sts (1 st for each garter selvedge ridge) along other side of heel flap, then knit to end of Needle 2—84 (88) sts total; 32 (34)

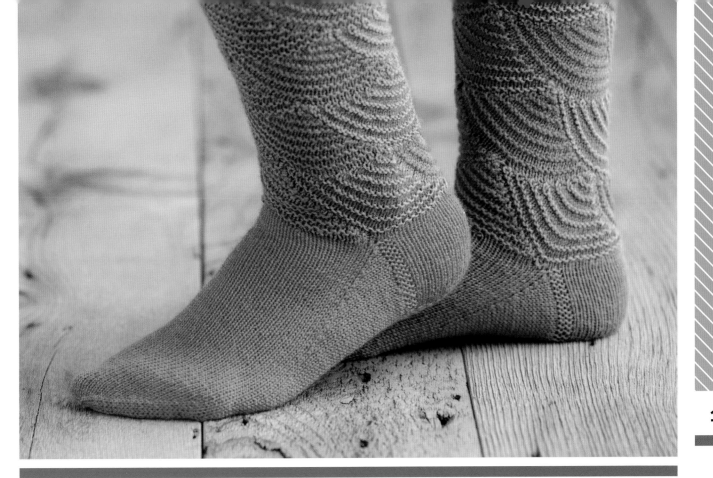

instep sts on Needle 1; 52 (54) heel and gusset sts on Needle 2.

Rnds 1 and 2: Knit.

Rnd 3: With Needle 1, knit; with Needle 2, k1, ssk, knit to last 3 sts, k2tog, k1—2 sts dec'd.

Rep these 3 rnds 9 more times—64 (68) sts rem; 32 (34) sts each needle.

Cont even in St st until foot measures 7½ (7¾)" (19 [19.5] cm) from center back of heel, or 2 (2¼)" (5 [5.5] cm) less than desired total foot length.

Toe

Dec rnd: With Needle 1, *k1, ssk, knit to last 3 sts, k2tog, k1; with Needle 2, rep from *—4 sts dec'd; 2 sts dec'd each needle.

Knit 3 rnds even, then rep dec rnd—56 (60) sts rem; 28 (30) sts each needle.

[Knit 2 rnds even, then rep dec rnd] 2 (3) time(s)—48 sts rem for both sizes; 24 sts each needle.

[Knit 1 rnd even, then rep dec rnd] 4 times—32 sts rem; 16 sts each needle.

Rep dec rnd every rnd 6 more times—8 sts rem; 4 sts each needle; toe measures 2 (2¼)" (5 [5.5] cm).

Finishing

Cut yarn, leaving an 8" (20.5 cm) tail. Thread tail onto tapestry needle, draw through rem sts, pull tight to close hole, and fasten off on WS.

CUFF

Set-up rnd: With same color as used for foot and Needle 1, *pick up and knit 15 (17) sts (about 1 st for each garter ridge or St st stripe) along the selvedge of one crescent at the leg opening, then pick up and knit 15 (17) sts along the selvedge of the next crescent in the same manner; with Needle 2, rep from *—60 (68) sts; 30 (34) sts each needle.

Place marker (pm) and join for working in rnds.

[Knit 1 rnd, purl 1 rnd] 4 (5) times—cuff measures about ½ (¾)" (1.3 [2] cm).

BO as foll: K1, *yo, k1, with left needle pull the first k1 and the yo up and over the second k1 and off the needle; rep from * until 1 st rem, then fasten off last st.

Weave in loose ends.

Glossary

Op-Art Socks

Abbreviations

beg(s)	begin(s); beginning
BO	bind off
CC	contrasting color
cm	centimeter(s)
cn	cable needle
CO	cast on
cont	continue(s); continuing
dec(s)	decrease(s); decreasing
dpn	double-pointed needles
foll	follow(s); following
g	gram(s)
inc(s)	increase(s); increasing
k	knit
k1f&b	knit into the front and back of same stitch
k2tog	knit two stitches together
kwise	knitwise, as if to knit
m	marker(s)
MC	main color
mm	millimeter(s)
M1	make one (increase)
p	purl
p1f&b	purl into front and back of same stitch
p2tog	purl two stitches together
patt(s)	pattern(s)
psso	pass slipped stitch over
pwise	purlwise, as if to purl
rem	remain(s); remaining
rep	repeat(s); repeating
rev St st	reverse stockinette stitch
rnd(s)	round(s)
RS	right side
sl	slip
sl st	slip st (slip 1 stitch purlwise unless otherwise indicated)
ssk	slip, slip, knit (decrease)
st(s)	stitch(es)
St st	stockinette stitch
tbl	through back loop
tog	together
WS	wrong side
wyb	with yarn in back
wyf	with yarn in front
yd	yard(s)
yo	yarnover
*	repeat starting point
* *	repeat all instructions between asterisks
()	alternate measurements and/or instructions
[]	work instructions as a group a specified number of times

Bind-Offs

STANDARD BIND-OFF

Knit the first stitch, *knit the next stitch (two stitches on right needle), insert left needle tip into first stitch on right needle (**Figure 1**) and lift this stitch up and over the second stitch (**Figure 2**) and off the needle (**Figure 3**). Repeat from * for the desired number of stitches.

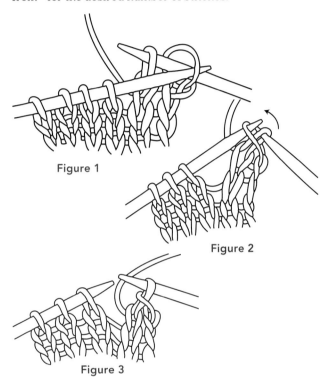

Figure 1

Figure 2

Figure 3

Cast-Ons

BACKWARD-LOOP CAST-ON

*Loop working yarn and place it on needle backward so that it doesn't unwind. Repeat from *.

CABLE CAST-ON

If there are no stitches on the needles, make a slipknot of working yarn and place it on the needle, then use the knitted method to cast-on one more stitch—two stitches on needle. Hold needle with working yarn in your left hand. *Insert right needle between the first two stitches on left needle (**Figure 1**), wrap yarn around needle as if to knit, draw yarn through (**Figure 2**), and place new loop on left needle (**Figure 3**) to form a new stitch. Repeat from * for the desired number of stitches, always working between the first two stitches on the left needle.

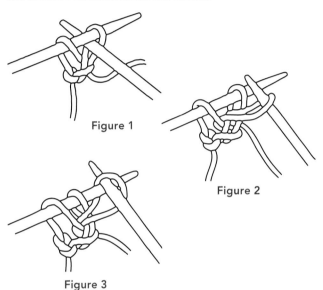

Figure 1

Figure 2

Figure 3

CROCHET CHAIN PROVISIONAL CAST-ON

With waste yarn and crochet hook, make a loose crochet chain (see page 155) about four stitches more than you need to cast on. With knitting needle, working yarn, and beginning two stitches from end of chain, pick up and knit one stitch through the back loop of each crochet chain (**Figure 1**) for desired number of stitches. When you're ready to work in the opposite direction, pull out the crochet chain to expose live stitches (**Figure 2**).

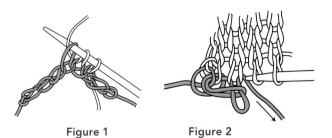

Figure 1

Figure 2

INVISIBLE PROVISIONAL CAST-ON

Make a loose slipknot of working yarn and place it on the right needle. Hold a length of contrasting waste yarn next to the slipknot and around your left thumb; hold working yarn over your left index finger. *Bring the right needle forward, then under waste yarn, over working yarn, grab a loop of working yarn and bring it forward under working yarn (**Figure 1**), then bring needle back behind the working yarn and grab a second loop (**Figure 2**).

Repeat from * for the desired number of stitches. When you're ready to work in the opposite direction, place the exposed loops on a knitting needle as you pull out the waste yarn.

Figure 1

Figure 2

KNITTED CAST-ON

Make a slipknot of working yarn and place it on the left needle if there are no stitches already there. *Use the right needle to knit the first stitch (or slipknot) on left needle (**Figure 1**) and place the new loop onto left needle to form a new stitch (**Figure 2**). Repeat from * for the designated number of stitches, always working into the last stitch made.

Figure 1

Figure 2

LONG-TAIL (CONTINENTAL) CAST-ON

Leaving a tail about ½" (1.3 cm) per stitch to be cast-on, make a slipknot and place it on the right needle.

Place the thumb and index finger of your left hand between the yarn ends so that the working yarn is around your index finger and the tail end is around your thumb. Secure both yarn ends with your other fingers. Hold your palm upward, making a V of yarn (**Figure 1**).

*Bring the needle up through the loop on your thumb (**Figure 2**), catch the first strand around your index finger, and bring the needle back down through the loop on your thumb (**Figure 3**).

Drop the loop off your thumb, and placing your thumb back in the V configuration, while tightening the resulting stitch on the needle (**Figure 4**).

Repeat from * for the desired number of stitches.

Figure 1

Figure 2

Figure 3

Figure 4

Crochet

CROCHET CHAIN (CH)

Make a slipknot and place it on crochet hook if there isn't a loop already on the hook. *Yarn over hook and draw through loop on hook. Repeat from * for the desired number of stitches. To fasten off, cut yarn and draw end through last loop formed.

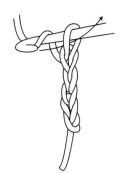

SINGLE CROCHET (SC)

*Insert hook into the second chain from the hook (or the next stitch), yarn over hook and draw through a loop, yarn over hook (**Figure 1**), and draw it through both loops on hook (**Figure 2**). Repeat from * for the desired number of stitches.

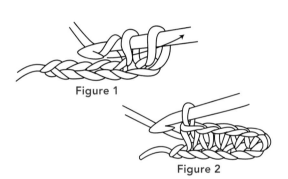

Figure 1

Figure 2

Decreases

KNIT 2 TOGETHER (K2TOG)

Knit two stitches together as if they were a single stitch.

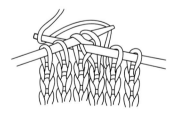

PURL 2 TOGETHER (P2TOG)

Purl two stitches together as if they were a single stitch.

SLIP, SLIP, KNIT (SSK)

Slip two stitches individually knitwise (**Figure 1**), insert left needle tip into the front of these two slipped stitches, and use the right needle to knit them together through their back loops (**Figure 2**).

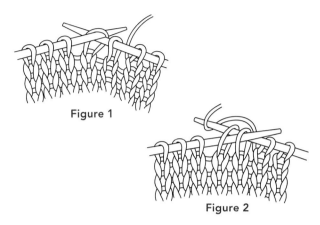

Figure 1

Figure 2

Grafting

KITCHENER STITCH

Arrange stitches on two needles so that there is the same number of stitches on each needle. Hold the needles parallel to each other with wrong sides of the knitting together. Allowing about ½" (1.3 cm) per stitch to be grafted, thread matching yarn on a tapestry needle. Work from right to left as follows:

Step 1. Bring tapestry needle through the first stitch on the front needle as if to purl and leave the stitch on the needle (**Figure 1**).

Step 2. Bring tapestry needle through the first stitch on the back needle as if to knit and leave that stitch on the needle (**Figure 2**).

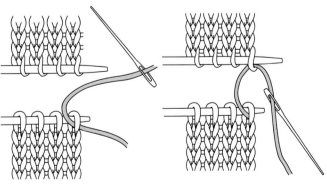

Figure 1

Figure 2

Step 3. Bring tapestry needle through the first front stitch as if to knit and slip this stitch off the needle, then bring tapestry needle through the next front stitch as if to purl and leave this stitch on the needle (**Figure 3**).

Step 4. Bring tapestry needle through the first back stitch as if to purl and slip this stitch off the needle, then bring tapestry needle through the next back stitch as if to knit and leave this stitch on the needle (**Figure 4**).

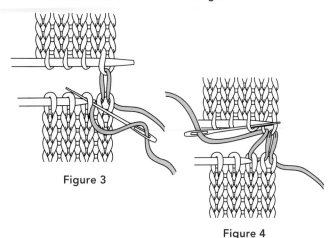

Figure 3

Figure 4

Repeat Steps 3 and 4 until one stitch remains on each needle, adjusting the tension to match the rest of the knitting as you go. To finish, bring tapestry needle through the front stitch as if to knit and slip this stitch off the needle, then bring tapestry needle through the back stitch as if to purl and slip this stitch off the needle.

Increases

BAR INCREASE (K1F&B)

Knit into a stitch but leave it on the left needle (**Figure 1**), then knit through the back loop of the same stitch (**Figure 2**) and slip the original stitch off the needle.

Figure 1

Figure 2

MAKE-ONE
Left Slant (M1L)

Note: Use the left slant if no direction of slant is specified.

With left needle tip, lift the strand between the last knitted stitch and the first stitch on the left needle from front to back (**Figure 1**), then knit the lifted loop through the back (**Figure 2**).

Figure 1

Figure 2

Purlwise (M1P)

Work as for the left slant but purl the lifted strand instead of knitting it.

Right Slant (M1R)

With left needle tip, lift the strand between the needles from back to front (**Figure 1**). Knit the lifted loop through the front (**Figure 2**).

Figure 1

Figure 2

Pick Up and Knit

PICK UP AND KNIT ALONG CO OR BO EDGE

With right side facing and working from right to left, insert the tip of the needle into the center of the stitch below the bind-off or cast-on edge (**Figure 1**), wrap yarn around needle, and pull through a loop (**Figure 2**). Pick up one stitch for every existing stitch.

Figure 1 Figure 2

PICK UP AND KNIT ALONG HEEL FLAP
Pick Up a Single Loop

For very little bulk along the pick-up edge, pick up gusset stitches through the front half of the edge stitches (shown here in stockinette). *Insert the needle under the front half of the selvedge stitch (**Figure 1**), wrap the yarn around needle (**Figure 2**), and pull a loop through. Repeat from * for the desired number of stitches.

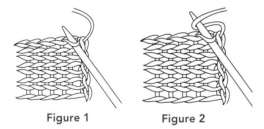

Figure 1 Figure 2

Pick Up Both Loops

For a sturdier join, pick up the gusset stitches through both halves of the edge stitch (shown here in stockinette). *Insert the needle under both halves of the selvedge stitch (**Figure 1**), wrap the yarn around needle (**Figure 2**), and pull a loop through. Repeat from * for the desired number of stitches (**Figure 3**).

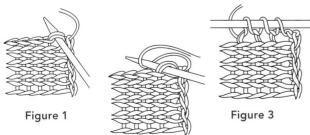

Figure 1 Figure 3

Figure 2

Pick Up Through the Back Loops

For a very snug join, pick up the gusset stitches by working into the back loop of either the first half or both halves of the selvedge stitches (shown here in stockinette). *Use the needle in your left hand to lift the selvedge stitch (**Figure 1**), then insert the right needle into the back of the lifted stitch, wrap the yarn around the right needle (**Figure 2**), and pull a loop through. Repeat from * for the desired number of stitches (**Figure 3**).

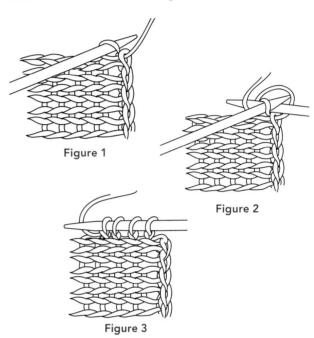

Figure 1

Figure 2

Figure 3

Pick Up and Purl

With wrong side of work facing and working from right to left, *insert needle tip under selvedge stitch from the far side to the near side (**Figure 1**), wrap yarn around needle, and pull a loop through (**Figure 2**). Repeat from * for desired number of stitches.

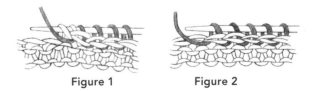

Figure 1 Figure 2

Seams

INVISIBLE VERTICAL-TO-HORIZONTAL SEAM

*Bring threaded tapestry needle from back to front in the V of a knit stitch just below the bound-off edge. Insert the needle under one or two bars between the first and second stitch in from the selvedge edge on the adjacent piece, then back to the front of the same knit stitch just under the bound-off edge. Repeat from *, striving to match the tension of the knitting.

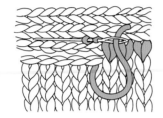

MATTRESS STITCH SEAM

Insert threaded needle under one bar between the two edge stitches on one piece, then under the corresponding bar plus the bar above it on the other piece (**Figure 1**). *Pick up the next two bars on the first piece (**Figure 2**), then the next two bars on the other (**Figure 3**). Repeat from *, ending by picking up the last bar or pair of bars on the first piece.

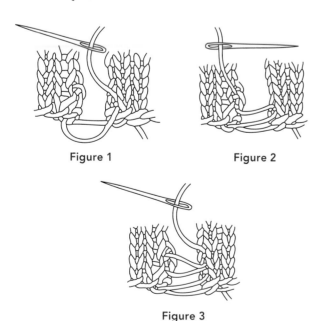

Figure 1

Figure 2

Figure 3

Short-Rows

KNIT SIDE

Work to turning point, slip the next stitch purlwise (**Figure 1**), bring the yarn to the front, then slip the same stitch back to the left needle (**Figure 2**), turn the work around and bring the yarn in position for the next stitch—one stitch has been wrapped, and the yarn is correctly positioned to work the next stitch.

To hide the wrap on a subsequent knit row, work it together with the wrapped stitch as follows: Insert right needle tip under the wrap (from the front if wrapped stitch is a knit stitch; from the back if wrapped stitch is a purl stitch; **Figure 3**), then into the stitch on the needle, and work the stitch and its wrap together as a single stitch.

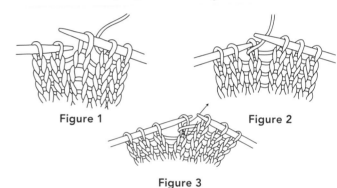

Figure 1

Figure 2

Figure 3

PURL SIDE

Work to the turning point, slip the next stitch purlwise to the right needle, bring the yarn to the back of the work (**Figure 1**), return the slipped stitch to the left needle, bring the yarn to the front between the needles (**Figure 2**), and turn the work so that the knit side is facing—one stitch has been wrapped, and the yarn is correctly positioned to knit the next stitch.

To hide the wrap on a subsequent purl row, use the tip of the right needle to pick up the wrap from the back, place it on the left needle (**Figure 3**), then purl it together with the wrapped stitch.

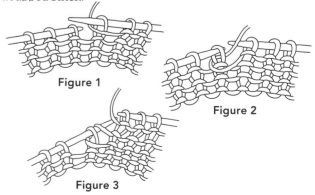

Figure 1

Figure 2

Figure 3

Sources for Yarns

Berroco Inc./Lang Yarns
PO Box 367
14 Elmdale Rd.
Uxbridge, MA 01569
(401) 769-1212
berroco.com
in Canada: Westminster Fibers
(Canada)

**Skacel/Austermann/Trekking/
Zitron**
PO Box 88110
Seattle, WA 98138
(800) 255-1278
skacelknitting.com

Westminster Fibers (Canada)
10 Roybridge Gate, Ste. 200
Vaughan, ON
Canada L4H 3M8
USA (800) 445-9276
Canada (800) 263-2354
westminsterfibers.com

Index

Treat your feet

AND BECOME A SOCK KNITTING EXPERT WITH THE HELP OF THESE INTERWEAVE RESOURCES

Sock Knitting Master Class
Innovative Techniques + Patterns from Top Designers

Ann Budd

ISBN 978-1-59668-312-9
$26.95

Around the World in Knitted Socks
26 Inspired Designs

Stephanie van der Linden

ISBN 978-1-59668-230-6
$24.95

Sock Innovation
Knitting Techniques & Patterns for One-of-a-Kind Socks

Cookie A.

ISBN 978-1-59668-109-5
$22.95

Join Knittingdaily.com, an online community that shares your passion for knitting. You'll get a free eNewsletter, free patterns, projects store, a daily blog, event updates, galleries, tips and techniques, and more. Sign up for *Knitting Daily* at **Knittingdaily.com.**

INTERWEAVE KNITS

From cover to cover, *Interweave Knits* magazine presents great projects for the beginner to the advanced knitter. Every issue is packed full of captivating smart designs, step-by-step instructions, easy-to-understand illustrations, plus well-written, lively articles sure to inspire. **Interweaveknits.com**

Available at your favorite retailer or knitting daily shop

shop.knittingdaily.com